Short Life in a Strange World

Short Life in a Strange World

*Birth to
Death in
42 Panels*

Toby Ferris

HARPER

An Imprint of HarperCollins*Publishers*

HarperCollins books may be purchased for educational, business, or
sales promotional use. For information, please email the Special Markets
Department at SPsales@harpercollins.com.

Published simultaneously in Great Britain in 2020 by 4th Estate, an imprint
of HarperCollins Publishers.

FIRST U.S. EDITION

Library of Congress Cataloging-in-Publication Data has been applied for.

ISBN 978-0-06-293175-7

20 21 22 23 24 LSC 10 9 8 7 6 5 4 3 2 1

Contents

The Panels

Belgium	Antwerp	• Dulle Griet • Twelve Proverbs	Museum Mayer van den Bergh
	Brussels	• The Census at Bethlehem • The Fall of the Rebel Angels • Winter Landscape with a Bird Trap	Musées royaux des Beaux-Arts de Belgique
Netherlands	Rotterdam	• The Tower of Babel	Museum Boijmans Van Beuningen
UK	London	• Christ and the Woman Taken in Adultery • Landcape with the Flight into Egypt	Courtauld Institute of Art
		• The Adoration of the Kings	National Gallery
		• The Massacre of the Innocents	Royal Collection
	Banbury	• The Dormition of the Virgin	Upton House
Switzerland	Winterthur	• The Adoration of the Magi in the Snow	Sammlung Oskar Reinhart 'Am Römerholz'

France	Paris	• The Beggars	Musée du Louvre
Austria	Vienna	• Children's Games • Christ Carrying the Cross • The Fight Between Carnival and Lent • The Conversion of Saul • The Dark Day • Hunters in the Snow • The Peasant and the Birdnester • The Village Kermis • The Wedding Banquet • The Return of the Herd • The Suicide of Saul • The Tower of Babel	Kunsthistorisches Museum
Czech Republic	Prague	• The Hay Harvest	Roudnice Lobkowicz Collection
Hungary	Budapest	• The Preaching of St John the Baptist	Szépmüvészeti Múzeum
Italy	Naples	• The Blind Leading the Blind • The Misanthrope	Museo di Capodimonte
	Rome	• View of the Bay of Naples	Galleria Doria Pamphilj
Spain	Madrid	• The Triumph of Death • The Wine of St Martin's Day	Museo Nacional del Prado

Germany	Berlin	• Netherlandish Proverbs • Two Monkeys	Staatliche Museen zu Berlin, Gemäldegalerie
	Darmstadt	• The Magpie on the Gallows	Hessisches Landesmuseum
	Munich	• Head of an Old Woman • The Land of Cockaigne	Alte Pinakothek
	Bamberg	• The Drunkard Pushed into the Pigsty (copy, Pieter Brueghel the Younger, after Pieter Bruegel the Elder, private collection)	Historisches Museum
USA	Detroit	• The Wedding Dance	Detroit Institute of Arts
	New York	• The Harvesters	Metropolitan Museum of Art
		• Three Soldiers	Frick Collection
	San Diego	• Landscape with the Parable of the Sower	Timken Museum of Art

For Simon, Frank and Sid,
and in memory of Robert Henry

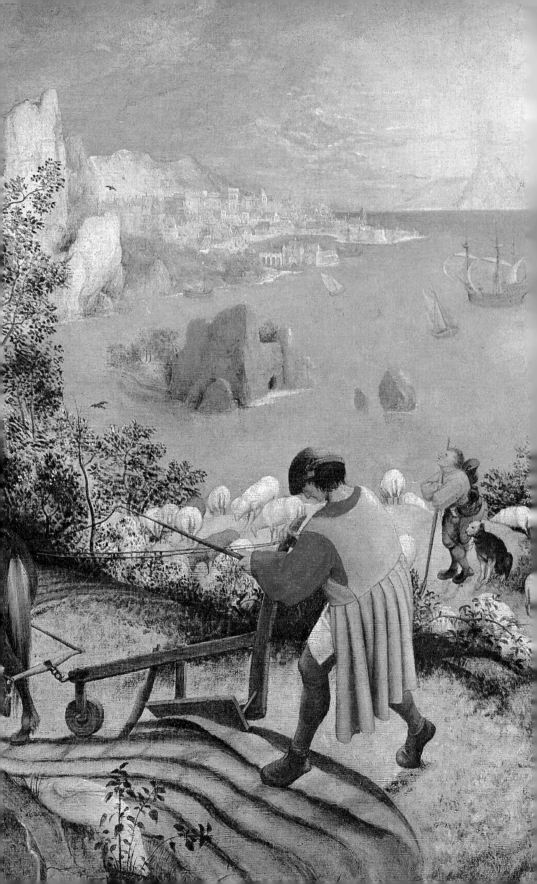

I Flight

'… the boy a frolic courage caught
To fly at random …'

Arthur Golding, translating Ovid

I once saw a young man fall from the sky.

I barely knew him. Dan was perhaps twenty, on leave from the army. My girlfriend's sister, Zabdi, worked as a paragliding instructor on the Isle of Arran, and Dan was a friend of her boyfriend, Chris. And so there we were on a September morning in the late 1990s, Dan and Chris and my girlfriend Anna and Zabdi and I, on the slopes of a green hill on the Isle of Arran, paragliding.

When we picked him up in the minibus, Dan, already a qualified and experienced paraglider, was watching a video of stunt paragliders performing wild manoeuvres, swinging energetically beneath their canopies in figures of eight, looping the loop, skirting crags, skimming lakes, and Dan was clearly inspired. Later, on the mountain, as I was harnessed up and ready to bumble into the air, Zabdi put her hand on my chest and told me to wait: Dan had taken off higher up and was

coming overhead. We watched him glide over us for a few seconds, and then, at an altitude of a couple of hundred feet, he started to swing beneath his canopy much as we had seen them do on the video, back and forth, like a pendulum, higher and higher, six, eight swings sweeping out an ever-lengthening arc, just enough time for Zabdi to mutter something under her breath (*for fuck's sake, Dan*). Sure enough, he got up too far above his canopy and dropped into it, and in the skip of a heartbeat was tumbling uncontrollably earthward. We watched him fall, lost in his billowing parachute silks, then part emerging, arms thrown out, wheeling, tumbling, and then, thud, into the hillside. As I recall it, the hillside shook, but perhaps it didn't; perhaps it was just an interior thud I felt. I remember Zabdi screaming 'Dan' and belting down the hillside towards where he lay, invisible in the deep gorse. I unharnessed myself and ran after her. There he was, stretched out on his back, laughing uncontrollably. His canopy, we reasoned later, must have caught a little air just as he landed and broken his fall. And then there was that cushion of gorse. Lucky boy.

The helicopter, a red-and-grey Sea King, had to lollop over from the mainland, nevertheless, and airlift him to Glasgow. He was in traction for six weeks, broken bones and compressed vertebrae. He hated the army, didn't want to go back, and was never happier, they told me, than when he was lying there, immobilized, contemplating his mad descent.

A couple of years later he went missing in Dundee after a night's drinking and was believed murdered, or drowned, until they found his body in a disused factory. He had been climbing on the roof, and it had given way.

*

In 2012, at the age of forty-two, I decided that I would travel to see the forty-two or so extant paintings by Pieter Bruegel the Elder. A mania for Bruegel had recently gripped me, and I had been thinking about little else. And then in early May of that year I realized that all of the paintings (except one) hung in public, or publicly viewable, collections. All were reachable. I suddenly saw that there was a great Bruegel Object out there, dismembered like the body of Osiris and strewn around the museums of Europe and North America, and I set myself to reconstitute it. I drew up a spreadsheet on which I recorded where the constituent limbs and parts of this prostrate god were located, and started to plan my journeys.

The *Landscape with the Fall of Icarus*, while it is on my spread-sheet, has been downgraded to a section devoted to probable copies, misattributions and mislabellings. *Icarus* is not one of the forty-two, is not authentic Bruegel but most likely a copy. It is unsigned and undated. It is painted on canvas. Most spreadsheet Bruegels are on wood panel, and can be dendro-chronologically confirmed, and those that are on canvas are not in oil but in tempera. Radiocarbon dating of the *Icarus* is inconclusive – there are ambiguities in the calibration curve, thick layers of oxidized varnish which mask colours and throw off precision – but the samples of the oldest canvas harvested suggest a date from the end of the sixteenth century or the beginning of the seventeenth, thirty years after Bruegel died.

In January 2011, however, this doesn't much matter: the spreadsheet is a year off, and the *Icarus* is the reason I am in the Bruegel room. I am drawn by its fame. W. H. Auden

wrote a poem about it. So did William Carlos Williams. Everyone has seen it, in reproduction if not in fact.

I am in Brussels waiting for a friend whose flight is delayed; we are supposed to be on our way to Bruges, but I have a few loose hours to fill. I leave my bags at the station and walk up into the centre of the city, and locate what Auden called the Musée des Beaux Arts.

Museums are safe havens. International space. No one looks twice at you in a museum. No one expects you to speak French, for example, as they might elsewhere in Brussels, in the real city. So I have a cappuccino and a croissant, and I automatically belong. I start to breathe easy.

The museum is extensive, however, and, my coffee done, I get a little lost wandering in the modern wings. It turns out there is such a thing as nineteenth-century Belgian art. And a big thing it is. But eventually I clamber up to the upper galleries where they have constructed a chronological circuit from Van der Weyden to Rembrandt and Rubens, more or less. I pick a door at hazard: it is the wrong door, and I make my progress clockwise, back through history. I freefall past Rembrandts and Van Dycks and other brown paintings, start to meet some shuddering resistance around the end of the sixteenth century, and I am still some distance away from the fifteenth-century Flems where I expect softly to touch down and walk with the strange beasts in Eden, when I happen into the corner room of Bruegels.

Here is *Icarus*. My idle descent through the gallery may have come to an abrupt halt, but my life has just accelerated without my realizing it. I have entered the slipstream of an as yet invisible project, a dark mass lying in the future. If I could look down on myself, see myself situated in all the

4

meaningful relations of my life, my hair would be streaming, my cheeks juddering, in the chill jets of air.

Gravity is a weak but insistent force. Perhaps not a force at all, but a geometry. Who knows where its centres lie, or to what we are tending?

My notebooks of the time are sketchy on the subject of Bruegel. I see that I made a solitary note about the *Icarus*. That ploughman, I observed, was never going to be able to turn his horse and his plough at the bottom of that field.

It is not a profound observation. I have picked up on an oddity of composition – the narrow, constrained hundred, the clodhopping ploughman and his lean horse. But it leads, I see now, to others. The ploughman's weight distribution is all wrong. The sheep, also, are ill-managed, crammed into a perilous corner of a field.

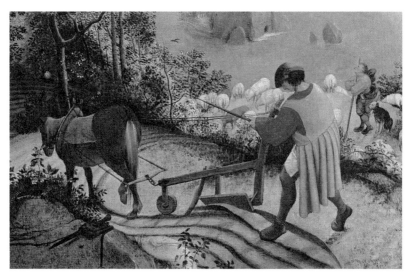

Clodhopping ploughman: *Landscape with the Fall of Icarus*, detail.

And the ship is wrongly rigged. Bruegel made a number of drawings of ships for a series of engravings in the early 1560s, caravels and sloops and brigantines and oceangoing three-masters, all accurately observed and set down, their complex unreadable rigging read anyway by a sharp eye. An adopted son of the great port of Antwerp, he would have had time to learn. Anyway, this *Icarus* ship is wrongly rigged or cack-handedly painted (the anamorphic hull would suggest the latter). Expensive delicate ship, Auden calls it. But those tiny seamen are furling all the wrong sails, leaving the lateen at the back, the absurd straining foresail caught in a squall or a hurricane – how is the ploughman's cap not blown off, zipped up into some vortex of winds? – the billow of the sail at odds, seemingly, with the play of its cross-spar, the whole contraption flapping about chaotically. The shrouds on the foremast are wrongly positioned (or again, poorly painted). Much too much sail, in too narrow a space (although a second ship in the background is charging into port with a full spread of sail and an apparent death wish).

The ship still manages to be a conception of no little beauty, stupidly buoyant and energetic, a Dionysiac vehicle.

Three of Bruegel's ship engravings are ornamented with scenes from classical mythology: one, of three caravels in a rising gale, has Arion riding on his dolphin, playing his harp; another, of two galleys following a three-masted ship, has the fall of Phaethon unfolding like a great pantomime in the sky; and a third, of a ship not at all unlike that in the painting (only better done, and with a full spread of sail), has both Daedalus and a tumbling Icarus overhead.

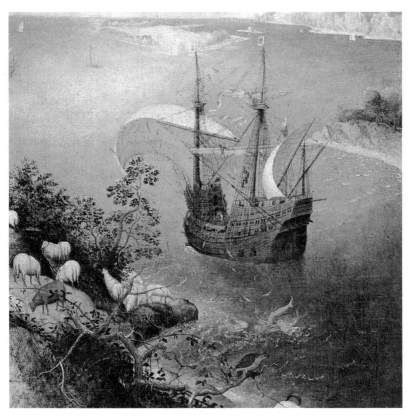

Dionysiac vehicle: *Landscape with the Fall of Icarus*, detail.

Bruegel rarely painted classical gods or myths. His themes were biblical, vernacular. But ocean-going ships, with their whiff of impossible distance and difference, seem to have brought it out in him. And so this ship, fabulous technology, churns up Icarus in its wake.

Experienced paragliders will skip from thermal to thermal, or dance on the uplift over a ridge. I never attained any such level of skill. I could only lumber off a hilltop like a misevolved

seabird, and then hang inert beneath my canopy while it and I floated softly earthwards at an angle of, approximately, 11.5 degrees. I could take off from and land at given points, the one a straightforward geometrical projection of the other. And that was it. There was to be no soaring. Dan, or Icarus, I was not.

It was extraordinary, nonetheless. As I picture it in memory, the world stretched beneath me like a Bruegelian landscape, blue mountains on the horizon, sea skirting the world, little villages in the distance, tiny copses below, miniature cows grazing the verdant champaign. I would survey all this, rigid in my harness, listening to the calm directions of my instructor, Zabdi, whose voice was relayed over a radio strapped to my shoulder.

In the evenings Zabdi and her boyfriend Chris would share their folklore: tales of paragliders colliding, their cords twisted into some double-helix of destruction, or of gliders veering off course, into mountains, out to sea, disappearing.

Most striking of all were the tales of paragliders sucked up tens of thousands of feet into black storm clouds before plummeting to earth again, frozen and asphyxiated. These stories of cloud suck, as it is known, may be folkloric, but they are also true. Survivors tell of encountering marvels up there: furious, volatile darkness, hailstones the size of oranges, incredible forces of updraught and precipitation. They would be tossed around in regions of lurid physics, as though buffeted in the red eye of Jupiter, would black out, and then, if they lived to tell of it, would be spat back frostbitten, wild-eyed, jabbering: ancient mariners of the upper airs.

*

Icarus's wings would not have melted, we must conclude, but frozen. He would not have splashed spreadeagled as in the pseudo-Bruegel, his feathers fluttering down after him. He would have plunged, an icy meteorite, into the green sea.

Daedalus should have known. He was the great artificer, the great engineer. He could have reasoned it out, drawn some sort of empirical conclusion. There are high mountains in Crete, mountains capped with snow in late spring, early summer. It is cold up there, in the White Mountains.

Perhaps he was blinded by the desire to escape his Cretan prison. It was Daedalus who had constructed the wooden cow for Pasiphaë so that she could couple with the white bull of heaven; Daedalus who had devised the Cretan labyrinth, modelled on the maze that led to the underworld, to house her ungodly progeny. Here was a man who understood longing and how to channel it, be that longing bestial and unsightly, or youthful and yearning. Who is to say he did not also yearn, in his way?

In another version of the pseudo-Bruegel composition, also in Brussels, in the Van Buuren Museum, Daedalus is painted in the sky, looking back down at his tumbling boy. This may be a more precise copy of the lost original. Or, more likely, the mystified copyist has spelled out the logic which Bruegel deliberately elides. Bruegel wants the shepherd to be looking up at a great blankness, because it is out of just such an unknowable blankness – his father's manic absence – that Icarus, solitary rebel angel, falls. There are no gods or men in the sky. They are all down here, slowly ploughing the heavy clay.

*

The *Landscape with the Fall of Icarus* came to light and was acquired by the Musées des Beaux-Arts in 1912, just nine years after the first powered flight. A painting for a modern age, an age of exhilaration.

The chief problem faced by the Wright Brothers at Kitty Hawk in 1903, once they had got their Flyer miraculously, stupidly, airborne, was learning how to operate it. No one had ever flown a powered aircraft before, there was no manual; the brothers had previously built and flown gliders, but gliders rely on thermals and updraughts, on a different ethos of flying. Now they were out on their own, piloting their precarious bird of struts and wires and great-spruce wood, in ignorance of the physics which was keeping them in the air. Four short flights (of, respectively, 120 feet, 175 feet, 200 feet and 852 feet) on 17th December concluded with a tumbling nose-down landing which irreparably damaged the contraption, and it never flew again.

The concept, however, had got irrevocably aloft. Pretty soon, to fly was to live. I grew up on stories of my father's wartime experiences in open-topped biplanes – specifically, in the Fairey Swordfish, a plane so antiquated, so creaky, so simple, it was hard to bring down since the only critical parts were the engine and the pilot. You could shoot a Swordfish full of holes, as my father told me and as the *Bismarck* would discover to its cost, and it would keep on coming at you. Very slowly, but with a big torpedo.

No one shot my father's Swordfish full of holes. He was eighteen when he volunteered for the Fleet Air Arm. His call-up papers in 1943 instructed him to bring a tennis racquet to his basic training. An astigmatic left eye kept him from piloting, but he flew as a gunner-navigator over the

grey North Atlantic from his base in Scotland. Later his squadron was located in Canada, then Northern Ireland, and he finished the war in Ceylon, preparing for an invasion of Singapore which never happened. He saw no action at all. But he returned with a repertoire of stories – of snakes in his shower, of feuds with Canadian lumberjacks, of leave taken in New York City – garnered by a boy of eighteen, nineteen, twenty who had spent his early manhood sitting at the whirring, clattering, piston-thumping centre of a machine of Daedalic absurdity, hunting an invisible, perhaps wholly absent, enemy, exhilarated beyond measure. It would get no better than this.

On the day I first took to the air in a paraglider I was asked by a ten-year-old boy, nephew to Anna and Zabdi, to describe the exhilaration. And I told him that it had not been exhilarating, exactly, but an exercise in control: there had been adrenalin, for sure, but it had been released in a glut of hyper-attention. I had been, above all, attentive to details of harness and rigging, to the mechanics and materials keeping me aloft. He seemed disappointed, and I did not know how to communicate to him that I was in fact excited about this.

It was a version of excitement known to Daedalus, and not Icarus. Wilbur and Orville Wright would have understood. For them on that first day the exhilaration would have been as much in the play of canvas and wood, in the creak of the struts and the stench of petrol, as in any sensations of buoyancy and velocity. Bruegel, a miniaturist by instinct, his nose close to the oils on the canvas or panel, must have known something similar, painting his absurd

ship. A good painting, like a real ship, is a Daedalic object: not a pretty thing of spirit and billows for the painter who labours in front of it, but a straining, groaning, improvable, precarious livelihood.

The ship on Bruegel's canvas, by contrast, is all fluttering impetuosity, out of control, ignorant of physics. Alive.

I like to think of my spreadsheet as a modern-day Daedalic object, a thing of glue and feathers and grids and spars designed to harness the airy desires of my midlife, or a parachute gradually rippling and filling as I block out the paintings I have seen, breaking my fall.

Daedalus means *cunningly wrought*, but I am not sure how cunning my spreadsheet is. It is a reductive object. Bruegel is broken down into a simple alphabetical list, with each painting further broken down into a location, a date, a medium (oil on oak panel; tempera on canvas), a series of dimensions. I have calculated the area of each painting, and the proportion of each painting considered as a fragment of a vast singular object, which I call the Bruegel Object.

Roughly 1,082 cells of information, as it stands.

Where the information tapers off – beyond, in other words, my 1,082 cells of data – there is an effective infinity of empty cells stretching beside and below. To be precise, according to Microsoft's published data on Excel, there are $1.71798691 \times 10^{10}$ cells, or 17 billion, give or take.

The totality of my data clings to the edge of a great sea of unknowing which represents, I suppose, everything which is not on the spreadsheet: my ignorance of Bruegel; my ignorance of the museums in which his panels hang; my

ignorance of the cities which those museums grace; and my ignorance of the impulses or affinities which have brought me to the brink of this project.

Why Bruegel?, *why all of it?* and *why now?* are questions the spreadsheet is not designed to address.

Over 17 billion cells of ignorance, then. But I have my little monastic garden of 1,082 cells, my tidy simulacrum of the cosmos.

Why this mania to quantify? Bruegel himself was not immune. In all art, there is hardly a better documenter of his own work. Almost every panel is signed and dated. Logic demands that somewhere he kept a ruled notebook in which he listed each painting that he completed, its subject, its medium and materials, its size, its destination, its cost and price and sale date, perhaps a note on problems overcome, solutions supplied.

The documentation of the Bruegel Object is secure. This is, in part, its attraction. We know what, we know where, we know when. Exclusions and reassignments, among the panels if not the drawings, are minimal, almost impossible, at least since the nineteenth century when Bruegel's panels were routinely ascribed to Bosch.

Bruegel understood. Quantified objects are easier to handle. They are a necessary simplification. Just as mathematics does not represent some underlying truth of the cosmos, but is a simplification of it, its noise and bustle and impurity reduced to clean lines, or just as a Wright Flyer or a Fairey Swordfish is a simplification of a kestrel and thus, like mathematics, a new thing of its own, so too my spreadsheet is a manageable

representation of an unimaginable complexity: the Bruegel panels, their endlessly interacting content, and their filigree intersections with the world, and with me.

The labyrinth that Daedalus invented to house the Minotaur was a way of ritualizing, hence managing, monstrous and unnameable desire. And we, too, need a way either to handle or net the creatures of imagination which rear up in the recesses of the night: black certainty of failure, nebulous inadequacy, hints of diminishing power, the ghosts of age, decay and death. And conversely, we need a way to detect whatever fleet and fugitive neutrinos of joy, or curiosity, or bliss, or ecstasy, remain to us, interstitial but real. Rarely, rarely comest thou, spirit of delight, says Shelley. But the next time thou do comest, I'll have spread my nets. I'll be ready.

> 'Language is a perpetual orphic song,
> Which rules with Daedal harmony a throng
> Of thoughts and forms, which else senseless and
> shapeless were.'
> Percy Bysshe Shelley, *Prometheus Unbound*, Act 4: 415–17

On that first viewing of the *Icarus*, if my notes and my memory are anything to go by, I missed the dead man. At the bottom of the field, in the bushes, barely visible, there is the top of the bald or balding head of a dead man. An old man. A corpse. Icarus may have been escaping, on a mad escapade; this dead man was never so fleet of foot.

Perhaps it is proverbial (there are old Dutch proverbs

about dead men and ploughs). Perhaps it is cryptic, a trace element of something strange. Bruegel liked to encode his paintings. It takes a moment to find Icarus, for one thing, and once you have him you can read all of Ovid in the canvas, near-enough. So here is a fragment of information that might be unspooled.

A banal fragment. Death lies concealed in everything, we all know that. There is no project conceived, just as there is no human or indeed mammalian or vertebrate or eukaryotic child conceived or split off, that does not contain the miniature story of its own end. But containment works two ways: that which is contained is also isolated. Bruegel has trapped this little death demon in his painting, and can then, for a spell, walk away from it. Think of him now, the painting done (even if this is not his painting), a youngish, moderately famous man, walking around in the sunlight somewhere, in Antwerp or Brussels, greeting his neighbours, clearing the smell of oils and turpentine from his nostrils, catching some early spring, perhaps, watching the ships spread economical sail with their cargoes of pepper and worked cloth for Lübeck or Cadiz, his spirits buoyant on the soft airs. For a while yet.

I never dared much, nor aspired to dare. I never risked much. There is very little risk in these projects, certainly. There is only a long slow gliding descent through the museums of Europe and North America, safe in international space: hotel, station, airport, museum. I expect no exhilaration, and no escape to speak of, because for all that motion in air is a form of freedom, at some point you will land again, and one rocky shore is much like another.

The world has its systems and those systems are your freedom. You cannot escape them. Go where you will, do whatever you do, you can only step from one path to the next, one script to another. Not only is there nothing new under the sun: it has all been commoditized for your convenience. Icarus, at the dawn of the historical world, assumed that up there somewhere transformation would be available. His world is Ovidian, after all, and at any point he might sprout branches, scales, talons, tusks, the whole calculus of his trajectory might alter. His father knew otherwise. But his father also knew that although one rocky shore, one Aegean tyranny, is much like another, there are, even so, gradations. Fine gradations of freedom. We are not all equally free, and we are not all equally bound. Some scripts are better than others. Marginally.

I clamber about over my spreadsheet these days much as Dan clambered over his factory roof. With less jeopardy, perhaps, but you can always fall through where you least expect. We do not approach death as from a distance, down a perspective avenue: we walk about on top of it, constantly, our feet touching the feet of the unremembered traces of ourselves which will one day replace us.

As a young teenager I, like Dan – only not like Dan, never with that much gaiety and abandon – climbed over the roofs of disused factories. Growing up, I lived near a concrete works in partial desuetude. These were factories that in their heyday had spun concrete lamp posts for the municipalities of England. But a concrete lamp post was, by the 1980s, a costly item, durable, but expensive. Steel was the thing now.

Aluminium. So the factory was running down to nothing. In a couple of years the site would be a housing estate; for now the old concrete posts were left lying around overgrown by brambles, or half-buried like amphorae in Rome.

My brother and I roamed pretty freely over the site. It had its dangers but this was the 1980s, the last days of the wild youth of the world, in this corner of it anyway, and no one cared. On one occasion I slithered merrily on my arse down a sloping roof of corrugated fibreglass, and down the ziggurat of water tanks and drainpipes and packing cases at the corner of the building which had served as our ladder up, and then turned to watch my brother follow me. He descended with ashen care.

My brother was less fearful than me, by and large, so when he finally got down I made him explain: he had watched me go, and had seen how the roof had bowed and sagged under my weight. It had looked certain to him, he said, that I would plummet through it, on to the disused workbenches and iron-mongery and cement floor many metres below.

Perhaps the roof was not as fragile as all that. Perhaps I did not come close to death that day. Perhaps some of the other structures I climbed on – water towers, stacked concrete pontoons, assorted roofs – were more perilous. I did in fact fall once or twice, once from some pontoons, once from the high ceiling of a building I was abseiling into down a steel wire; but I always just got up and patted myself down. On I plodded, through an ordinary life, past this individual I briefly met called Dan, and on from that. Until that day I stood in a room of the Beaux-Arts in Brussels, looking at the *Landscape with the Fall of Icarus*.

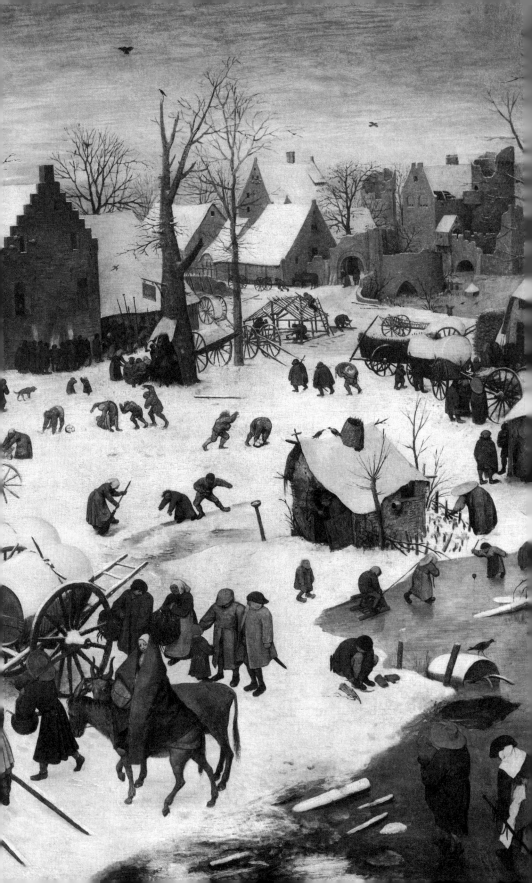

II Census

Brussels (8.284%)

'The more things happen to you the more you can't
Tell or remember even what they were.'

William Empson, 'Let It Go'

Two days after my encounter with the *Icarus*, I am back in
Brussels and back in the museum, this time with my friend
Steve Barley, who has finally arrived from Rome. Now I
know how to get the chronology right, ascending to the
empyrean of Bruegel as though by a winding stair or a twist-
ing thermal. Thus we eddy from Robert Campin to Van der
Weyden to Bosch to Joachim Patinir to Herri met de Bles.
And so on and up.

We enter the corner room and I make a rapid audit,
reminding myself. The right side of the room as you enter is
Elder Bruegel; the left side is Younger Brueghel. I am here for
the Elder Bruegel. Elder Bruegel is the great Bruegel. I ignore
the Younger and settle to the business of scrutinizing Bruegel.

However, there is a distracting oddity. On the west wall of the room hangs the Elder's *Census at Bethlehem*, a large panel painted in 1566. But on the south wall, roughly 8½ yards distant and hanging at an angle of 90 degrees to it, is another, near-identical *Census at Bethlehem*, painted by his son Pieter Brueghel the Younger in about 1610. It is one of at least thirteen copies the Younger made of the original, all of them faithful and well executed.

I start by trying to ignore it: it is good, but it is hack work, a cynical workshop production, a pointless replica. I am here to focus. But it happens that there is a spot, situated at the apex of a triangle the base of which is formed by the two paintings, where you can take them both in. If you had bovine eyes, the whole corner would become a giant and blurry and (to your cow mind) bewildering stereoscope.

I do not have bovine eyes or a cow mind. If I want to compare Bruegel with Brueghel, Elder with Younger, I have to swivel my head. And in reality, there is not one triangle at the apex of which you stand. Either you stand in front of the Elder and glance at the Younger, far away, or you stand in front of the Younger and look over your shoulder obliquely at the Elder. There are two triangles (at least); you move in a zone between their vertices.

And in this god-like, cow-like zone, what do you see?

In both cases, a snowbound village scene dominated by children playing and scuffling in the snow and their elders scratching out a living with their fardels and pigs' blood and snowed-under carts, their small and wintry concerns. Around the inn in the left foreground a crowd gathers, submitting their names to the census; others straggle in across the frozen river, and across the frozen pond. Mary and Joseph are

unobtrusively there: Mary, riding on an ass, nine-tenths concealed in her blue robe; Joseph likewise hidden behind a large hat but waggling a two-handed saw over his shoulder.

They are both as yet unnumbered.

For Pieter Bruegel the Elder, there was only ever one *Census*. It was a singular object. Unlike his son, he did not run an extensive workshop, did not bang out copies. He made few paintings, each one in his own hand.

When he died in 1569 at the age of about forty-two, his eldest son was four or five years old, his youngest, Jan, just one. In terms of art history, there is no genealogical connection between father and sons, merely a tectonic overlap. Pieter the Younger inherited a series of world-famous images (if by *world* you are content to understand Northern and Habsburg Europe), probably in the form of what are known as cartoons, drawings used to transfer an image to a panel. His entire career down to his death in 1636 was grounded on these images, whether he was making direct copies or spinning genre pieces from them.

He most likely saw little of his father's original work, much of it already carted away to the great imperial collections – hence the small differences which creep in, the errors in replication, the drift.

As with his name. Pieter the Elder had started out plain Pieter Brueghel of Breda, signing his name with a calligraphic flourish on the drawings he produced as a young man. When he started painting in oils towards the end of the 1550s, he dropped the 'h' and began signing his name Bruegel in chiselled capitals, frequently with a ligature between the v (the

Roman u) and the e, usually with the date (and after 1562 the date is generally written in Roman rather than Arabic numerals, with two or three exceptions), never with a P. or Peter – in the couple of cases where a P. was placed in front of bruegel, the paintings later turned out to be rather careless modern forgeries. 'Brueghel' was a bit burgher, perhaps, a bit stomping peasant; 'BRUEGEL' is cleaner, more Roman, befitting a Stoic observer of stomping peasants.

His sons for some reason restored the 'h' to the family name. *Brueghel*. Early in his career, Pieter the Younger aped his father's Latinizing capitals, but reverted to small-case letters for most of his copies, and he never creates a ligature between the v and the e, although he does occasionally between the h and the e. Until 1616, he always appended his initial, 'P-Brueghel'. After 1616, he altered the spelling of his surname once again, reversing the v (or u) and e, 'P-Breughel'. In these ways, the Younger distinguished himself not only from his father, but from his younger brother Jan, who always signed simply 'Brueghel'. Subsequent generations, notably Jan Brueghel's son, Jan Breughel the Younger, retained the order of e and the u: 'Breughel'.

Father and sons and grandsons and great-grandsons, taken together, make a blurry bruegel/Brueghel/Breughel object.

There was also a daughter, Maria Bruegel. Or Brueghel? We are not even sure about Maria: some have it as *Marie*. We know nothing about her. Older than her brothers, most likely, and certainly older than Jan, who was born only months before his father died. Probability suggests death in

infancy. Her brother Pieter the Younger would have seven children, only one of whom would survive to adulthood.

Some children barely draw breath. My mother recollects a brother, Harry, who died before morning on the night he was born. She says she heard him crying that single night in the 1930s, in the solitary room in the west of Ireland that would constitute his universe. Crying perhaps under the baptismal hand. Harry, in the eye of God. And then he was gone.

So too Maria. Gone. The merest flicker of data in the endless ticker-taping lists of the quick and the dead.

I move between the invisible apices of my triangles, comparing Bruegel with Brueghel. It is a midweek morning in early January, raining outside the museum and largely empty inside. This is where my as yet undefined project has brought me, dead-reckoning in a room of old paintings.

I am forty-two, around the age at which the Elder died. Forty-two is the number of Bruegels on the spreadsheet. My own father has died, a year or two previously, aged eighty-four. When I was born he was forty-four. I was the second son. There are two years between my brother and me. I have also recently become a father myself, to two sons, between whom there are two years. Pieter Bruegel had two sons: the Younger, and Jan the Elder, between whom there were four years.

And so on. You do not really explain an intersection by following up or down any of its convergent, or for that matter divergent, paths. It is sufficient to note that my midlife is characterized by the interaction of multiple convergent (divergent?) vectors: my dead father, my brother, my small sons, myself, and the Bruegels. Many similar triangles.

The census is an unusual subject. Bruegel has painted one of the culminating moments of bureaucratic life. Bureaucracy is the science of docketing the routine comings and goings of existence – births and deaths, taxes paid and taxes owing; it is a rolling programme of work, one without end.

A census, however, is a one-off. It is a flourish of the bureaucrat's art. You do not merely keep the ball of a census rolling: it wants planning and execution. It is, properly speaking, a project, a projection of bureaucracy. And it has an end: a Domesday Book of taxable, pressable souls.

From a distance – to the administrator or historian – a census is an exercise in control and power, not always pleasant, but always impressive in its way, like a datastream ziggurat or Hoover Dam. Seen close to, however, it pixilates into a sequence of inexact iterations. The bureaucratic ground troops do not mechanically fill in blanks. They have to keep a weather eye cocked on the confusion of crowds, have to sort quickly, roughly (there are only so many categories) but accurately. They have to fix a point in time where there are no points in time.

Bruegel's *Census at Bethlehem* therefore depicts a world in transformation. The census is drawn through the village, through that mess of humanity at the inn door, like the carding of wool. The stream of individuals passes back and forth over the frozen river: people come in nebulous and free to have their names written down in a book, their existence validated in ink; they go out docketed and numbered, but also informed, no longer unlicked stray lumps of humanity but named individuals, with a location and an occupation and a marital status, enjoying a spark of existence beyond their own clay.

How, then, to number the paintings which hang in this room? How to enter them on the spreadsheet?

On an adjacent wall to the *Census* in Brussels is the *Winter Landscape with a Bird Trap*, a small sepia painting. Little figures skate on the frozen river, or huddle over their game of curling. On the bank, under a tree, a trap is set for birds: a heavy assembly of planks (in construction, not unlike the panel it is painted on) is propped up on a stick, a lure of crumbs beneath it; from the stick, there is the merest trace of a taut string leading into a house on the left of the panel. Snatch the stick from under the planks and you might catch a bird or two, just as the painter of panels, ever watchful, might catch and trap a soul, or a village of souls. Snatch the

Always watching, always waiting: *Winter Landscape with a Bird Trap*, detail.

ice from under those skating children, and you might drag one or two down. The birder, the painter, the Devil are always watching, always waiting.

The skaters and the birds are linked by two stylized black birds in the foreground. They are the same size in real terms as the skaters, the same tonality also; they could be mistaken at first glance for skaters.

Birds and skating villagers live a similar existence: birds have wings and skaters ease along at great speed; both are in danger, both seem at liberty. The birds could fly away, live in the woods, while the villagers could slide around that bend in the river and be gone in minutes, never to return. But the ice will melt and the villagers will remain. Winter birds, too, are territorial. All are rooted here.

Including Bruegel. Bruegel might have skated around that bend and away, to Antwerp, to Royal Brussels, to Rome and Naples and Calabria. But he came back. According to Karel van Mander, who included, in his 1604 *Schilder-boeck*, or *Book on Painting*, brief lives of the great Netherlandish painters, Bruegel frequently visited the villages around Antwerp and Brussels in disguise, infiltrating festival and kermis (a kermis – from '*kirk mis*' or 'church mass' – being the annual festival held in honour of the village church's named saint), observing but unobserved.

His panels are littered with figures standing on the edge of crowds, watching. Some are well-heeled, clearly not village folk, returned from the city for family weddings, to partake again, briefly, of the drunken, cavorting rhythms of village life.

One way or another, in paint as in life, this was Bruegel's world.

Bruegel's *Bird Trap* was a popular subject. There are at least 125 known and documented copies.

But what is a copy? If I were to take out paint and easel now, and run up some version of my own, would that constitute a copy? Number 126. Mark it down. At what point does the painterly spore of Bruegel peter out to blank snow? When can we say that the code has replicated itself into muddy, unrecognizable progeny, into mass reproduction?

On the wall opposite the *Census*, there is a large canvas, an *Adoration of the Magi*. This is not generally attributed to Bruegel, but may be after a lost composition, like the *Icarus*. It is in watercolour, an unusual medium for Bruegel. There is a tempera *Blind Leading the Blind* in Naples, and a *Misanthrope*; there is *The Wine of St Martin's Day* in Madrid; otherwise it is all oil, all panel.

The canvas is badly damaged. Who knows how many panels have been lost over the years, painted over, chucked in skips, on bonfires. Van Mander mentions two versions of *Christ Carrying the Cross* (one remains); a *Temptation of Christ*, with Christ looking down over a wide landscape; a peasant wedding, in watercolour, with peasants giving presents to the bride; and one other watercolour in the hands of the same collector, undescribed. We know of others, gone missing. A crucifixion. A miniature *Tower of Babel*. The first in the sequence of *The Months* (April/May).

Whatever Bruegel saw when he contemplated his own Bruegel Object is lost to us, a ghost configuration. Whatever might be vouchsafed to posterity from a life lived – in

Bruegel's case, a lot; in my case, as in most cases, nothing – is only very approximately indexed to that life. I have very little interest in biography. It is not Bruegel's completeness that I am interested in but my own. But I am conscious that the dead panels stand whispering beyond my spreadsheeted ring of firelight, and no amount of conjuring will induce them to step forward. It is too late.

When my father died in 2009, he was eighty-four years old. A double-Bruegel. The parallelisms proliferate. I consciously peg each year in my life, for example, to a year in my father's, according to the age of our children: so in 2017, when my Bruegel project finished, my children were nine and eleven; my brother and I were nine and eleven in 1978.

Robert Henry Ferris in 1978 was making his last throw of the dice, leaving GEC, the General Electric Company – the huge conglomerate where he had worked, barring an interruption for war service, for nearly forty years – for a much smaller company, where he might just hope to be a bit of a big fish. That didn't really work out either. He was fifty-three, and his heart wasn't in it. He told me after he retired that, in all the years of his working life, he had never been early for work once. He had a lively mind and a fairly dull job. He didn't travel much. He just sort of stopped.

One evening, at around that time, he sat down and wrote in an enormous year diary one line: *It is said that in every life there is one story. This is mine.*

One line a night was enough, he said. If you wrote one line a night you would soon have a great big book. I was nine, and I was impressed. But it was too late. He liked his sedentary

whisky too much, could never find the energy to add anything to that one line. He could certainly write, but he lacked technique and discipline. And there it stayed on a shelf, the weighty volume with the solitary line and several hundred enormous blank pages, like the blank cells of my spreadsheet. A metaphor, and a bit of a shitty one at that. From time to time my brother or I would take down the volume and study it, either to shame him publicly (and he would laugh along jovially enough at his own foolishness) or to teeter privately on the brink of some immense intuition: not only was our father's life unfulfilled, but all life was most likely unfulfillable. 'It is this deep blankness is the real thing strange,' writes the poet William Empson. And there it was, this deep blankness, sitting on a shelf in our living room.

My father went on in due course to his deeper blankness, his long home. But when he was in hospital dying, my brother was searching the census records of our paternal family. My father was always reticent with family history. He had been born in 1925 in Camden, had grown up there and on Portpool Lane off the Gray's Inn Road, and later in Lee Green. There were some disconnected anecdotes – a story about a broken radio, about a Jewish funeral, about an aunt who sprinkled sugar on his buttered bread – not much else.

His mother had died of heart disease during the war when he was a very young man. He rarely spoke about her, but on one memorable evening over whisky towards the end of his life he found he could not recall her name. The grip of my father's memory was utterly secure until his last day. But he could not remember his mother's name.

Later, he dredged it up from somewhere. Anne. My brother uncovered more detail, and relayed it to my father in hospital. She was recorded as Annie on the census of 1911, at nine years old the youngest of five sisters growing up on what is now Tavistock Street, just off Drury Lane. She had been born around the corner on Stanhope Street, coloured black on Charles Booth's poverty map of the late 1880s to designate 'Lowest Class. Vicious, semi-criminal'. Stanhope Street along with the whole rookery around Clare Market was bulldozed soon after to make way for the arterial Kingsway. No. 1 Kingsway would become, until 1963, the head office of GEC, my father's first place of work. In 1940, during the Blitz, he would firewatch from its roof, and could have lobbed a cricket ball through the vanished window of his mother's slum birthplace.

Years later my grandfather told my mother that his wife – Annie – had had a temper on her. Choleric. Hot blood. Hasty heart. The death of her. She died, as I say, of heart disease in 1944, aged forty-two. Years of Bruegel. My father travelled down from Scotland where he was based with Coastal Command, whether in the nick of time, to watch by her bedside as the candles flickered out, or too late, I do not know. He was an only child. He and his father were thrust together to deal with this small loss in a world undergoing incalculable loss.

My father was not obviously close to his father. Pop, as he called him, lived with us until he died when I was eight. My mother says my father rarely addressed him, never had a conversation with him. Who knows if it was trauma, or sadness, or indifference which sundered or secretly united them.

When Pop died, only my father and my mother attended his funeral. My father took Pop's remaining possessions – a

few books, razor, alarm clock, wallet and clothes – and put them in a bin bag and slung them on the municipal dump. There was to be no gravestone, no memorial rose, no bench in a park, nothing to visit.

But within the year my father sat down at the empty diary and confronted its alarming blankness.

In truth, all this biographical detail was probably less use to my father than his anecdotes, and in any case it was difficult to gauge his response – his circuit of interest had contracted to the point where all that concerned him were the minutiae of the routines that were eking out his life.

But for my brother and me it assuaged the sense that here was a disconnected dot, about whom we knew not very much, going into the darkness. There was a chain. He was linked, and so were we. It was written in the census.

People may be numberless, but they are not identical; you are defined both by your similarity to and by your discrepancy from them. So, spot the difference.

The Younger's panel is fractionally larger – he may have been working to Antwerp rather than Brussels feet. Whatever the reason, the result is that figure groups, for which there would have been separate cartoons, are pulled this way and that within certain tolerances, marginal plays.

No two figures are dressed alike, fabrics change colour, there are odd reversals. The woman in the lower right, for example, wears a red-green combination of overskirt and underskirt inverted in the Brueghel copy. There are

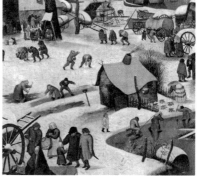

Criss-cross tracks, paths, desire lines: *The Census at Bethlehem*, detail –
Younger (left) and Elder (right).

microscopical differences between faces, individual posture.
The Younger had his own way with trees, bushy rather than
twiggy.

And then, more slowly, I see that the Younger favours
tracks. From the bottom right, where Mary has entered on
her donkey or ass, to the top left across the frozen river; and
again, from the wheels of the foreground frozen carts, there
are criss-cross tracks, paths, desire lines, animating the space.
This is a frozen world, but there is evidence of networks,
organized around an axis.

The Elder's foreground carts, by contrast, are going
nowhere. There are no paths, just yellowish ice wallows. He
has painted a village of spindly cartwheels, a spindly ladder
against a spindly barn, spindly trees. And he has painted a
world of endlessly repeated circles – the wreath, the barrels,
and especially the cartwheels, thirty-one of them, including
one a fraction below dead centre, hitched to no wagon and
orthogonal to the viewer, as though it were not a material
object at all, but a diagram of the interlocking cycles of village

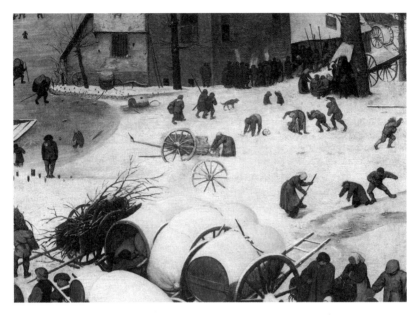

Hitched to no wagon: *The Census at Bethlehem*, detail.

life and the seasons, of the great wheels of history and Christian redemption.

And then finally I recognize what sets the two paintings apart: the Younger, perhaps seduced by those few inches in hand, has raised the branches of the largest foreground tree a fraction to reveal what in the Elder there is none of – a vanishing point, or what the Italians call a *punto di fuga*, a fugitive point, a point of escape. The Younger's brown frozen river winds out of the panel. His father's, by contrast, is entangled in the branches, perhaps coils around the back of the village, a labyrinthine waterway.

The only thing vanishing is that peculiar sun. The old world is ebbing to its conclusion.

The Younger – wittingly? unwittingly? – has made this dead cosmic circuitry bearable, transient. Along those paths

A vanishing point: *The Census at Bethlehem*, detail – Elder (top) and Younger (bottom)

and on that frozen river our eye is made to criss-cross, not circle, and finally escape the painting. And he has done all this in direct contravention of the central thought process of the original – that these circles go nowhere for a reason.

Pieter Brueghel the Younger may not have been a painter at all. He was unarguably an eminent man in the Antwerp art world – there is a portrait etching of him by Anthony van Dyck, in which, as it happens, he projects the sort of patient melancholy common to men with drooping noses and straggling moustaches. But he may only have been the inheritor of the cartoons and the general manager of a workshop which

employed anonymous hands to complete the copies. It is possible that he had no artistic personality, nothing but a signature and a locked chest of cartoons which he carefully opened and closed as required, a bureaucrat among artists, ghosting through the system, the painted artefacts. The notion that somewhere in that swirl of hands and methods and corporate production was the memory of a five-year-old boy transfixed by the death of his father is nothing more than an absurd projection of my own.

But this is why I am here. I did not come into this room in Brussels to discover a truth, but to impose one. To make something of all this. This is one way in which we react to the accumulation of life. We make spreadsheets, trace genealogies, embark on projects, write essays. We pore over the data in search of patterns. All this must and will be made to mean something.

I stand in the corner room of the museum, then, observing small differences. Discriminating.

And there is in fact one final difference – a figure, present in the Elder's panel but absent in all the Younger's copies, suggesting a late emendation on the father's part, a final gratuitous flourish of his art: it is the youth pulling on his skates, below the tiny child who cannot yet summon the courage to go out on the ice.

Life is treacherous, says the figure, but we have resources. We have skates. We can make of this treacherous ice our element. Sooner or later, we all pull on our skates and go out on the ice – as the father might have remarked to the son, had he had time.

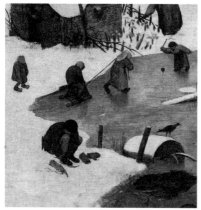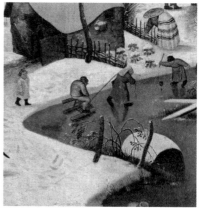

We have resources: *The Census at Bethlehem*, detail – Elder (left) and Younger (right).

This whole village, in fact, suddenly seems to be poised by the ice, spilling uncertainly but inevitably over its edges. Just to the right of the large tree by the water a father stands hands in pockets and watches his two small children testing the curious element.

The skater's absence from all copies (bar one – a recently discovered panel has the skater, suggesting a late, rectifying glimpse of the original, or a post-mortem addition) implies that it was the father who was diverging, making changes on the hoof, inserting figures at the last minute, blotting out the vanishing point in a moment of inspiration, and the son who adhered more faithfully to the earlier version, the cartoon or, more likely, sheaf of cartoons. There is, after all, a sensibility in copying well, an alertness to detail. One of the Younger's guiding virtues, you could say, was fidelity. Copying is meditative and respectful work, itself a way of thinking.

If he was occasionally caught out by the odd detail it hardly matters. At some point the fractional differences collapse into

the far greater mass of similarities. The census is not a record of our individuality in the end, but of our solidarity. Thus there is not a source of pictorial DNA – the Elder – and a series of ever-degrading replications. Rather there are versions of versions all orbiting a hypothetical centre of mass (the cartoon), just as the small children of the village eccentrically orbit the centres of mass set up between them and their parents, and their parents in turn orbit the invisible barycentre which lies between them and their ancestors, and which we commonly call *the community*. Each of us, present or absent, exerts our own small constant gravitational tug, variable in time, hard to calculate, take account of; but there, nevertheless, in the mass of data points, and the geometry which comprehends it.

III Fire

Antwerp and Rotterdam (6.316%)

'The air still moves, and by its moving cleareth,
The fire up ascends, and planets feedeth.'

Fulke Greville, *Caelica*

Months pass, and I wage a phoney war against the looming
Bruegel Object, pick off a panel here or there, drag myself like
a forlorn expedition over the still-featureless map of all
Bruegel. Finding landmarks.

The cities I visit are cities named in a dream of Europe.
Rotterdam. Antwerp. Places you might struggle to put a pin
in, but which underlie your notion of *European*. Once I have
visited them, I hardly know that I have been there: waystages
on a cosmic map.

Rotterdam, for instance. Rotterdam is a station, roadworks,
new buildings, a long straight walk to the museum along a
windy street. It is a museum built in the 1970s, an empty café
with coloured chairs.

That is Rotterdam. Have I been there? Barely.

I am in Rotterdam with a friend, a painter called Anna Keen. Sister of Zabdi, my paragliding instructor. In Rome in the 1990s we were a couple. We lived behind the Colosseum on top of the Domus Aurea, Nero's cavernous, mouldy, buried golden palace, with its revolving dining room and its obscene frescos.

Now Anna lives in Amsterdam, in a shed near the water, and I am paying a visit. In a couple of days my brother will join us.

The shed is part of a complex of work units – next door, for example, is a builder of speedboats, or racing yachts, I do not remember which. I only remember looking down the length of streamlined hulls, bright paintwork, varnish. Rigging? I don't recall.

Anna's shed is also her home and a source of income – she sublets parts of it as studio and living space to art students. Her brother Nick, a carpenter, has come over for a few days and built partition walls. Anna lives upstairs in the low-ceilinged loft that runs the length of the shed. You have to stoop as you walk along it. You ascend by a ladder between two antique electrostatic speakers into her wonky space of two thousand books and paint-stained electronics – laptop, router, amplifier, speakers – and naked plasterboard. A padded silver pipe runs up through the floor. Plastic flapping windows give on to the main space, where Anna has her own wooden boat propped up and her immense easel, and endless red-and-white packets of a line of budget food called Euro Shopper which for some reason she cannot stop buying, and presumably consuming, and wants to paint. On each packet is a schematic drawing indicating the

packet's contents – a red-and-white cow (milk), a red-and-white peanut (peanut butter), a red-and-white gravy boat (brown sauce), a red-and-white whisk (whipping cream, UHT). They are everywhere. A ready-made Warholian homogenization of all food and all household goods, in this most dehomogenized of spaces.

Anna has installed a large wood-burning stove in her kitchen, and it directs heat around the shed complex along silver-insulated pipes. It is February, the stove is working full time, and everything you touch is either scalding hot or icy. The inhabitants of the shed (three, four art students, Anna, Anna's brother, Anna's brother's girlfriend, my brother, and me) shuffle around wrapped in scarfs and old jumpers, clutching mugs of tea, seeing how close we can get to the fiery stove without singeing our flesh. Whatever the stove radiates seems to dissipate within an inch or two of its cast iron: the zone of warmth is perilous and narrow.

I persuade Anna to come to Rotterdam and look at the Bruegel.

Rotterdam. To recapitulate: a station, a street, a museum, the wind, and *The Tower of Babel*.

Museums are for the most part horizontal structures. I do not know many properly vertical museums. But the Rotterdam museum contains one of the great essays in verticality. It is the smaller of Bruegel's two Babel panels – the other hangs in Vienna – but the larger of the two towers. The compositions are similar. The Vienna tower is built around a cankerous rock and in the foreground, receiving obeisance from his stonemasons, there is a king (Flavius Josephus ascribed the building of the tower to Nimrod); the ships are much larger than those in

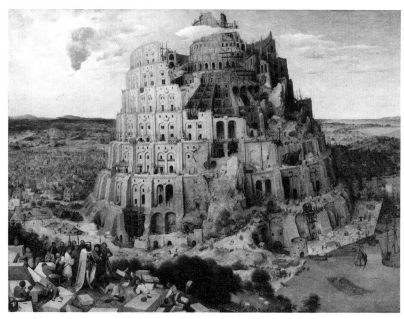

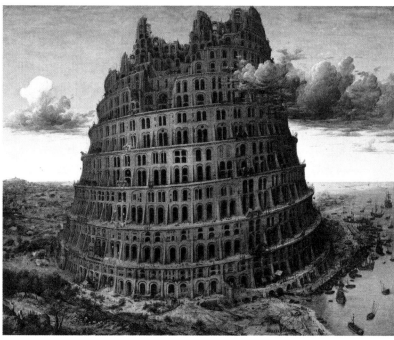

Essays in verticality: *The Tower of Babel* – Vienna (top) and Rotterdam (bottom).

the Rotterdam panel, the horizon subtly higher; in Rotterdam we are higher, therefore, and see further.

The rocky outcrop jutting from the Vienna tower is not the foundation but the metamorphosis of the built structure – there can have been no pre-existing plugs of rock on this flat plain. The weight of the tower has compressed and transformed its materials. It is subsiding on the shore side into marshy land.

The Rotterdam panel, on the other hand, is a pure geometry. Lessons have been learned. The only transmutation of materials here is into upthrusting energies. No wonder the builders' jealous god got worried.

Both towers not only dominate their respective landscapes: they are the landscape. Everything of interest on the nondescript plains is subsumed into the towers, just as a great city – Antwerp, for instance, or Brussels – will suck economic energy from the land and the seas which surround it.

Bruegel was an inheritor of the Netherlandish tradition of the World Landscape – painters such as Herri met de Bles and Joachim Patinir had for a generation before Bruegel produced increasingly broad and schematic landscapes where great rivers and mountains and plunging precipitate views and cliffs and oceans beyond stood as much for a representation of the cosmos as for anything you might see in nature.

Landscape started to emerge from the background, took a sociological, topological, cartographical, thematic turn. It became not just a reflection of cosmic order but the whole theatre of man and his salvation, the *teatrum mundi*, the theatre of the world.

Bruegel introduced a note of difference, however. A naturalism. Simon Schama observes that, relative to the work of

Patinir and met de Bles, the landscapes of the early seventeenth century had been 'deprogrammed'. They had ceased to be grand schematics of the cosmos, or moral topographies, and were now 'just' trees, woods, streams. And this process of deprogramming begins with Bruegel.

In around 1552, Bruegel, a young painter newly emerged from his apprenticeship, travelled to Italy, most likely with fellow painter Maarten de Vos and the sculptor Jacob Jonghelinck. He travelled down through France (we know of a lost gouache *View of Lyon*); proceeded over the Alps to Rome, where he stayed for two years; and then pressed on more briefly to Naples, Reggio Calabria, and in all likelihood Sicily.

Such a trip was not unusual for ambitious Northern painters, who were expected to educate themselves in the ruins of classical antiquity and the works of the Italian Renaissance masters. Bruegel most likely did precisely that but, perhaps at the instigation of the Antwerp printer Hieronymus Cock, he also documented his trip with reams of topological views: the Bay of Naples, Reggio Calabria, the Strait of Messina, Rome, the Alps. And on his return, it was with these views and a set of generic engravings – the so-called *Large Landscapes*, incorporating elements of his Alpine journey – that the young Bruegel established his reputation. 'On his travels,' wrote Van Mander, 'he drew many views from life so that it is said that when he was in the Alps he swallowed all those mountains and rocks which, upon returning home, he spat out again on to canvases and panels.'

Bruegel had a precise eye. His work has been described as 'ethnographic', so fastidious is it with details of peasant life, and in the same way his World Landscapes never neglect shape

of leaf or jizz of flying bird – a generic silhouette in the sky is, on closer inspection, a magpie or a cormorant; a foreground plant is not just an iris but an *Iris germanica*. The natural world adorns the schematic landscape, or the schematic landscape polarizes the naturalistic detail, in a way that Ruisdael or Hobbema, or Constable or Monet, would have understood. The real keeps impinging on the meaningfully arranged. And vice versa. We are caught in suspension between what God ordains and what Bruegel experiences. And the two are not necessarily aligned.

On his Italian journey, Bruegel must have seen and drawn, and, to judge from his versions of Babel, slightly obsessed over, the Colosseum. Both the Rotterdam tower and the Vienna tower are colosseums telescoping upward to infinity. Both are set on the plain. There are some distant hills in the Vienna panel, none in the Rotterdam panel. To repeat, both towers *are* the landscape, translations of the cosmic landscape into urban form. These are stone cities pulled up from the earth in the manner of origami trees, birthing strange rocks, over-topping the clouds, bending the frame of the earth. Symbolic, but also detailed. Naturalistic.

The Rotterdam tower – the later of the two, by some five years – is both an architectural and a chromatic fantasy.

At the top, the endless intricacy of its internal form is revealed. The Gothic variation and repetition of its windows and arches makes of them not merely entrances but a sort of hyperbolic internal structure, as though the builders had lighted

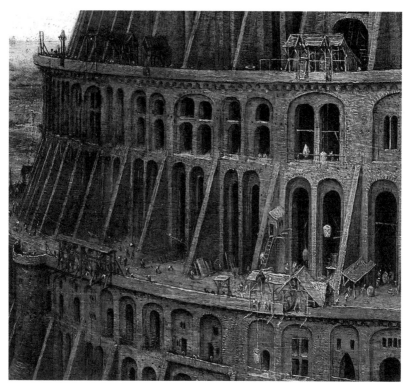

Pollen of the mason's art: *The Tower of Babel* (Rotterdam), detail.

on some multidimensional or geodesic solution to the incalculable stone weight of the structure that had defeated them in the Vienna panel; this fresh tower will go up and up supporting its own weight on tensile Gothic arches and windows.

There is no king here, no central intelligence and motive force. The builders of this monstrous beautiful thing scurry over its exterior and interior like the manifestation of an algorithm, working their twig-like cranes and filigree hoists, leaving deposits on the pinkish sandstone of white and red from where the marble dust and brick dust are shaken like chalks, pollen of the mason's art.

At the base of both towers are culverts or sally ports where a boat might drift inside, sail right into the heart of the endlessly ramifying structure. You might load your ship with barrels of gunpowder and seek out the keystone, the arch or spar whose destruction would bring the whole of this tyranny crashing down. Every project has its point of weakness. A niggle, a suspicion, a discord. If there were not, there would be no need for a project. Straight life would suffice. The project is an attempt to reconcile irreconcilables, to square the circle. Something must be fudged in the process.

Freedoms, for instance. Manfred Sellink, cataloguer of Bruegel, finds the Rotterdam tower more menacing than the Vienna; the equally eminent Larry Silver regards it as an index of the productive capability of a free people (the Netherlanders) contrasted with the crooked construction of a subjugated slave race (the Spanish).

I do not know whether the tower is menacing or not. It is certainly fascinating. Did Bruegel have the ways of tyranny on his mind? It seems obvious to us – his Netherlands were part of the Habsburg Empire, effectively under Spanish rule. In his lifetime its people would start to resist, and, just months before his death, rebel.

Why else, after all, would you paint the Tower of Babel again and again (and again – there is documentary evidence of a third version from his Rome years, on ivory, now lost)? Who knows? The Colosseum must have made its impression on a young visual mind, its self-similarity, its modularity, its controlled barbarity. The Tower of Babel in the biblical sources represents hubris and fragmentation, but it also

stands on the last edge of a unified world, one sufficiently sure of itself to embark on a grandiose building project. Bruegel's contemporary and friend in Antwerp, the printer Christophe Plantin, would in the last year of Bruegel's life begin setting his great bible, the *Antwerp Polyglot*, in five languages, Hebrew, Greek, Latin, Aramaic and Syriac, with dictionaries and grammars, itself a monument to clarity in fragmentation – as though bringing all these languages together in one huge volume under a sufficient weight of scholarship might metamorphose the sedimentation of scripture into a solid impregnable rock.

Tower, Empire, Bible: grown sufficiently tall, sufficiently all-encompassing, sufficiently all-explaining, they become like the earth itself: inescapable, eternal, boundless.

What lies under the eye of God and eternity? Great landscapes and towers, and tiny people.

On the fourth spiral of the Rotterdam tower, very close to the mid-point of the panel, you can make out, if you crane in close, very close, and stare hard (with your god-like eye), a tiny procession with, at its centre, a red baldachin. Under this, it has been suggested, a pope is making his ascent of the tower. Roman colosseum, pope at Rome, tyrannical Spanish inquisitors. Draw your conclusions.

A society on the brink of revolution, or lying under the yoke of tyranny, grows cryptic. Things are necessarily hidden. We have no way of knowing where Bruegel's sympathies lay. All we know is that his compositional instinct veered towards crypsis: hide the subject.

I am beginning to get a feel for the Bruegel map. An outsider's feel. The feel of an autodidact.

The Bruegel tower in Rotterdam is a pin. I can wind a string around it, stretch it over to Vienna and wind it again.

I still do not know, in Rotterdam, that I will see them all, that this is my project, so the map of all Bruegel remains at this point mostly featureless, speculative, a land of hearsay. I know that there are plenty in Vienna; others are in Madrid, Paris, London, New York. I have looked at the Bruegel page on Wikipedia, and have promised myself a book on Bruegel. But which one? Another unknown landscape stretches out before me, of Bruegel scholarship.

It will be by no means my first project. I have spent half a lifetime working up projects: Robinson Crusoe canoes, antique flying machines that never fly. All useless devices, but each informed by the same creative spurt, each one a new, futile form of flight, of escape. Just like that tower on the plain, on the edge of the sea, fugitive city making for the skies.

In the early 1950s my father and a friend of his called Bill (surname unrecorded) booked themselves on to a coach tour of the Low Countries: Bruges, Ghent, Brussels, Antwerp, Amsterdam. But the authority of their guide, the tyranny of the schedule, the sluggishness of the coach immediately chafed, and they abandoned the tour and took themselves off on a mad jaunt of their own devising: church, bar, red-light district. My father still talked of it half a century later (although he glossed over the red-light districts; I learnt about

these after he died, from a notebook he kept). The trip was, for the rest of his life, a reminder of the exultations to be had from torching the programme and careening off the map.

I have known similar moments of minor exultation. For example, I have walked out of more jobs than most people have had jobs.

Things change, one moment to the next. One moment you are employed, seemingly reliable, a plodder; the next you are enjoying some sort of giddy breakdown.

The last time I walked out of a job, my first son was not yet one year old. This is not responsible behaviour. After a few months, I ended up on my feet, again, just, but this had to be the last time. I have tried revolution. The knucklebones are just knucklebones, in the end, and the patterns are always familiar. Perhaps I did not burn deep enough, early enough; perhaps I should also have salted the black fields of my existence. But the suspicion remains: there might be other ways to model your life.

On our return from Amsterdam, my brother and I run into difficulties. We have chosen to take the train so that we can stop for a few hours in the Brussels museum and refresh ourselves with Bruegel, but the train lines are down at some key junction. We wait for an hour on a cold platform with Styrofoam coffees, then take a train to the next stop down the line – The Hague. We have to get off. No one knows what is happening. We are told to get on a certain train, which takes us to the next stop – Rotterdam. And we have to get off again.

Thus it continues, all day: we work our way from Amsterdam to Brussels one stop at a time.

Bruegel did not live in a world of timetables. Deadlines? Highly doubtful, although I can at least imagine a time-is-money Hieronymus Cock goading on his young artist, clapping his hands together in a show of energy, dividing up the labour, watching his costs. I can also imagine his young artist, possessed of a peasant's appreciation of his own value, resisting, taking his time, not so much *doing* as *getting around to*.

We live otherwise. We must get back to England today. At each stop, when it seems we have finally run out of luck, my brother and I furiously google alternative planes, buses, but then before we can act a train turns up and there is a frantic cramming to get aboard. Dordrecht. Roosendaal. Antwerp. It grows late. Dark. We miss our connection in Brussels. And we miss the Bruegels. In the thick press of quantified time, all spears of purpose are, sooner or later, shivered.

I have a superstition about travel: it has a prevailing wind. If you make a there-and-back-again journey, you will be swept along easily in one direction, and have to beat back painfully in the other. But this is more than an ordinary squall or countervailing trades: it is clear to me now that we have offended the Netherland Poseidon. We have treated his realm as one entity, a large flat land with a common language, dotted with emblematic Bruegels. But it is not. It is fractured: by language, by politics, by religion, by river and sea, by the repelling magnetic North–South grain. And so we are smashed this way and that.

*

In 1566, called by contemporaries the *Wonderyear*, the Netherlands, North and South, were host to a spate of image-breaking. Churches were sacked, statues and paintings smashed, pulled down and burned, and the consecrated host, which renegade hedge-preachers called 'the baked god', was generally humiliated.

Some of the hedge-preachers – so-called because they preached outside the town and beyond the reach of civic jurisdictions – were Calvinist ministers who had returned after the suspension of the Inquisition in the Netherlands by the regent Margaret of Parma in April of that year; others were disgruntled ex-monks jumping the walls. They preached reform, and they preached iconoclasm, and in August, starting on the 10th in the town of Steenvoorde in the industrialized Westerkwartier of Flanders, some made good on their preaching by leading a mob to the chapel and sacking its images.

The violence spread, reaching Ypres on the 15th, Antwerp on the 20th, Ghent on the 22nd, Tournai on the 23rd and Valenciennes on the 24th. In Antwerp, the Feast of the Assumption on the 15th passed off peacefully with a parade of a statue of the Virgin, but on the 19th a group of youths entered the church where it was housed and mocked it. They were dispersed, but returned on the 20th accompanied by half the town. After some psalm singing, the church was sacked, with the rioters parading in the vestments, drinking the holy wine, and bathing their feet in the holy oil. In Ghent, the image-breaking extended to mutilation, mock-torture and mock-execution of statues and paintings. The great Van Eyck altarpiece *Het Lam Gods* was only saved by being hastily disassembled and concealed in a locked tower of the church under guard, while the iconoclasts went about their business below.

For the most part, and in contrast to the iconoclasms else-where in Europe (France, Switzerland, England), the proce-dure was genial, carnivalesque and often very orderly, a holiday from incense and mummery. Through August and September, the hedge-preachers moved in to some of the now cleansed churches, cities were barricaded against the often complicit local authorities, independence declared. But the Spanish clamped down. Early in 1567 the Duke of Alba arrived from over the Alps with armies and siege trains, and the uncoordinated fires of rebellions were extinguished one by one.

By 1566, Bruegel had left Antwerp for Brussels, a distance of 30 miles, exchanging the commercial capital of the Spanish Netherlands for the political.

His birthplace is usually given as Breda (c.1525) or environs, but he seems to have grown to artistic maturity in Antwerp. It is supposed that he settled there after his return from Italy in 1554, although there is no documentary evidence. However, his early artistic endeavours were all drawings for engravings for Antwerp print houses (notably, the Sign of the Four Winds, run by Hieronymus Cock). His first surviving painting, which hangs in San Diego, dates from 1557, but only a handful of paintings were made before 1561. It was from 1562 that paint-ing really took over. By 1563 he had settled in Brussels and married Mayken Coecke, daughter of his master, Pieter Coecke van Aelst, and the miniaturist Mayken Verhulst; Van Mander has Mayken Verhulst persuading Bruegel to settle in Antwerp in order to distance himself from a previous amour, a serving girl he wanted to marry but found to be a serial liar. In Brussels, Bruegel ran a small workshop (where, according

to Van Mander, he delighted in spooking his assistants and pupils with ghostly noises), although there is little if any evidence of workshop hands in his painting (some have taken the sky in the *Census*, for example, that lurid sun and the flat-tened treetop through which it shines, to be by assistants). From 1562 Bruegel painted an average of five (surviving) panels or canvases per year, until 1568, the year before he died, implying that he must have died early in 1569.

And so there he is, Bruegel the Elder: a creature of paint and prints, of signatures and hearsay. Nothing more now.

The documentary evidence for my father's life is similarly scant, if methodical. I have, for instance, a small stack of his notebooks, maintained over seventy years. Five, in total. As follows:

1. A discoloured brown notebook, *Where Is It?* printed in black across its cover, in which my father maintained a list of all the books he read from January 1939 until he lost his sight in the late 1990s. Seven hundred books in total, ordered both alphabetically and chronologically, with a column indicating the month and year they were finished, and a column indicating how many books by that author had now been read. He kept this notebook by his bed, where he did most of his reading, for as long as I remember.

2. A slim Bible-black notebook inscribed on the inside flyleaf *Engineering Formulae, Proofs, Definitions etc.* Probably dating from the late 1940s/early 1950s. Three tiny handwritten tabs allow the reader to flip from AC to DC to M (for 'mechanical'?); each page is numbered

by hand, most are filled with neatly copied-out definitions (or proofs, or formulae) pertaining to his studies, in different shades of blue ink.

3. A book of recipes and food ideas, probably dating from his bachelor years in Bath. On the whole, an empty notebook. Avocado Pear and Prawns (no recipe, just the purity of a name). Rabbit pie. Roast meats. Something called 'sausages – "burnt"'. Sophia Loren's sauce for 'spaghetti as used in Naples'. Some simple sweets (tinned grapefruit, tinned gooseberries, treacle pudding, lime jelly with grapefruit segments). All food he would still savour, if rarely actually cook, in later life (and if I recall he never lost his taste for sausages done to charcoal).

4. The flimsy green notebook in which he recorded the details of his tour of the Low Countries: train times, duty-free allowances, budgets, phrases in French (*Je voudrais que vous fassiez chercher nos bagages*); a list of what he had to declare at customs (perfume, earrings, chocolates and cheese, a pair of hair combs, a china jug, two hundred cigarettes, a bottle and a half of brandy); and a neat list of 'places visited' (*Qualification: Towns and places in which we have set foot and toured, or taken refreshment, or both. Not towns and places passed through*). Thus Ostend, Bruges, Blankenberge, Brussels, Vimy Ridge, Arras, Armentières, Ypres, Ghent, Antwerp, Luxembourg, Amsterdam.

5. His flying log, detailing each hour he flew (in Canada, in Northern Ireland, in Scotland, in Ceylon), with notes on weather, visibility, direction, radio contact maintained or lost, guns fired, etc., stamped here and there and signed by his commanding officers.

A skeleton of a
life: My father's
notebooks.

And there it is. A skeleton of a life, in lists. Definitions.
Formulae. Recipes. Etc. More than we have for Bruegel,
by some considerable measure. For Bruegel, there is no
such archival skeleton beyond those dates and signatures.
We do not glimpse his book of recipes for rabbit-skin
glue. His tour of the red-light district in Rome. We have
only the vivid remnant flesh of the paintings and drawings
and engravings.

For all the lack of documentation, we can say that the Bruegel
Object, dispersed across hemispheres, nevertheless had an
originating trajectory across a troubled land, a land in which
images of all kinds were suspect, tortured, executed.

If you set up a boundary there will be a corresponding osmosis, a crossing, a new dynamic between zones. Breda is now on the Dutch side of the border, across from Antwerp, a Belgian town, but in the Spanish Netherlands, Breda was naturally a satellite of prosperous Antwerp a little to the south, not of pokey Dordrecht or Roosendaal, and still less of Amsterdam, hick town in the cold and peasant North. Antwerp was an intersection with the wide world; Holland was a puddle.

Over the next century, there would be a sorting, Catholic South to Protestant North, vice versa, as positions, professions of faith, hardened. Bruegel himself was likely a Catholic (he was given a Catholic burial), although in 1566 he would make a painting of a hedge-preacher going about his business (*The Preaching of St John the Baptist* in Budapest), and the humanist circles in Antwerp with which he had been associated moved freely and enquiringly in the space marked out by the old faith and the new, Erasmian accommodations and Calvinist defiance. Bruegel the artist was a product of secular print culture. He didn't do altarpieces.

One year later, the project only just beginning to assume a shape, I visit Antwerp with my brother.

My brother's departure is delayed at the last minute by a rescheduled job interview, so I travel out on my own, and while I wait for him I visit the Museum Mayer van den Bergh.

Like the Frick in New York, the Mayer van den Bergh is the ossified private collection of a wealthy industrialist. The floors creak, there are libraries and trinkets, furniture and paintings. On this weekday afternoon in February, I am alone

with the guards, who follow me slowly from room to room. People cannot be trusted not to destroy images.

These are the things I recall. A large triptych by Quentin Matsys, with a crucifixion and a line of citizenry returning from Golgotha to the Holy City. A room not so much of sculpture as of bits of stone – medieval, Gothic, Roman, Etruscan. A large rustic painting by a contemporary of Bruegel's, Pieter Aertsen. Aertsen was from the North Netherlands, based in Amsterdam, and painted peasant scenes and altarpieces; most of the altarpieces were destroyed in a later iconoclasm, the *Alteratie* or Changeover of 1578.

And there are a couple of Bruegels: *Dulle Griet* (1563) and *Twaalf Spreuken* or *Twelve Proverbs* (1558). Why else would I be here?

In 1562, Bruegel inaugurated his new primary focus on panel painting with a series, or sequence, or family of three panels of near-identical dimensions and congruent, Boschian subjects: *Dulle Griet*, *The Fall of the Rebel Angels* and *The Triumph of Death*.

Bruegel was known in his lifetime as the new Bosch. His works were marketed as such (and some of the earlier engravings – for example, *Big Fish Eat Little Fish* – were falsely signed *Hieronymus Bos*, probably at the instigation of Bruegel's printer, Hieronymus Cock). To his contemporaries, he was not Peasant Bruegel, but Bosch-Bruegel. The earliest commentator on his work (Lodovico Guicciardini, writing in 1567) remarked on the rebirth in these latter days of the great visionary of the North (Bosch) in the person of Pieter Bruegel.

We now clearly see that Bruegel was a very different, and considerably greater, painter than Bosch. If Bruegel was an inheritor of the Bosch style early in his painterly career, he was also a humanist painter at ease with the carnivalesque, the Rabelaisian; Bosch, who died only a few years before Bruegel was born, was a medieval painter for whom monstrosity was an index of spiritual corruption. Bosch's monsters mutate in Bruegel into something more arch, more playful; they are curiosities escaped from a *Wunderkammer*, not devils slithering up through the cracks in creation, less Satanic than Linnaean.

This is reflected in the catalogues of the two painters. Try drawing up a spreadsheet of All Bosch, a great Bosch Object, at your peril. You will never get beyond the tangle of *Workshop of …*, or *School of …*, or *Follower of …* The Bosch Object is all smoke and mirrors. The Bruegel Object is all meticulous documentation.

In *Dulle Griet*, a supersized and deranged woman is plundering in front of a hell's mouth, marauding on the fringes of the human and spiritual worlds; she leads an army of tiny females who are engaged hand-to-hand with Boschian creatures and armed men. A second large figure, a giant, sits on top of a building with a ship of fools across his shoulders, ladling money out of his gaping arse. The panel is a melting pot of proverbs.

Baudelaire in the 1850s described Bruegel as a political artist. Perhaps this is the kind of thing he had in mind. The regent of the Netherlands was called Margaret, Margaret of Parma; *Dulle Griet* translates roughly as *Mad Meg*. The Netherlands are aflame and the devils are out, cities burning,

society collapsing, imploding. But this is 1561 or 1562. While there are tensions, we are a few years out from the hedge-preaching and the *Imagestorm*, the Eighty Years' War.

Perhaps it is a battle of the sexes, a reactionary taming of the (untameable) shrew, a world-turned-upside-down where women wield manic power, an uproarious crisis of authority. Or perhaps we should look at Bruegel's drawings for the engravings of the seven deadly sins – there are parallels between Griet and the figure of Iracunda, or Wrath.

On the train on the way over I read an exhaustive and interesting essay by Margaret Sullivan in which she traces the iconography of the stock figures of Madness and Folly and links them to Meg and the giant respectively, but I find I can't remember much about it as I stand here. I content myself instead with trying to work out the architectural division of the space, the logic of the towers and the curtain walls, and enjoying the ruddy sky.

> 'Some pages [of Alexander Wied's very good book on Bruegel] read like a parody of the frenzied activity of modern scholars – most strikingly the bewildering pages on *Dulle Griet*, who nonetheless remains triumphantly unexplained.'
> Review by Helen Langdon of Alexander Wied's *Bruegel* in the
> *Burlington Magazine*, January 1982

Do you formulate or access a reading or readings as you stand in front of a painting? Readings are always present – the art historian Michael Baxandall says that we do not discuss

paintings but descriptions of paintings – but readings, or descriptions, are distinct from the process of observation. A reading, or a description, is grounded on a logical sorting, a winnowing of detail; observation is messier, more repetitive, obsessive, returning again and again to the same objects. Whatever readings or descriptions you arrive with, you can be sure the painting will cock a snook at them.

I suppose a professional might notice the way his or her attention drifts around the panel, recording shifts of attention as flickers of data. I am not a professional. I make, nonetheless, the following notes in my notebook: the experience of standing in front of *Dulle Griet*, I record, is one of dissipation. My attention fragments over the detail. I look closely, not broadly. It is an experience of noticing, in between bouts of inattention and mind-wandering: of looking with the eyes alone. It is not an experience of understanding. The things you thought you would see are not the things you see. Who knows what you now think? Who cares, really?

I do notice one thing above everything else. The sky is ruddier than I thought. I have never seen a sky remotely as ruddy as this in any reproduction. That sky really is burning. I stare at it. It is a colour field. You have a little psychological wobble if you stand in front of it long enough. Had Bruegel met Rothko or Van Gogh, they would have agreed on this at least: saturated colour impinges on you.

How? Emotionally? Viscerally? Not viscerally – whatever is happening is definitely happening in my head, somewhere behind my eyes. I feel, on this occasion, no emotion. Is it evocative? It does not evoke memory, or association. It is just an overriding perceptual stimulus. We have a less fully-worked-out network of descriptors for percepts than we do,

say, for emotions, hence our difficulty discussing aesthetics. Percepts are just more or less noteworthy.

Yes, there it is: to stand in front of *Dulle Griet* is to experience a noteworthy percept, of ruddiness.

Perhaps painters in the sixteenth century – who had been apprenticed to other painters from a young age, grinding and mixing paints, staring at bowls and pastes and palettes of saturated colour morning to night, lost dreamy adolescents there in the workshop reeking of glues and sizes, while outside the world was passing through a duller, less superficial age, an age of few images and no industrial dyes – perhaps sixteenth-century painters, in short, were more sensitive to the allure of pure pigment.

The ruddy sky is all the ruddier for the silhouetted city, the rigging and towers and cavorting creatures picked out in front of it. The charred blackness brings out the red.

In particular there is a tower with a rigged flagpole: frogs, or frog-like entities, are climbing the rigging; a monkey watches from the tower. And one of the frogs is dancing a victory jig as the horizon burns. He is waving a spear. Elsewhere, more frog entities are dancing a round-dance on a tiered structure.

A burning city was not the most unusual sight in the sixteenth century: it was something to which the imagination, if not the eye, would have been accustomed.

In 1534, Bruegel's putative hometown of Breda burned to the ground. Of 3,000 buildings, only 150 remained.

Such was the periodic fate of medieval cities, wooden towns. Like the forests renewed by wildfire, so too cities were

regularly reduced by fire escaped from hearth or furnace or set (in the popular imagination) by conspiratorial arsonists communicating by means of secret signs placed on buildings. Come running with a bucket if you must, but this is how cities clear their undergrowth.

This ruddiness was the colour to fear in the sixteenth century.

'The burning of forest began settlement,' says Stephen J. Pyne in his history of European fire regimes, *Vestal Fire*: 'the burning of cities ended it.'

On 14th May 1940, following a breakdown of communication (signal flares lost in the smoke of battle while the Dutch negotiated surrender), the Luftwaffe bombed Rotterdam. Some planes turned back, but a remnant fleet of fifty-seven low-flying Heinkel He 111s dropped 1,150 110lb and 158 550lb bombs on the Dutch forces holding the north bank of the Nieuwe Maas River. The wooden city burned for two days, the fires fuelled not only by the buildings but by tanks of vegetable oil located near the old port. An estimated 850 people died, and 85,000 were rendered homeless; 24,978 homes, 24 churches, 2,320 stores, 775 warehouses and 62 schools were destroyed.

On the day following the raid, British Bomber Command was instructed to alter its directives on so-called strategic bombing, and begin targeting cities of the Ruhr, including their civilian populations. The era of firestorms – Hamburg, Dresden, Tokyo – had begun.

Rotterdam would be bombed again, multiple times, over the next four years, by Allied forces. The city was no longer as combustible as it had been on 14th May 1940, but other forms of destruction were available.

'When the invasion of Holland took place, I was recalled
 from leave and went on my first operation on 15th
 May 1940 against mainland Germany. Our target was
 Dortmund and on the way back we were routed via
 Rotterdam. The German Air Force had bombed
 Rotterdam the day before and it was still in flames. I
 realized then only too well that the phoney war was
 over and that this was for real. By that time the fire
 services had extinguished a number of fires, but they
 were still dotted around the whole city. This was the
 first time I'd ever seen devastation by fires on this
 scale. We went right over the southern outskirts of
 Rotterdam at about 6,000 or 7,000 feet, and you could
 actually smell the smoke from the fires burning on the
 ground. I was shocked seeing a city in flames like that.
 Devastation on a scale I had never experienced.'
Air Commodore Wilf Burnett, DSO

*

To make a painting is to hope that it will last. But none lasts
for ever. Any singular object is a hostage to looting, theft,
earthquake, fire, flood, bombing, and other local versions of
the apocalypse. The post-war map of Europe, as of much of
the globe, was excoriated, flattened, pounded to ashes;
millions died and much was destroyed.

The Bruegel Object, so far as we know, was untouched. The
paintings were smuggled underground, into mines and
tunnels; when they re-emerged, they were unwrapped and
dusted down and rehung, icons of resurrection. The yawning
gaps in civilization crusted over, and on we went.

But it is only a matter of time and accident. When will the last Bruegel painting disappear? They are fragile. Which one will it be? And what about records of his paintings, his existence? Will his name vanish along with the last painting, or will he, some Apelles of a forgotten history, a forgotten Europe, persist as myth, the JPEGs flickering out on servers one by one, corrupt unreadable binary representations of long-forgotten cult objects?

One week before our Antwerp visit I get word that Anna Keen's Amsterdam studio and home has burned to the ground. The shed next to hers, the one with the yachts or speedboats, caught fire around breakfast time; both it and Anna's shed were flammable subsystems, wood and canvas and paper and gallons of volatile chemicals, boats and easels, sailcloth and packets of economy food. The whole lot went up in a plume of blue smoke so high it made the local TV news.

Anna got out in her pyjamas but lost everything else. Her studio was a workshop and a home for much of her life. In Rome, she would pick through skips for furniture, curiosities, would sketch endlessly with thick black soft charcoals and snub-nosed pencils and sometimes in pen and wash.

And now it was all gone. All her paints and painting equipment, unsold paintings and work in progress, rolls of canvas, stretchers, a lifetime's sketchbooks, her library, her computer, her clothes, her documents, her electrostats (as she called them) and amplifier. Everything except her pyjamas, her bicycle and a small wooden dinghy she had bought in Venice. Nothing was insured. She had pressing debts, no income, and

was several months pregnant with the child of a man who might or might not intend to stay around.

The next morning, she was out in the biblical wreckage of her life, sketching the twisted forms, picking over corners of vanished books, documenting the carnage. What else can you do? Habit will see you through.

I speak to Anna on the phone and suggest she come down to Antwerp, or meet us in Bruges or Brussels. Or we could come up to Amsterdam. But she has appointments to replace her passport and deal with legal problems of rent and deposits.

So I am in Antwerp, alone, waiting for my brother. Next to *Dulle Griet* hangs *Twelve Proverbs*, an early work, essentially twelve separate representations of proverbs in roundels, set within one frame on which the relevant proverbs (*My endeavours are in vain; I piss at the moon – Ill-tempered and surly am I, I bang my head against the wall – I hide under a blue cloak, the more I conceal the more I reveal – He whose work is for nothing casts pearls before swine*) are inscribed. There is a marbled decorative element and the backgrounds to the figures are a uniform red. The handwriting of the inscriptions dates the assembly to between 1560 and 1580.

It is, in fact, a set of apotheosized placemats. It was a popular format. *Teljoorschilders*, or plate-painters, were recognized as distinct craftsmen in the Antwerp painters' guild between 1570 and 1610. Their plate-format paintings were usually set off against red backgrounds and had diameters of roughly 20 centimetres. They came in sets of six or twelve or twenty-four. Proverbs were an appropriate adornment, connected as they were with domestic wisdom.

A search for Bruegel proverb-placemats on Google throws up nothing. A missed opportunity, for someone.

What do you do in front of such an object (assuming you are not eating your dinner off it) if not read each proverb in turn, moving from the wall-plaque to the painting and back again?

Bruegel thought in proverbs. The proverb had pedigree as a rational device, formalized in Erasmus's collection of adages, first published in 1500 and added to, revised, expanded for the next three decades. By the end of his life, Erasmus had collected 4,151 proverbs and adages and dicta, a list parodied by Rabelais's parallel version in *Gargantua* of (mostly scatological) proverbs and mirrored by countless other collections through the sixteenth century.

We like to think we have left proverbs behind. We demonstrate our intelligence by sharply differentiating ourselves, picking out the anomalous, the noteworthy, the untoward in the world around us; we hunt out the discrepancy on the untidy fringes of knowledge because it is here that we will locate the telling detail, pull at the loose thread, which will in turn explode the commonplace that threatens to engulf us. 'Insignificance is the locus of true significance,' said Roland Barthes; 'this should never be forgotten.'

But for Bruegel it was all proverbs. For him, those strange edges of experience were merely a long way from a relevant proverb. And this answers to common experience. It is how we read our lives, how Roland Barthes, like it or not, read his. We may flatter ourselves that we generate the proverbs by which we understand our lives from our own experience, but they are proverbs just the same.

Dan falling from the sky, Anna drawing in the ruins after the fire, my father running off the rails in Belgium: these are just some of my proverbs – I who piss at the moon.

On the return from the Antwerp trip, my brother and I manage to make it to the Musées des Beaux-Arts in Brussels. While my brother marvels at the *Census*, I spend a little time with the painting known as *The Fall of the Rebel Angels*, or sometimes as *The Archangel Michael Slaying the Apocalyptic Dragon*, sister painting to *Dulle Griet* and *The Triumph of Death*.

The panel is a tangle of Boschian creatures, cast down in a great flood from the illumination of heaven in the top centre, petering away in the bottom left into a silhouetted sinkhole of brown washes. Running through the whole are the coils of the Apocalyptic Dragon. The devils are composites – insectoids with fish parts, humanoids with bird parts, mechanoids with crustacean parts – but out of the great press of them, one or two perfectly recognizable creatures are squeezed: a dragonfly, a mangy dog, a bear. Devilry, in the world, is ever-present. It would not take much for this world to bubble up around us, mutate, reveal itself; if we push hard enough, the frogs will rise up with spears, and hell, when we go there, will be peopled by recognizable forms, all the more horrific for being close to the known.

And there, at the mid-point of the painting, is St Michael, studious Daedalic creature, neither more nor less fantastical than the bestiary he pursues: coiffured, winged, delicate, mechanical.

Michael and his angelic cohort are bringing order. They slay, thrust down into darkness, tag, assign. They work

68

calmly to God's blueprint, his spreadsheet. The unregulated life of the devils is a non-project, we learn. God has a project, and a project entails not building only, but winnowing. And so, as with all Last Judgements, we are witness to a resolution of ambiguity, the restless harmonic language of life moved suddenly and irrevocably to a cadence.

What are we looking at, in fact? The beginning or the end of this great narrative that God and his antithetical Devil have set in train? Fall of Rebel Angels or Slaying of Apocalyptic Dragon? Both, clearly, the one with its tail in the mouth of the other. Beginning and end are one. End and beginning. One eternal struggle, one never-ending battle.

To make something meaningful, we must be prepared to render much of the world meaningless. This was on the mind of the gloomy Calvinist poet Fulke Greville, 1st Lord Brooke, friend and biographer of Sir Philip Sidney, who was born around the time Bruegel was returning from Italy in 1554. Fulke Greville had his London house somewhere in the nest of streets – Leather Lane, Hatton Garden, Saffron Hill – lying between Clerkenwell Road and High Holborn where my father grew up; hence also Greville Street, and Brooke Street. He died in 1628, in agony, when, having been stabbed by a disgruntled servant, his wounds were dressed with congealed pig fat, presumably to stop the bleeding; the pig fat went rancid, infected the wounds, and caused the poet much suffering for the several weeks which preceded his death.

In his posthumously published sonnet sequence, *Caelica*, Fulke Greville wrote that 'the fire up ascends and planets feedeth'; fires cool, in other words, matter condenses, the original spark is lost in dull matter. What you are left with,

when you are done sacking your city, is a fragile charred object: timber frames, human bones, all blackened, etherealized to lightness. Planets, maybe, but planets of pumice.

So too the project: in accomplishing something, it reduces. In imagination, a project is a structural object that formalizes our desires, makes our spiritual growth available to analytics. But in fact you do not build teeming worlds: you calcify the

Coiffured, winged, delicate, mechanical: *The Fall of the Rebel Angels*, detail.

teeming worlds of the imagination to a sequence of dried husks, objects in the world: sacked cities, spreadsheets and itineraries (*in Amsterdam we made a tour of the red-light district*); a sheaf of drawings of a fire-ravaged life, somewhere in a notebook.

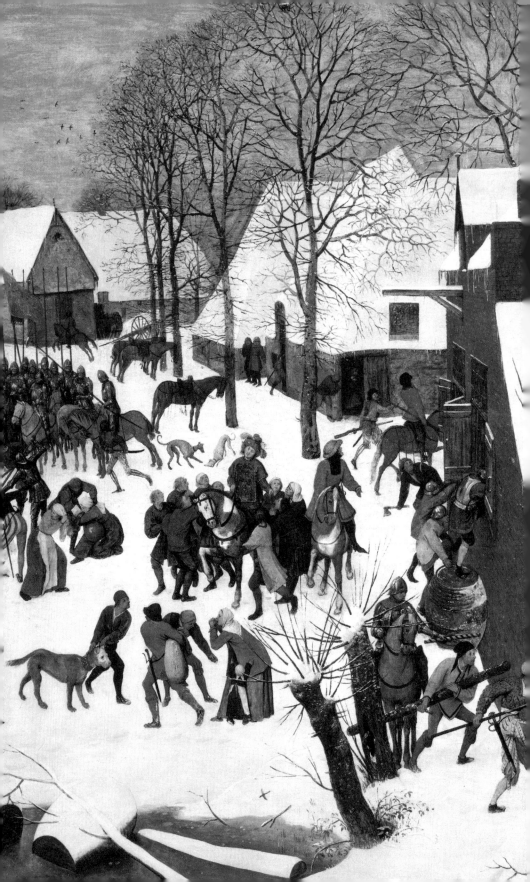

IV Massacre

'As a lone ant from a broken ant-hill
from the wreckage of Europe, ego scriptor.'

Ezra Pound, *Cantos*, LXXVI 128–9

Spot the difference, again.

The *Massacre of the Innocents* hangs in the Royal Collection. It is a panel roughly the same size as *The Census at Bethlehem*, painted at around the same time (1566), also depicting a snowy village.

The painting was bought after the Restoration for the Royal Collection from the Breda art dealer William Frizzell. By 1666 it was hanging in the King's Privy Gallery, described in an inventory as follows:

Brugle. Souldiers fyring of housess and plundering. A Winter peice.

A winter piece indeed. Soldiers maraud through a village just like that in *The Census at Bethlehem* or *The Adoration of the Magi*

in the Snow. They kick in doors and raid houses. They are obediently looking for, and slaughtering, children.

Or they are in the copies. There are around twenty copies of the painting, many (fourteen?) by Pieter Brueghel the Younger. There is a smallish one in Upton House near Oxford, and a good copy in Vienna, taken for a long time to be the original, until dendrochronological analysis showed that the wood of the panel on which it was painted cannot have been felled before 1569, the year of Bruegel's death.

The original, by contrast, has been bowdlerized, painted over to conceal details of the slaughter. The bundle or package on the lap of the woman in red in the original used to be, we know from the copies, a dead naked baby. To her right, the goose dangled by the neck and about to be stabbed by the armed man was once a child, dangled by the arm. Between the woman in red and the armed man lies a dead child, again translated to a nondescript bundle. Behind the woman in red there is a flock of birds (swaddled infants) being butchered with spears. A man with a cap over his eyes in the foreground is about to stab a calf (child) with a dagger. On it goes.

Children generally are pulled and yanked by soldiers and hysterical parents in both original and copies. Where a child is not actually slaughtered, the redaction leaves that child intact, as though children-as-plunder were an acceptable conceit.

Either way, there is no escape. At the far end of the street a figure tiptoes out across the ice holding a small child in its arms, watched by the mother – it may be a soldier taking care not to slip on the ice (he carries a sword), or it may be a father trying to make off quietly. But behind him on the bridge, near enough at the vanishing point of the painting, an armoured man sits astride a horse, watching. Everything is

blocked off, closed down: by the yellowish snow, by the soldiers, by the arrival of bureaucratically ordained death in a Renaissance village.

The painting was probably redacted before it came into the collection of Charles II, not out of a delicate sensibility, but because, sold into the collection of the Habsburg emperor Rudolf II, it might have been politically embarrassing. The figure directing the massacre was also altered, from a black-robed and bearded man to one distinguished only by the colour of his armour, most likely because the bearded figure was too readily identifiable as the Duke of Alba. These are as much Habsburg as Herodian atrocities, a massacre from the dawn of modern Europe.

Unlike Bruegel, whoever carried out the editing was working to a short-term remit and in places, where the slaughtered innocents have been painted over and rationalized, the new paint is wearing thin. We see the legs and arms of the slaughtered children starting to emerge, like bodies from a mass

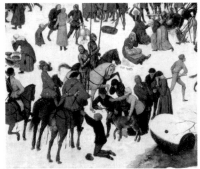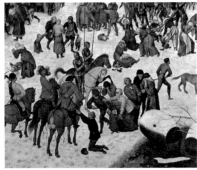

On it goes: *The Massacre of the Innocents*, detail – copy (left) and bowdlerized original (right).

grave. Bury the truth if you must; one day someone will dig it up again.

I remember as a teenager watching the final episode of M.A.S.H. (*Goodbye, Farewell and Amen*) in which Alan Alda's character, 'Hawkeye' Pierce, in order to prevent detection by North Korean soldiers of a bus on which he and a number of refugees are hiding, desperately instructs a Korean woman to keep her chicken quiet, and so she kills the chicken. He is appalled by this, can't seem to get it off his mind until in therapy he recalls, finally, that which he had repressed: the woman had not killed her squawking chicken, she had smothered her crying child.

This seemed improbable to me – not that the woman would smother her child but that Hawkeye would forget. But we do it all the time, culturally and personally. We rationalize our massacres, our crimes, our injustices. We smear other, more palatable objects over them. The things we remember are often just diversions. But the paint fades, and memory persists, one way or another.

What Bruegel chose to show, others hurried to conceal. X-ray photography undertaken by the Kunsthistorisches Museum in Vienna has revealed other attempts to sanitize the paintings, notably in *The Fight Between Carnival and Lent*, where a corpse in the cart pulled by the old woman has been hidden beneath a layer of brown paint, and a skeletal body lying in the right foreground next to the sick child is obscured beneath a white shroud.

Perhaps underlying all of Bruegel there is a psychological hardness which is alien to us. His was a world in which

children died (60 per cent before the age of sixteen), and soldiers routinely pillaged, sacked cities, burned farms, cannibalized their slaughtered enemy on the battlefield; a world in which beggars were leprous, deformed, irredeemable. We look at his panels now and we see an artist of great sensibility, one who moved real, small people and their suffering and concerns centre stage and displaced in the process the central figures of history: Christ or Alba didn't signify so much. But it could be that we mistake his clear-sightedness for compassion.

At the start of my project, Britain was still party to a post-war European settlement which had sought to enshrine certain liberal sensibilities at its heart, personified by the great European totems: Bruegel, Shakespeare, Beethoven and the rest. But I only saw the *Massacre* at the very end, in early 2018, when it was hanging in an exhibition in the Queen's Gallery in Buckingham Palace. Now, Europe had broken like an egg, and we, Boschian monsters, had hatched out: menacing, dull-eyed. The Europe I crossed and crossed again in my hunt for Bruegel, that great fellow European, had been fragmenting under my feet. 'So much beauty and pathos of old things passing away,' wrote D. H. Lawrence in 1916, 'and no new things coming: my God, it breaks my soul.' Before I went to Budapest in early 2017 someone told me to be careful: she had heard from a friend that the station was awash with Syrian refugees (and in fact, there had been just such a crisis, with trains to 'the West' cancelled and riot police at work, in 2015). I saw no refugees at all, which was alarming in a different way, or should have been. This was the Hungary of Viktor Orbán's

'illiberal state', one which would shortly write indefinite detention of asylum seekers in containment camps into its legal codes, in cheerful breach of the UN Universal Declaration of Human Rights.

Bruegel's world was on the brink of collapse. In the last months of his life the Netherlands would embark on its decades-long war of independence with Spain, a war destined to bleed into the Europe-wide conflagration of the Thirty Years' War.

I grew up into a world which had done with all that. The Second World War was closer to the Thirty Years' War than it was to me, even if my father had taken part in it. Europe was healed, and history done. But underlying it all, at its roots, there had always been these bodies, this massacre. Everything I had grown up valuing had in fact been layers of other people's atonement, daubed over the continent like thick paint. Paint that was now peeling away, as the generations passed.

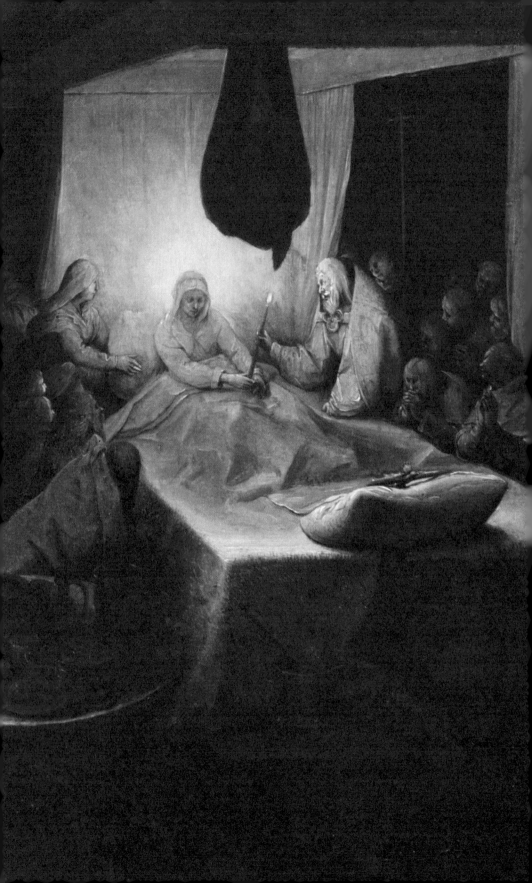

V Grey

England (2.904%)

'*Homo, fuge!* Whither should I fly?'

Christopher Marlowe, *Doctor Faustus*

Archaeologizing, I find that the project proper was conceived somewhere between the National Gallery *Adoration of the Kings* and the Courtauld *Flight into Egypt*, in an email to my friend Steve Barley in which I stated that I planned to see every panel by Pieter Bruegel the Elder in its proper situation, the museum or place in which it customarily hangs. The email is dated 9th May 2012.

According to the email, I had by that time made a cursory list of the panels and their locations. Not an actual list, perhaps; I might merely have flipped through Larry Silver's 8lb book on Bruegel, running itineraries in my head. The panels were located mostly in Europe, with a small cluster in the United States. They were all, bar one, in publicly viewable collections. The email, written in a flurry of mid-morning enthusiasm (I seem to recall), may very well have breathed life into the whole idea.

That was a good year for projects, or dreaming up projects. For most of 2012, I was not working. I was at home. I was on the payroll of a dying software company, one which had been trying to make a game that was a simulacrum of the Second World War. Each iteration of the game was to unfold at twice real time, so that a full run-through would take years. Players were to be generals or politicians and would drift in and out of the game just as real generals and politicians drifted in and out of history.

The game (called *World War II*: even the name was like a Borgesian map precisely covering the thing it mapped) was to be played on a spinnable, zoomable globe, not unlike Google Earth, but we larded too much data on to it. There was topographical data (river, contour, sea-level data – we spent many hours deciding how to reconcile our modern data sets with the changes to the Zuider Zee and the Aral Sea), orders of battle, economic assets, armour penetration at so many yards, rates of advance, aircraft stall speeds. In short, everything. My first job was to comb through the immense spreadsheets where the data was held, tracking down errors. There were many errors, and I combed for months. Perhaps it was here that I developed my appreciation for what a spreadsheet could contain. Worlds. Worlds within worlds. Error, but also precision. Copiousness.

But there was too much data and not enough coding technique. When anything moved on the map, everything smoked and creaked, just like the real war. The game crashed frequently. We never managed more than a few hours with a handful of players, and even then with only Germany, Poland and Russia in play.

By the end of 2011 I was on short hours; by 2012 I was barely going in. I sat at home each day tinkering with my own spinnable, zoomable website, *Anatomy of Norbiton*, watching it grow and sag, each day that passed a cell filled on the blank Excel of my future life.

It was not an unhappy time, but it was one that perhaps craved a defined and manageable project. Something that did not encompass the whole spinnable, zoomable world.

Bruegel painted several modest panels in a monochrome technique known as grisaille. The word intends shades of grey, but in Bruegel's grisailles there are also browns and yellows and flecks of white, in part where they have degraded over time, but in part answering to the chromatic imagination of the painter.

Three survive. They are small – in total they represent 0.578 per cent of the Bruegel Object, by size. A fourth, *Visit to a Farmhouse* in the Institut Néerlandais, in Paris, is usually attributed now to Jan Brueghel the Elder, the painter's second son, and may or may not be a copy after a lost original.

At least one has been lost: in the early seventeenth century the Dutch humanist Arnoldus Buchelius recorded a *Crucifixion*, dated 1559, in the collection of one Bartholomew Ferreris in Leyden.

Two of the remaining three are in England. England is the land of the grisailles. This is where you come to get your greys.

Bruegel had an alter ego, another PB, another Pieter (or Peeter), a painter of Antwerp: Peeter Baltens. Baltens

was born two years after Bruegel (so far as we can judge), and yet was the more senior of the two in 1551 when he subcontracted Bruegel to paint the grisaille wings of an altarpiece for the glovemakers' guild in the Cathedral of St Rombout in Mechelen; Baltens, the rising man, would do the main panel.

Grisaille is a technique which imitates relief sculpture. A Netherlandish triptych altarpiece would typically remain closed, its grisaille outer wings, depicting saints in niches or statuesque annunciations, on display to the world. The wings would only be opened on feast days, to reveal the great blaze of colour within.

Bruegel's were to represent St Rombout and St Gommaire. The altarpiece is lost, sunk beneath the grey waves of time, as are the reputation of Baltens and the magical interventions of St Gommaire. Baltens was also a fine poet, apparently, and would in time become something of a luminary in his native Antwerp. He would go on to paint many genre pieces similar to those of Bruegel (a *Tower of Babel*, for example, or a *Wine of St Martin's Day*), and art history has still not determined who was clambering over whom.

Baltens signed his name variously Peeter B., PB, Peeter Baltens, Peeter Balten, as though he could never quite bring himself into Bruegel's chiselled Roman focus. Picture them, for a moment, working together on the altarpiece, two young men of ambition. The worldly Baltens, already securing commissions, who would go on to move in influential circles, and then be forgotten; and Bruegel, content to break his teeth on these grey wings.

*

Before I set eyes on any of the grey panels, there is an object of Italianate colour, an outlier in Bruegel's output, to tick off: *The Adoration of the Kings* in the National Gallery.

It is December 2011 and, Shandy-like, I am still teetering on the event horizon of the project proper. I am in the National Gallery to see the big Leonardo show, women with ermines and madonnas with rocks. But I am now consciously drawn to Bruegels, and so arrive early in order to hunt down the *Adoration*.

The *Adoration* is, for Bruegel, an unusual vertical format, with very little recession in depth. Figures crowd in on the holy family, breathe down their necks. It is a typically Netherlandish composition, but it is clearly also the fruit of Bruegel's Italian voyage. He knows his tempera saints, the vibrancy of their robes, the colour shading of greens and yellows and oranges.

No doubt from time to time he was assailed by a longing to return. Memory of the Warm South is a well-worn mental state, up here in the Grey North.

When I was at university, I used to go sometimes in the undifferentiated grey East Anglian winter to the Fitzwilliam Museum and sit in the Italian Gallery, and look at all that colour – Ghirlandaio, Veneziano, Titian, Veronese – and remember my solitary trip to Italy, a week in Rome and a week in Florence. These were the days before cheap flights, Italy might as well have been Tahiti, or the moon. To return would have required a plan, a way of earning some money. I was never very good at planning, working towards. I just had my impossible longings and imaginings. And so there I sat.

*

There is menace in the kings who visit the Christ Child in more than one Netherlandish *Adoration of the Magi*. These magi of Bruegel's, these pagan witches who tote inappropriately luxurious gifts, are harbingers of Aztec gold, Inca silver, Spanish mercenaries. They bring thuggish, armoured retinues wielding rusty iron blades, spiked clubs. A thicket of pikes, brutal objects, helmets, maced hands on crossbows.

The clothes of the kings are designed to conceal purpose. Balthasar is lost inside a formless cape and soft boots. The kneeling Caspar wears a pink surcoat whose long empty ermined arm drags in the dust; it takes a moment to see that his actual arms are busy elsewhere. And the crabbed and awkward and frankly ugly Christ Child is no more than a reflection of what these powerful men expect to see in another king: suspicious, paranoid, withdrawn.

And they bring insidious magical objects. Balthasar presents his gift of myrrh in a replica golden ship's hull bearing a gold-trimmed jade or emerald shell to which a golden chain is attached, looping through the hands of the king as though he will never truly surrender it. On top of the shell is an armillary sphere, on top of that a sapphire in a golden bud. From the mouth of the shell a tiny figure of a man is expelling another blue stone, sapphire or topaz, or black pearl, like a dung beetle pushing dung. You would not like to touch this thing. Secret clasps might release hidden snakes, scorpions, noxious insects, Persian devilry.

*

Renaissance painting depicts a sham world. Where later painters of still life – Chardin, Cézanne – might pluck objects from the continuum of their actual environment (apples and

dead pigeons, stoppered stone jugs and garlic bulbs), single them out and arrange them, Renaissance and Baroque painters raided their dressing-up baskets, their cupboards of props.

To art historians these props are known as staffage, the bits and pieces that furnish a painting. Bruegel did not run a large workshop, and in Antwerp, so far as we know, no workshop at all. But he could no doubt open chests full of velvety hats and cloaks, fragments of ermine, rusty weapons, crossbows, musical instruments (hurdy-gurdy, bagpipes), brass pots and coloured stones, from all of which he could assemble a simulacrum of an opulent world, and drum up a little colour and warmth.

Pagan witches: *The Adoration of the Kings*, detail.

The mid-sixteenth-century Netherlands was a deeply theatrical society. Each town had at the centre of its civic life its *rederijkers* or chambers of rhetoricians, its amateur dramatics club. The *rederijkers* organized the festivities which punctuated the church and civic calendar, set up the floats and processions and dramas. Every so often there were great competitions of amateur dramatics: the *rederijkers* of a given region would assemble for days-long festivals, known as *landjuweel*, and pit their dramas one against the other in their typical genres, the *facties* (satires), the *kluchten* (farces), the *spel van sinne* (allegorical dramas).

In Antwerp, the *rederijkers* society was called *De Violieren*, and its members included many of the city's artistic fraternity, amongst them Hieronymus Cock and the painters Frans Floris and Maerten de Vos, the latter of whom may have travelled to Italy with Bruegel.

Little surprise, then, that the world of the theatre penetrated the world of painting to such an extent. In the Fitzwilliam Museum of Cambridge, there is a painting by Pieter Brueghel the Younger of a peasant festival, possibly a copy of a composition of his father's, and at its centre an impromptu stage has been set up and a familiar peasant farce is playing out, something about the Devil seducing a wife while the husband conceals himself in a basket. His father's *Fight Between Carnival and Lent* was a popular *rederijkers* theme, as was the fat farmer and the lean farmer (subject of a pair of Bruegel engravings). The art historian Walter Gibson notes that Bosch's *Haywain*, and perhaps also an engraving by Frans Hogenberg of 1559, inspired a float of a haywain in the 1563 annual religious procession in Antwerp: on top of the haywain rode a devil called 'Alluring

Deceit', and it was followed around by representations of usurers, bankers and pedlars, each trying to snatch a bit of hay for himself.

Did Bruegel participate in all this theatre? Of course he did. He may have had nothing to do with the *Violieren*, or the *landjuweel* (although it is much more likely that, an artist and a humanist, he was involved in both), but at the very least he would have strolled about and taken in the myriad little concentrations and distillations of human experience, the popular and carnivalesque theatre from which, just over the water and a generation later, Shakespeare would spring. And we could do worse than think of Bruegel not as a philosopher in paint but as an impresario of freeze-frame theatrics, ringmaster in a Barnum and Bailey world.

The Italy which Bruegel visited in the early 1550s was a repository of especially choice objects: fragments of the ancient, and eminent productions of the modern, world. Life there was a colourful jumble, a bazaar. You went to measure and collect and rummage and learn, and bring back.

What did Bruegel bring back? What would any painter bring back, piled high on a cart like a travelling theatre, trundled over the Alps? Materials, new paints, fresh brushes, pristine vellum sketchbooks or sketchbooks filled with grubby charcoal images; jars of wine, preserved foods, a palette of new technique, new acquaintance, new experience; a sharp but fading memory of a life in miniature, lived hurriedly, then bottled. Never to be visited again.

*

When I returned from Italy in 2003, after ten years living in Milan, Rome and Venice, I brought with me, buried in my backpack, a huge stone mortar which someone had given me – at least 150 years old, she said. It had been at her house in Tuscany for as long as she could remember. I remember falling over in the Vauxhall Bridge Road as I ran for the last train, and my pack was so heavy I could barely get up. I lay there like a tortoise while gloomy drivers peered over their steering wheels at the spectacle.

I also indifferently left a great deal behind, at the house of a friend, at a place of work, with an ex-girlfriend. Many books. My small yellow teapot. Staffage. Props to a forgotten play.

Steve Barley still lives in Rome, but his mother lives in Bedford, so in August of 2012 I rent a car and drive over from Cambridge, pick him up, and we motor out towards the Oxfordshire–Warwickshire border.

We are heading for Upton House, near Banbury, and an encounter with the first of the grisailles, *The Dormition of the Virgin*.

The Christian narratives throw up great theatrical tableaux of death – we take our gods up to high places and crucify them, we behead or disembowel or in some way break to pieces our prophets and martyrs, we sacrifice our firstborn on mountains, our lambs on altars. Alive, you are only rehearsing in the wings of true existence but when you die you will step through the curtain and into the dazzling lights, under which you will play out, for all eternity, the powerfully real and poignant drama of the cosmos.

So it is that in the Upton House *Dormition* the Virgin

ghosts to her conclusion, not alone, not in contemplation, seeing out her last moments in devout or terrified isolation, but surrounded by an audience of saints and groundlings.

No martyrdom for her, no glorious dismemberment. She takes that other path, to dissolution. She dissolves on a grey panel, etherealized in monochrome oils. And yet, even here, there is the staffage, the props: the candles, the chiaroscuro, the crucifix. Death is a billowing of incense, of fragrant smokes; it is a murmuring of incantations, an overspilling and upwelling of solemnity.

Who will not go to make witness in the theatre of death? See a person die? On a scaffold, online, on their deathbed. Who will not succumb to curiosity? We go and watch. Depict the

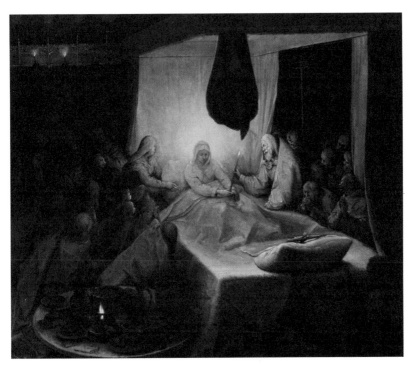

She dissolves on a grey panel: *The Dormition of the Virgin*, detail.

moment on panels, a focus for the contemplation of our own solitary passing. Not far off now, if you are an elder Bruegel.

Here lies the Virgin, then, in her death room. Everything is contracted here for her. She will never leave this place, not bodily. The whole universe has shrunk to a space some metres by some metres. Pace it out, in your grief, if you must; she never will. The last, numerable sources of light (count them: one candle, one fire, one halo, one oil lamp) map the flickering neurons behind her brow, going out one by one amid the encroaching aeons of unconscious darkness.

When, in the years following the death of my father, my mother reached a certain point in her slowly progressing dementia – a confluence of deliriums and self-neglect and falls – we moved her to a nursing home, not so much against her will as without her knowledge. She never properly understood that she was there. Unsociable, she declined the pleasure of the large lounge where the old shrimps, as she was pleased to call her fellow residents, slumbered like mystic Norns on the threshold of unknowing. She confined herself for the most part to her single room, her television and her unread newspaper, making rhythmic phone calls to the few people in life she remembered: me, my brother, my uncle. Voices kept her in place, to some extent. Triangulated her.

My visits always surprised her. She never wanted to talk much. She just wanted to watch television in company. Repeats of long-gone antique shows, or nature

documentaries, simple quizzes. Dementia TV: tiny smiling bronzed presenters swirling like little demons waiting on your soul, not really present, illusions of company in an empty room.

The *Dormition* was owned, and perhaps commissioned, by Bruegel's contemporary and friend, the atlas-maker Abraham Ortelius. It was painted around 1564, and ten years later, after the death of the artist, Ortelius had Philips Galle make an engraving of it, and from that engraving prints were distributed to illustrious friends and associates.

On the prints made from the engraving Ortelius added a devotional, meditative text, on the Virgin's happiness at passing from this great stage of fools, on being reunited with her god-son, and on her sorrow at leaving the disciples.

Along with many of Bruegel's contemporaries among the humanist elites of Antwerp, Ortelius was associated with the underground heterodox sect known as the Family of Love. Familists held that the profession of faith of an individual, whether Catholic or Calvinist or Anabaptist, or indeed Muslim or Jew, was irrelevant. Ritual was just theatre. What mattered was the alignment of the heart.

Familist affiliation is unknowable: it is a clandestine sect. The lurid palette of secret societies, with their hammy winks and handshakes, cod-ritual and costume, lies concealed, perhaps, beneath the grisaille wings of the Antwerp intellectual elites. Was the great Antwerp printer Christophe Plantin a Familist? Some have thought so, many are not so sure. Ortelius? Probably. Bruegel? Guilty at the very least by association. When Plantin publishes a book by Hendrik Niclaes,

mystical progenitor of the Familist sect, does that mark affiliation? When Bruegel paints John the Baptist as a hedge-preacher, does that argue a heretical devotion?

Who can say? The indecipherability of Bruegel's heart and of Bruegel's paintings are one and the same.

In the late 1960s my father, a middle manager with a stalled career at the General Electric Company, was told to employ a certain individual in his department at a starting salary not far short of his own, and far in excess of other members of the department. Convinced that what he was party to here was a species of Masonic corruption (by no means unusual in key British institutions of the time, and regularly exposed in those years by investigative journalism in *The Times*), he instantly handed in his resignation.

In the decades following the war, GEC made its money, not by selling toasters and light bulbs (although it also sold toasters and light bulbs), but by contracting for heavy electrical-engineering projects – power stations, including nuclear power stations – and military electronics. This involved it necessarily in the arcane business of the State, which in the 1950s and 1960s was conducted in wood-panelled, smoke-filled rooms by men – admirals and industrialists and spooks and ministers – who had honed their code of genteel ruthlessness in battle, in Burma and North Africa and Normandy, and turned that code now to squeezing what they could from the last knockings of Empire.

Or so I imagine.

And so, I think, my father imagined. He had spent the 1950s in Bath, responsible for GEC's military contracts with

the naval bases at Plymouth and Dartmouth. He was very pleased that he was required to sign the Official Secrets Act – to feel that, on the outer rim of the labyrinth as he was, he might still be treading the eccentric path to the centre.

He was not. Much later, he would cheerfully admit that he did not have any secrets of note to protect. But he was having a nice time. If in these years he felt on the brink of a more colourful life, then, as so often, to feel on the brink of some-thing is to be in the midst of it. When I was growing up he liked to have a couple of drinks while the Sunday roast was cooking, and, half-cooked himself, would tell us his stories of that late-flourishing youth, when he lodged in a boarding house with half a dozen other young men, an establishment run by a terrifying but affectionate throwback called Fanny Blathwaite who liked to talk of her 'young gentlemen' and both rued and secretly indulged their mild hooliganism and incompetent womanizing. He had a narrow but practised repertoire of stories: of how he once poured a jug of milk over the head of an obnoxious fellow boarder who had insulted him at breakfast; or how he went drunken dancing at the Pump Rooms every New Year, to return at first light; of how, lonely one Christmas, he proposed marriage to one of his three current girlfriends, only to withdraw the proposal by telegram when he had cheered up a bit. He was an entertain-ing storyteller, prone to embellishment, and we heard his stories so often that mention of Fanny Blathwaite, that mythic being who emerged only in the Pythian fumes of alco-hol, would invariably send my mother's eyes rolling theatri-cally back in her head. Fanny bloody Blathwaite.

Bath in the 1950s, like Italy for Bruegel in the 1550s, marked the furthest extent of my father's adventure out into

the world. Whatever he thought might come next had not. So when, years later, he found himself in effect selling light bulbs from a grey building in Wembley and living out a suburban, married, fatherly existence a thousand spiritual miles from the wood-panelled, secret-laden heart of Empire he had imagined for himself, it was not so surprising that his mind should throw open the grey panels of current experience to reveal the recondite blaze of colour within: Masons, cabals, sects.

There was always a bit of residual hooligan in my father: a clever working-class boy conscious of slights to his dignity, given to theatrical displays of resistance. But his furious resignation from GEC was short-lived. Within two days, the situation was resolved in some way and my father returned to work, no less convinced that there were malign professional influences at play around him. Perhaps he was right.

Bruegel's panels have hidden connections. Dendrochronological analysis of the board on which the *Dormition* is painted – a particularly fine board, by all accounts: a tight-grained oak, a premium radial cut, guarantor of its painting's good survival – suggests that it was felled in the east Baltic at some point after 1552. And at least two other of Bruegel's panels were cut from the very same tree: the Courtauld *Flight into Egypt* (1563), and the Brussels *Landscape with a Bird Trap* (1565), the latter a single board, exceptionally wide for a Baltic tree, and containing, therefore, six sapwood rings.

In the *Dormition*, Bruegel has left a smudged fingerprint in the paint, just below the cat and the andiron. There is another fingerprint in the *Landscape with a Bird Trap*, where he seems to have used his finger to lighten the corner of a hole in the ice.

Bruegel scholars Christina Currie and Dominique Allart, in an effort to prove authorship, consulted with the chief superintendent of the Liège Police over the *Winter Landscape* fingerprint, but it proved to be incomplete, and inconclusive.

Bruegel is a difficult man to pin down.

Not long after Upton House, I visit the Courtauld Gallery on the Strand and examine the *Landscape with the Flight into Egypt* and the grisaille *Christ and the Woman Taken in Adultery*.

The Courtauld Gallery is 350 yards from No. 1 Kingsway, the old GEC building. My father could have walked over here in his lunch hour. For an introvert working day after day in an office rife with other voices, it would have been just the thing. A cool open empty space, dotted with Bruegels and Tiepolos and Manets.

One of the functions of a gallery is – should be – to make available a certain sort of space. Now that congregations no longer sit open-mouthed while priests crank open the grisaille wings of the great altarpiece, our best experience of art takes place in solitude: a quiet hour in a frescoed chapel, say, or ambling around an empty museum.

The Courtauld is not empty, but it is pretty quiet on a Tuesday morning. As it happens, the Bruegels only came in to the collection in the late 1970s, by which time my father was working in Wembley. He could not have seen them, ghosts of the future. But this is doubly a pity, since, unlike the delicate enclosure of *The Dormition of the Virgin*, or the claustrophobic menace of *The Adoration of the Kings*, both Courtauld Bruegels open up space.

In *Christ and the Woman Taken in Adultery*, for example, Bruegel's Christ creates space in the crowd by leaning forward and scratching his unanswerable caveat in the dust of the step of the Temple:

DIE SONDER SONDE IST, DIE [WERP DEN EERSTEN STEEN]
(He that is without sin among you, [let him first cast a stone at her]) – John 8:7

It is a contractual clause – actually, we have here just the subclause, the conditional clause – which removes the woman from one severe oppression (stones, Pharisees) into another, milder but more pervasive, one which will, in the end, rend nations and continents. The Pharisees had their Temple, their Jerusalem, their Israel: the coming Christians will demand the World.

Still, better than having stones cast at you. This way, at least, you gain a little time, a little space. It is a small panel, and crowded with bodies, and yet it is uncluttered. Spacious.

Christ's spell, written in the dust, has driven back the mob. The righteous are starting to turn away, are casting last looks at the dissipating drama, dropping stones. Space is opening up: physical space, of course, but also space for compassion – we are all grisaille bodies, seen under the eye of eternity – and space for introspection.

Landscape with the Flight into Egypt makes its space in a different way. It is a small panel, but near-infinite: not a *Flight* but a *Landscape (with Flight)*. A landscape, moreover, painted by an

obsessive miniaturist. There is an anonymous little city, and near it a little port village, their sloping roofs picked out with flecks of white; there are tiny flowers in the foreground, and a pair of scuttling salamanders evading the hooves of the donkey, there are winding paths and opening vistas.

It is into this landscape that the holy family escapes.

Joseph, that hoary old adjunct to salvation, a relic of paternalism, leads the donkey. In the *Adoration* he stood apologetic before those terrifying kings, a figure with his hat over his impotent loins. In the *Census* he carried his saw over his shoulder, still bound to the patterns of his daily life. Now here he is again, dragged this way and that by his powerful young wife, who communes with angels, bears gods, flees the wrath of kings.

The genealogy of gods runs in the female line. Joseph is absolved of the need to be anything but a spectator to his own

Scratching his unanswerable caveat in the dust: *Christ and the Woman Taken in Adultery*, detail.

life. No one is looking at him. He is not, nor ever will be, centre stage. A mere smudged fingerprint on the edge of the panel of his own life.

But for now, just for now, he has a purpose, and his purpose is flight. His young wife has eyes only for her saviour, her baby, but Joseph, a solid figure hidden behind a great round hat, looks out over the landscape to see what lies ahead.

To fly from the Judea of Herod to the Egypt of the Pharaohs is in one sense merely to move between versions of bondage and tyranny. Tyranny, of one sort or another, is all-pervasive. At the point where Marlowe's Faustus signs his contract with Mephistopheles, the words *homo, fuge!* – man, fly! – appear in blood on his arm, a warning come too late. There can be no flight for Faustus, locked as he is into the terms of a cosmic contract. It is the same for Jonah setting sail for Tarshish, for Peter at cock crow, for Christ in Gethsemane. *Whither shall I go from thy Spirit*, runs Psalm 139, *or whither shall I flee from thy presence? If I ascend into heaven, thou art there: if I lie down in hell, thou art there.*

And it is the same for Joseph. Joseph has not signed a contract with the Devil, quite the reverse, but a contract with eternity nonetheless has his name on it. And if in this panel he is not fleeing his obligations, but rather honouring that contract in the spirit and the letter, he is nevertheless experiencing a moment of liberation, hovering between realms.

Because an act of flight, while futile, is not meaningless. Whatever in life you flee – devil, god, or the GEC – you flee in vain: it will catch up with you in the end. But just for a moment, a moment of giddy exhilaration, you can steal a march, and put yourself beyond reach.

What sort of inner landscape did my father contemplate on those two days of absence after he quit his job?

He, like Joseph, was father to a young family. Whether that family was burden or salvation is unclear, but a family can be, to its members, its initiates, a little arcanum, a concentration of concealed colour and vibrancy. In such a case, sitting at home contemplating options (for the family, for himself) must have felt like teetering on the threshold of understanding.

In the Bruegel panel, Joseph and his family are on the point of crossing into a new land. They stand on its threshold. A little further along the path there is a rickety bridge to be traversed before the path steeples up through a ravine and then winds down to the land below.

Joseph might feel marginal to his own life, but what seems a margin can also sometimes be a point of inflection. You are

Spread your wings: *Landscape with the Flight into Egypt*, detail.

entering a different landscape, and a new land holds promise of change, a new arrangement. To glimpse that land is to witness the panels of an altarpiece thrown open. You are suddenly graced with visions of mountains dissolving into an endless, peopled plain. And you are reminded that life has possibilities.

And anyway, first you have to get there. Icarus or Daedalus, spread your wings.

By the end of that year, 2012, the software company had finally imploded under the weight of its maps, its spreadsheets, its graphic colour and theatres of war, and I was no longer free in the ways I had been. I found a different job, teaching English as a foreign language. Agreeable, fruitless, unquantifiable work, aimed at nothing but the replication of my own tongue. Work which required only my smiling or frowning presence from time to time, not much else.

By now, however, I was locked into a project. I was browsing flights – actual flights, on planes, to San Diego, to Detroit, to Vienna, to Madrid – and examining maps, devising itineraries. I was buying up Bruegel real estate in the form of scholarship and tomes and volumes. I was dreaming of travel and shape. Life might seem to be played out under a grey English sky, but it was a sky flecked and starred now with iridescent objects that were not just memory, but were out there in the world, waiting to be found.

VI Beggar

Paris (0.082%)

'Rash, cancre, fistula to hug glib shoulders, mingle
Herpetic limbs with stumps and cosset the mad.'

Basil Bunting, *Briggflatts* III

In Paris, in the Louvre, there is a solitary Bruegel panel: *The Beggars*. It is a small panel (397.75 cm²), and a late one, signed and dated: *BRUEGEL M.D.LXVIII. 1568*.

The beggars are depicted on the day known as Copper Monday, a day of procession and almsgiving which followed Epiphany, as we know from their traditional paper crowns. They are also wearing the foxtails and, in one case, the bells associated with leprosy, the disease which accounts for their identikit disability. They are accompanied by a woman with a begging bowl who is collecting on their behalf while they perform – because it is a performance, however grotesque: the hats, the foxtails, the parade of disability, the sense of festival and carnival.

Festival and carnival: *The Beggars*.

Bruegel's is not a sentimental gaze, perhaps, but it remains a gaze. That is already something. Not uniquely among painters of his age, he is drawn to the observation of the marginalized, the outcast, the strange. Bruegel painted outsiders. Cripples, beggars, peasants, children: in crowds and in detail, all at swim in a turbulent social sea.

But where in other panels he paints them with a hint of redemption – something transcendent in a corner, a seek-and-ye-shall-find pearl scratched up in the dungheap of the village (an adoration of the Christ Child going on; the arrival of Mary and Joseph in Bethlehem) – here, there is nothing.

The Paris *Beggars* has been read as a satire – one of uncertain thrust, but the beggars, wearing paper crowns,

caps, berets and a bishop's mitre, might be taken to represent the social estates. Bruegel's gaze, though, is already a powerful organizing – we might even say moral – force. In my Bruegel voyages I have ghosted through Detroit and New York with their mumbling, shuffling homeless; I have walked past the dispossessed on the Strand, ignored out-thrust paper cups on the Charles Bridge in Prague, and stepped around sleeping bags in Antwerp and Brussels. Almost everywhere I have been, in fact, I have bypassed scenes of biblical woe in pursuit of my monomania, my small and private grail.

Is the panel documentary or emblematic? It has been taken to allude to the so-called Beggars' Revolt against the Spanish occupation, which took the foxtail as its motif. And it may be so: Bruegel paints figures from the margins, but not necessarily with sympathy. His concern is typically intellectual, observational, curious; but it tends also always towards the proverbial, the political.

Whether the panel is documentary or emblematic, political or proverbial, there is in these figures nonetheless a battling physical energy which, if not exactly heroic, or redeemable, is certainly noteworthy. In particular, the three figures facing out of the panel have managed to get themselves upright with, if not grace, then vigour and determination.

I remember that George Eliot, in one of her letters, talks about tiredness, listlessness; about how, in order to do anything, you have to build and maintain a mental bridge of energy over the abyss of physical and intellectual and emotional tiredness.

I don't know about a bridge of energy – it sounds exhausting before you even start – but that sense of conscious focus in performance unites Bruegel's beggars. We all drag ourselves up by our bootstraps, up to the vertical, on a more or less daily basis. We drape our necessary roles over a concealed, or ill-concealed, core of ennui, of exhaustion.

Doubly so out on the margins. To exist precariously, on the edge of the social, is to be held always in a sort of tension. The beggars are perpetually at arm's length, whether that arm is visible or invisible. Outsiders are excluded. Children are not privy to the ways of the world. Women occupy a domestic, not a political sphere. Peasants grow their turnips in snow-bound villages. The aged are put to pasture. Each subsists not easily, but in tension.

Is there a way back in? The art historian Edward Snow, quoting Rilke, notices the 'hopelessly open gate' behind the beggars. To go though it – to be allowed to pass within the walls – would be a powerful mercy, a reacceptance within the social group, offering survival, comfort, warmth.

But it is hopeless. The sixteenth century was a century of mutilation, much of it deliberate. Adulterers and sodomites, notably, were subject to the penalty of *denasatio*, or the lopping of the nose, a way of branding the criminal for all people and for all time. *Denasatio* was likewise inflicted on exiled criminals who returned before their term. To cut off the nose was to signal expulsion indelibly.

The only routes back in were tortuous. Bands of mercenaries were not fussy, and the sixteenth century was a good time for mercenaries. In *Christ Carrying the Cross*, in Vienna, one

The lopping of the nose: *Christ Carrying the Cross*, detail.

of the red-coated mercenaries who polices the procession and scans the crowd from horseback is a nose-less individual, a criminal not so much reintegrated in as reattached to society, a malevolent but useful prosthesis.

I saw *The Beggars* in 2012, on a visit to Paris with my family. The day after my visit to the Louvre, on my way to the Musée d'Orsay, I happened to pass a man begging in the street. He was in late middle age, heavy built with a prophet's beard. He was propelling himself along in a sort of agony of balance and endurance, with a pair of crutches stuck under his armpits, an empty cap held out for alms between the fingers of his right

hand, dragging the insides of his splayed feet on the pavement behind him. He was wearing discoloured white trainers which almost smoked with the friction. I do not know how he did not pitch forward on his face with each thump of the crutches.

This was not, you had to surmise, how he usually got about. It was a performance, and an impressive one at that.

I did not give him any money. He was, had he known, unapproachable, a little smouldering apocalypse of the street. And irreducible. He represented a particular wavelength of human experience which might be absorbed or refracted or reflected by different sorts of social organization, but which can never be eliminated. A sort of recalcitrant energy. A resistance. If, as I say, there was something apocalyptic about his presence, then it was because the apocalypse is a form of revelation, and to dramatize is, in the end, to make visible. As Bruegel understood.

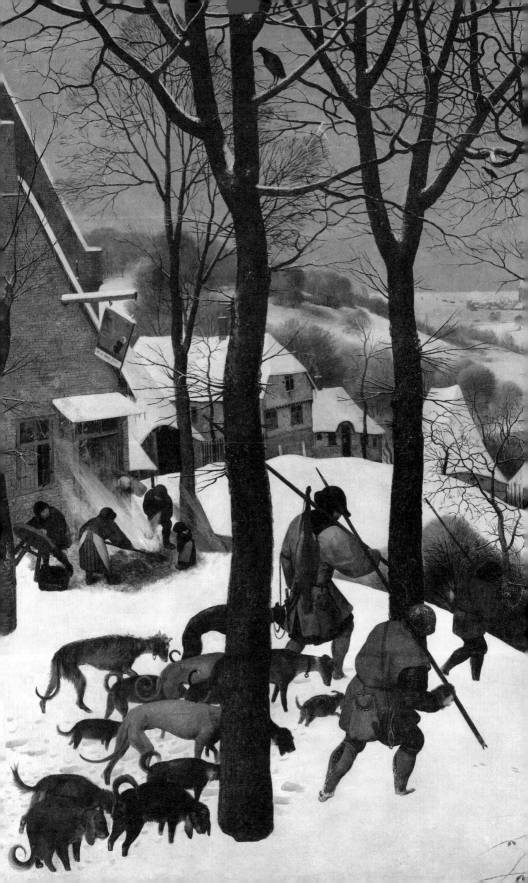

VII Cold

Winterthur – Vienna (40.32%)

'The life contest is primarily a competition for
available energy.'

Ludwig Boltzmann

Projects are a summer pursuit. Collections. Hobbies.
Expeditions. The working world stops for a few days or weeks,
the daily drab, and each man goes out to enjoy the sunshine,
the skies and the warm air, to restore himself in his shorts and
his manias. Each man or each woman.

Regardless, I took a winter journey. For Bruegel painted
winter.

Specifically, he is said to have painted the millennial winter
of 1564–5, when Queen Elizabeth skated on the Thames and
the birds dropped like blocks of ice from the trees, and
Netherlanders drove their wagons and wondering horses
over the frozen Scheldt at Antwerp. But this was an age of
hard winters, the Little Ice Age in which, each year, the world
seized up for a spell, children skittered across the surfaces of
torrential rivers with eerie ease.

In February 2013 I took multiple trains through a sequence of winter cities, Winterthur to Zurich, Zurich to Frankfurt, Frankfurt to Würzburg, Würzburg to Nuremberg and on to Munich, then Munich to Vienna, clearing up Bruegels as I went.

How do you equip yourself for a winter journey in Bruegelian space?

I equip myself as follows:

Flight bag (black, wheeled, Samsonite); laptop; mobile phone; binoculars; camera; coloured pens; notebooks; a book; a padded winter half-coat; other clothes (photographs show me in a waterproof beanie I usually use for hiking/camping); earplugs. Toothbrush. Cufflinks.

Paraphernalia, much of it black (laptop, BlackBerry, binoculars, camera, coat), by subconscious convergence rather than conscious choice. If I wore a suit I could pass for an international man of business. I am not youthful, my equipment says, I do not play, have toys; I am all about the business – the business, in my case, being Bruegel, but that is, so to speak, my business.

Here I go then, winter crow.

All that preparation, that neatly and precisely assembled paraphernalia, will come to naught. It is ever so. The preparation of the expedition always unfolds in chaos after the first night. Canoes are broken, supplies spilt. My first time abroad, hitching in France in 1988 with a friend, I had a shoulder bag rather than a rucksack. I had brought a camping stove, I think, with the intention of making tea, and therefore some

powdered milk; I also had a half-bottle of Scotch. Somehow, on that torrid first day trying to find our way into, and then out of, Calais, which to our surprise involved hours of marching on roads without pavements, I swung this great swag bag of incompetence from one shoulder to the other, like a Bruegelian proverb; and somehow both the powdered milk and the whisky opened themselves and went to a mulch there in my bag, so that for the next fortnight everything I had brought with me was covered in a milky whisky paste.

The preparation unravels. Always. The rigorous kit is made in the doing, in the execution. Sir Fitzroy Maclean, Britain's envoy to Tito and his partisans in the Second World War, relates (in his account of the war, *Eastern Approaches*) how, advancing on Belgrade, his small force linked up with the Red Army, which had by now fought its way over long months and years from Stalingrad. These Soviet soldiers, he observed, were dressed in whatever they could pick up and scavenge from the land or from their fallen foe; their lorries carried only fuel and ammunition, but their gun barrels gleamed. Meanwhile in Normandy in the days following the Allied invasion, filing cabinets and dentists' chairs were piling up on the beaches.

Joseph Koerner, in *Bosch and Bruegel: From Enemy Painting to Everyday Life*, notes Bruegel's fascination with what anthropologists designate 'style': the precise and subtle variation in the design or use of equipment of one sort or another – knife, belt, sub-machine gun. Thus Bruegel's peasants are precisely accoutred, their boots laced correctly, their hats worn at the exact angle habitual in their locale.

But those gleaming Red Army gun barrels peer out from under a disconcerting melange of coats and tunics, and this points to another peasant skill, a skill born of a life balancing always on the edge of survival. The military calls this skill field expediency, the making-do with whatever comes to hand in the moment, the improvisatory, rag-and-bone facility with bits of string, sheared metal, splintered offcuts of wood. Detritus is a resource; to live is the art of making shift.

Thus in *The Census at Bethlehem* the villagers have turned the hollow of a tree into a tavern, complete with awning and a tavern sign swinging from what might be a branch and what might be a bit of carpentry but is probably both; outside there is a bench and a barrel for a table. In *Winter Landscape with a Bird Trap*, the trap is just an old door with the hinges and latch still attached; an old door is also used as the tray on which two men carry the bowls of soup in *The Wedding Banquet*.

Elsewhere, in the *Census*, peasants are slaughtering a pig, and in *Hunters in the Snow* a fire is being prepared to smoke and preserve the family pig meat. The pig is the heraldic beast of field expediency. Semi-wild and fattened on acorns and mast, or on the rotting detritus of the farmyard, the pig has a thousand uses. Each bit is eaten, rendered, salted or smoked. A pig is bacon, a thousand varieties of sausage, blood pudding, pork chops, loins and belly, trotters and ham, joints for roasting, suckling; its abdominal fat is lard, its skin is parchment, or a pair of shoes, or a bag to hang from your belt. To slaughter a pig is to survive for months.

How else would you get through a winter?

*

I cannot slaughter a pig, I do not know how to render fat. But perhaps I have learnt one or two things over the years since I set off with a bag of powdered milk and a bottle of whisky. For instance, I know binoculars to be more useful than you might suppose, on a city break.

I carry a pair of binoculars because you occasionally need them for looking at a painting. Anna Keen used to walk around galleries and look at everything through an old pair of field glasses; she claimed it focused the mind, was a route to the abstraction of technical matters. I do not do this. I have no technical matters to address. But I will be passing through Würzburg and will pay my respects to Tiepolo's *Treppenhaus* ceiling, his frescoed representation of all the peoples of the world.

And then, on the walk from Winterthur station to 'Am Römerholz', the summer house (!) of industrialist Oskar Reinhart, where *The Adoration of the Magi in the Snow* hangs, my brother and I take what might be a wrong turning, up a flight of steps, to cut off a hairpin. Emerging at the top, we are momentarily unsure which way to go. There is a distant road sign, so I pull out the binoculars and read off *Sammlung Oskar Reinhart am Römerholz*; I feel pleased with myself, like Clint Eastwood or Richard Burton in *Where Eagles Dare*, but my brother laughs. Preparation is everything, he says; a rudimentary map and a pair of binoculars, it's all you need.

The flight of steps takes us past a white building built into the hillside. On the fence outside is written *Ergotherapie*. It occurs to me, as I fold up my binoculars, that this might be a sort of mental health clinic. Ergotism is a medical condition linked

to St Vitus's dance, with symptoms of convulsive spasms and psychosis, I recall for my brother's benefit; it was brought on by wheat mould, a mass poisoning, half of Europe gone mad in mouldy seasons and dancing to death.

There is much to be said about the Swiss and sanitaria, the attic of Europe, stuffed with secrets and sick relatives. Also about Vienna and its madhouses, Freud and Adler, manias and mental pathologies. Is this to be a trip along an axis of sickness, physical and pharmacological and psychological?

I later look up *Ergotherapie* and discover that it has nothing to do with ergotism. It means *occupational therapy*.

Occupational therapy. I haven't got so much to say about that.

The Bruegel *Adoration of the Magi in the Snow*, while small (at 1,929 cm², it is only a 0.396 per cent sliver of the Bruegel Object), is nevertheless a touch larger than I had imagined. Larry Silver, in his gigantic book, describes it as 'tiny'. Perhaps Larry Silver is himself a gigantic man who splinters chairs like toys when he sits on them and blows his nose on the newspaper, but the *Adoration* is not, to my eyes, 'tiny'. The Frick *Soldiers* is 'tiny'. The Bamberg *Pigsty*. The *Adoration* is an order of magnitude larger than either of these, almost exactly the same size as *Winter Landscape with a Bird Trap* which hangs very respectably in Brussels between the *Census* and *The Fall of the Rebel Angels*, both imposingly proportioned panels.

Not tiny, then. Let us call it, rather, approximative. It is a painting which, owing to its size (I concede), must approximate the detail it represents. If this were a painting by Chardin there would be one pear and a dead pheasant slumped over it; but here is a whole village and a cosmic drama unfolding, in

confirmation of which, at the vanishing point, where the street exits the town square, orthogonal to the viewer as in *The Census at Bethlehem*, there is a single cartwheel.

The painting was until recently dated 1567, after the great winter of 1564–5, but radiography of the almost illegible signature and date now places it in 1563. The great chill, for Bruegel, is not a historical event but a state of being.

In compensation, Bruegel's is a rapid, warming brush-stroke. A smudge and a couple of flicks animate a child, a conscious breathing creature paddling on the ice. There is an energy in the crowd which I had not noted in reproduction; there are interactions – the small girl on the sled appears to be heading stoutly for a hole in the ice; her mother is shouting a warning; a boy is play-acting firing an arrow at her; two other boys are testing the ice with a great log. The whole scene is flecked with falling snow, the flecks the last paint to be added to the panel, each fleck differently considered, a different shape, or size, a different shade of white.

Heading stoutly for a hole in the ice: *The Adoration of the Magi in the Snow*, (Pieter Brueghel the Younger, after Bruegel) detail.

*

I am fretful about how I am going to manage the Vienna experience. Will it simply obliterate this delicate small panel? I scan the Bruegel *Adoration* with extreme if not methodical care, for between twenty minutes and half an hour. I then come back to it on a loop from other paintings, rehearsing my reactions, still noting the odd new detail.

Later, on the train from Zurich to Frankfurt, I make some rough calculations. I have examined *The Adoration of the Magi in the Snow* at a rate of roughly 1.6 cm² per second. In Vienna there are twelve large panels, and, if I want to fit in an éclair in the café and glance at the Vermeer and the Correggio, I will have two hours for all of them, at a rate of 26.95 cm² per second. A furious pace.

I can see that I will have to embrace asymmetry. My brush with software engineering taught me that you do not generate worlds you cannot see. And my brain runs forgiving code. I miss things. I am distracted. I am not methodical. Quantification, after all, is only a scaffolding.

We take the train back to Zurich and find our hotel. We go to a concert at the Tonhalle and walk around the Zwingli church in the quiet of the evening and later eat fondue.

The next morning, early, we embark for Frankfurt, where we will meet Steve Barley, flying in from Rome. For the next four days, we will mostly move in international space: trains, stations, hotels, galleries and museums, escalators and lifts, restaurants, bars – places where everyone is welcome, or anyway invisible, if they have a little money. Like the child on the little sled, you glide along.

Years later, Steve Barley points out to me that the girl on the sled in the Winterthur *Adoration* is not rowing back towards the hole on the ice: she is pushing herself forwards, towards some branches.

He knows this, he says, because in the early 1990s, visiting China, he had sledded on the ice in a similar manner. He sends me a photograph. There he is, propelling himself glee-fully across a frozen Kunming Lake in Beijing towards a little daub of primary paint on the winter landscape, a Bruegelian child in a red coat and yellow hat – colours which would have been reversed, no doubt, in a copy by Pieter the Younger, as I have inadvertently reversed the direction of travel of the little girl in the *Adoration*. Error creeps in, in the retelling.

A Bruegelian child in a red coat and yellow hat: Steve Barley skating on Kunming Lake.

There are no Bruegels in Frankfurt, although there are some museums which we do go into – the Städel, the Liebieghaus.

In nearby Darmstadt there is one Bruegel, *The Magpie on the Gallows*. But they have shut the Darmstadt museum for a year; it is undergoing restoration.

It is a near-miss. I think of it as a pocket of resistance which I pass by on my Bruegel blitzkrieg. I can return later and mop it up.

Steve Barley and my brother and I take the train on to Würzburg, where my brother leaves us, heading back to Frankfurt and London. It is getting furiously cold now, across Europe. Barometric pressure is collapsing. Elements float free. The schedule loosens. Each train we catch is delayed, by a few minutes only, but delayed nonetheless, as though even Swiss–German railway efficiency were struggling to oil its points, to keep up steam in its boilers, to stay alive. Each stage of our journey is framed by a little fretfulness, a milling on cold platforms, a glancing at departure boards. But the trains come and we move on.

Nuremberg, our next stop, has sunk into a sub-cold realm. We leave our bags in a locker at the station, and walk, lifeless, across town. My photographic record breaks down at this point. Perhaps we were never here. I know that in the Lorenzkirche there is a towering Adam Kraft sandstone tabernacle, and a Veit Stoss crucifix hanging over the altar, the saviour's loincloth billowing and rippling in, we must

suppose, a hot spiritual wind. I have knowledge of these things. But any memory of the experience is lost to me.

As with the German National Museum. A great cold stone of a museum full of who knows what? Gilded saints, bronze water pitchers, limewood (Tilman Riemenschneider), illuminated manuscripts, dull and worthy paintings: many cold objects, to which I am unresponsive. Aesthetic response is grounded on a certain level of physical comfort. In this cold, we are stripped to scavenging animal hurt.

What is the meaning of temperature? Temperature is the average of the kinetic energy of each particle in a given thermal system. My body, for instance, as I stand in the Lorenzkirche, is at a higher state of average kinetic energy than the world that surrounds it – the Veit Stoss, the Adam Kraft, the pews, the stone, the cold and pious church air. Consequently, there will be a loss of thermal energy (from my perspective), or a dissipation of useful energy, into the world. The probable spread of thermal microstates of the church alters in my presence, albeit meaninglessly, undetectably. So do mine, very meaningfully, and very detectably. The church and I seek to equalize ourselves, to achieve the mutual bliss of thermodynamic equilibrium. To bring ourselves into a deathly but real alignment. I slow down, and the church, ever so slightly, speeds up.

It is the way of things. God's universe itself will ultimately settle on equilibrium, and it won't be much fun for anyone, God included. The oscillations of matter will still to nothing. As Bruegel knew. The cold world searches out your disequilibriums, and politely, remorselessly, addresses them. No surplus

is allowed, in the end. The higher our initial stock, the more quickly, dramatically, it drains. That childish skittering of sleds passes in time to the careworn slaughter of pigs, the trickle of pee in the snow, the increasingly intermittent, failing search for stimuli – ale, sex – culminating (is that the word?) in a peaceful, resigned equilibrium with the environment.

When I was a boy, my father used to tell us every year when it snowed to be wary of the physics and physiology of temperature. Posted to Canada during the war, he said that in conditions of extreme cold your fingers would stick to whatever you touched; on one notable occasion, he said, coming in from the negative 50 temperatures, he put his hands under hot running water and instantly fainted.

I don't know if it's a true story, but I pass it on to my own children, just in case.

At the other end of the thermal gradient of the war, posted to Ceylon, he found a snake coiled in his shower, and caught a malarial fever which recurred (he liked to think) every few years for the rest of his life.

Between the sweat and the shivers we live our lives.

In Munich, our hotel is just across from the train station. It is an old-fashioned fleapit. Steve Barley has asked for twin beds, but they only have a double. I stand and watch Steve protest to the receptionist that he and I can't share a bed. The receptionist dead-eyes him. Take it or leave it.

We take it. We throw our bags on to the bed and go out into the bitter dark in search of a beer cellar. The cellar is full

of Bayern Munich supporters. We sit at the end of a long table dominated by a knot of alpha-Bavarians, huge men slumped malignantly over their gallons of beers who seem barely to tolerate one another's presence, and who draw themselves up like walruses when Steve takes a pretzel from the communal pretzel basket, breaks off a piece, and replaces the fragment of pretzel. This, apparently, is unheard of, a great offence.

We know that Bruegel, in his illustration of pretzels (in, for example, *The Fight Between Carnival and Lent* or *Netherlandish Proverbs*), was careful to study their particularity, tracing the shape and form of knotting of the pretzel specific to a given locale (and indeed, as Joseph Koerner notes, modern historians owe much of their knowledge of local pretzel knots to Bruegel). Perhaps the care he took was not, in fact, evidence of his microscopic eye or his pebble-glassed fastidiousness about the ultra-structure of our world, but rather a ritual observance: he was taking care not to trouble the bile and ugly localism that disrespecting the pretzel can, evidently, stir. The pretzel, after all, is iconographically associated with conflict. Simon Schama points out (in *The Embarrassment of Riches*) that the root of its Dutch name, *krakeling* (cognate with our own *cracknel*), is *krakeel*, meaning *quarrel*, and there were children's games associated with pulling on the *krakeling*; children also wore them, in Germany and elsewhere, as charm bracelets (*bretzelen*) at Halloween, designed to ward off the Devil who might otherwise pick a quarrel over their little souls.

We are not so fastidious, nor do we wear appropriate amulets. In disrespecting the pretzel, we somehow let the Devil in, and are made to dance accordingly. One of the Bavarians, a savant, perhaps, of cult objects, religious magic,

or folk anthropology, picks up the remnant pretzel and hurls it back down the table accompanied by choice Bavarian words (such a small high voice for such a large man!) where it lands with a menacing dispersal of cutlery. There is a moment of mutual incomprehension, and our blood leaps up. What invisible norms have we transgressed? Perhaps we will never find out. Steve and I are neither small nor especially weedy, but these blubbery giants are on the point of tearing us into rough fatty pieces like the pork knuckles and joints that strew the table. To appease the god of pretzels.

One smaller and more forgiving Bavarian, who seems to be dining alone, speaks to us in good English. He is not interested in speaking to us, but he is interested in eating his bits of pig in peace, without pretzels flying around and trouble escalating. He speaks to the Bavarians in squeaky Bavarian. The malevolence of the table does not dissipate, but violence is held in check. We eat on miserably, decline the thought of a second (or third?) beer, and hurry back to our hotel, glancing over our shoulders.

The next morning, snow is falling. The plan is to go to Vienna today, a four-hour train ride, and the Munich gallery (two Bruegels) tomorrow morning, before an afternoon train and an evening flight back from Frankfurt.

It is cold, and I am not well. I have a rising fever. Thermal disequilibriums of the blood.

The closer we get to Vienna, the slower the train seems to go, the deeper the snow gets. There is a moment twenty minutes out of Rosenheim when we are stopped between fields and it is impossible to see where the snow-laden sky

and snow-clad fields join. The world is all snow. I can make out electricity pylons, and somewhere in that void a man or woman is walking a dog. They might as well be floating in the sky.

In my scant notes, it says that on the train I talked to Steve about the physicist and theorist of entropy, Ludwig Boltzmann, but then got in a tangle when I couldn't really explain what an ordered physical state was, let alone what followed from that. Perhaps I should just have stuck to biography, and its ordered facts.

In Vienna you can visit Boltzmann's gravestone, which has the equation for entropy (S) carved into it:

$$S = k. \log W$$

Entropy, says the equation, is proportional to the probability of a given state. Disorder in a given system is more probable than order. Hence all systems tend, as a matter of probability unfolding over time, to disorder.

What, then, is an ordered state? It will depend on the nature of the physical system under review, but in general, we can expect the atoms and molecules present in the physical system to display evidence of correlation or orientation or direction.

A thermal system will be ordered, I suppose, as it flows down gradients of disequilibrium. Does that make us, Steve and me, atomized in this motionless train, hanging here between the equal thermal hotspots of Munich and Vienna, disordered? I certainly sound disordered, although that might

be the fever. But Steve, in between patiently attending to my blather, is reading his book. For the most part, we carry our ordered states about with us, like the Devil in Paradise.

Both because he was its great theorist, and because he is now dead, Boltzmann understands more about entropy than I do. His gravestone confirms it.

According to Boltzmann, thermal systems become more disordered because there are innumerably more possible disordered states than ordered. Here and there short strings of coherence might appear – a sun, a Bruegel, a Boltzmann – but the order has no underlying meaning beyond the statistics of it, and the large, the very large, numbers at play.

The train gets moving before we have time to test Boltzmann's ideas in the fields of southern Germany. We arrive in Vienna. It is too cold to be walking to the museum, so we take the metro, only a couple of stops to Volkstheater, where we emerge on to the Museumstraße. It is Sunday, and everything is under 3 feet of fresh snow. Nothing moves except a handful of tourists, and us. We walk the 200 yards to the door of the museum – is it closed? It looks closed. No, we push at a door and it swings open.

This is the holy of holies, the tabernacle of Bruegel, so I ought to pause, really, on the threshold, to prepare myself. But how should I prepare myself? Mostly when I come to see my Bruegels I do not feel reverence, or joyful anticipation, or solemn resolution. I feel anxiety. I worry that there will be a fire alarm and the building will be evacuated before I have

checked off my panel. I worry that the panel will have been removed for restoration. I worry that I have come to the wrong museum. These are the thoughts that plague me. And the only way to purge them is to hurry things along, and place myself in front of the Bruegels, and breathe.

My approach, therefore, is not that of awe-stricken acolyte. I do not knee-tremble up the imposing marble stair. I merely stuff my bag and coat into a locker in the cloakroom and make directly and in a mild panic for the Bruegels.

Of which there are a round dozen. Twelve great Bruegels, drawn here, like the Bruegels in Madrid, by gravitational Habsburg power, the spoils of tyranny.

I know what is here, I have it all by heart. I take them in instantly, these moons of Jupiter, these apostles, this constellated zodiac: in a gulp of the eye, a swivel of the head – and then attempt, with methodical Galilean intent, to impose a little order of my own on the room.

I begin by pacing it out. It measures twenty-three and a half leisurely strides by fifteen. The wooden floor – parquet – squeaks and settles as you walk. It seems to be lightly sprung. Perhaps in my fever I have achieved a certain buoyancy, of limb and mind.

I make my round of the Bruegels in the following order:

1. *Hunters in the Snow*
2. *The Return of the Herd*
3. *The Dark Day*
4. *Children's Games*
5. *The Fight Between Carnival and Lent*
6. *The Village Kermis*
7. *The Wedding Banquet*

Those who know the room, and my angle of approach, will see that from my first entry I head over to the far corner, look at the so-called *Months* (*Hunters in the Snow*; *The Return of the Herd*; *The Dark Day*) in clockwise order, then pursue a retrograde course which breaks off in uncontrolled zigzags as this or that catches my eye. A loose particle among particles, with a given and an ever-changing average kinetic energy. But a heat map of my progress would read reddest in front of *Hunters in the Snow*.

How do hunters equip themselves for a winter journey? As follows:

Long wooden spears, whittled to a conical point; drawstring quarry bags; foot snares; puttees; furs; feathered caps; knives; and many scrawny dogs – I count fourteen, including one that is only a tail, and others that don't look as if they could hunt anything much.

From what are the hunters returning? From what impossible whiteness? If we were to turn around and look back down the tunnels of space through which they have passed, what would we see?

Of course, nothing. There is nothing behind them. They have come out of nowhere. In his *Ecclesiastical History of the English People*, the Venerable Bede relates how the pagan King

Edwin of Northumbria, visited by a Bishop Paulinus intent on converting him to Christianity, was sitting in council considering the new religion, and one of his elders illustrated the problem for him:

It is as if you and your great lords are sitting feasting in the great hall in wintertime; the fire is laid and the hall warmed, and it rains and snows and storms outside; a sparrow comes and flies rapidly through the hall; he comes in through one door and goes out at the other. While he is inside he is not touched by the winter's storm, but it is an eyeblink, the briefest interlude: from winter to winter he returns. Such too this human life appears, a mere interlude; what goes before and what comes after, we cannot know. Therefore, if this new teaching can bring us any greater clarity, then we should follow it.

What can the hunters tell us about the world beyond this village, this frozen landscape? No more than the sparrow. From winter to winter they return. Because both hunters and sparrow do not come from anywhere. Whatever little they are, however constrained village or great hall might be, they are nonetheless everything, captured in the blink of an eye.

Bruegel painted six panels for the Antwerp financier Nicolaes Jonghelinck in 1565, each representing two months and each depicting the works appropriate to that part of the season. They hung in Jonghelinck's country house, Ter Beken, on the outskirts of the city, probably in his dining room. But their owner rapidly found himself in financial trouble, and the

panels were confiscated in lieu of tax owed (and the house would be destroyed by the troops of Alessandro Farnese during the siege of Antwerp in 1585).

The panels were then presented by the City of Antwerp to Archduke Ernst of Austria on his ceremonial entry in 1594; they remained thereafter in Habsburg hands, in Prague and Vienna; by 1659 an inventory shows that one had already been lost (April/May).

Of the five that remain, one (*The Harvesters*) hangs in New York, one (*The Hay Harvest*) is in Prague.

Three are in Vienna – the cold seasons, the winter Bruegels. Here, in Vienna, you settle into a chilly corner, ask cold questions. What are those hunters wearing on their feet, in that snow? Are those plane trees or sycamores the peasants are pollarding with cold hands? What are we to make of a Shrovetide shipwreck?

Steve Barley notes the strong planar organization of *Hunters in the Snow*. It might almost be a tapestry, he says. He has a point. A tapestry is a textured, non-reflective object which does not create the illusion of recession in depth so strongly as a painting in oils can. Everything in a tapestry, particularly in the medieval Flemish tradition, is clearly gathered on the woven surface. So too in the Bruegel: for all the devices pulling our eye in – the line of trees, the frozen waterways, the declension of snow-capped roofs – the organization is as much by quadrant as by receding plane. The elements are stacked one on the other: proximate element overlies distant element (a perched rear-foreground bird is the same size as a bird trap just next to it in the middle ground; near-foreground brambles overlie near-

Same size as a bird trap: *Hunters in the Snow*, detail.

middle-ground trees and buildings); ice and sky are an identical tonality (as so often in winter Bruegel), as though the sky were frozen or the ice were a diaphanous region.

It is the same in *The Dark Day* (February/March), where foreground peasants poll willows, gather sycamore branches, repair plaster, and eat Shrovetide waffles, all against the horizons of the wide world, or in *The Return of the Herd* (October/November) where brindled cow, herdsmen and hunters are all funnelled towards the concealed village. In each case they do so within such a narrow band of luminosity and earthy tonality that you must situate yourself precisely in front of them, with barely an inch or two of tolerance, if you are both to make out detail and develop or retain a feel for scope. Such a fragile depth of field flattens vistas.

But if this is what they are, these seasons – tapestries of the cold months, made to keep out the draughts of mortality by dwelling on cycles, continuity – all three also vent chill worlds, of gallows and solitary peering cow eyes, of bagless hunters

and cold careening ships, of naked trees and distant rocks, of dead foxes and attenuated magpies. Their inhabitants may eat the odd waffle, find time to make their children paper Shrovetide crowns, play curling or pull infants on sleds and skate in line, but only because circumstances demand that they be physiologically inured, where we would just throw on a jumper or stay indoors.

In 1906, at the age of sixty-two, while on holiday with his wife and daughter in Duino, near Trieste, Ludwig Boltzmann committed suicide.

While his wife and daughter were swimming, he took a short cord from 'a crossbar of a window casement' and hanged himself. His fifteen-year-old daughter, Elsa, found the body.

Is suicide conceived in heat or cold? Boltzmann had been due to return to his lecturing post in Vienna the following day, but his mental equilibrium had been under siege for some time, in fact since around 1888 when his eldest son, Ludwig, had died at the age of eleven of undiagnosed appendicitis, a fact which Boltzmann seems to have carried as a weight of guilt. He was growing steadily more myopic, so much so that his wife would read papers to him so that his eyes might be saved; he had no formal pension, and worried constantly that if he could not work his family would starve. Increasingly through the 1890s he suffered from bad headaches and angina; he also endured repeated severe asthma attacks.

Between 1900 and 1902 Boltzmann underwent treatment for mental disorders which we would probably recognize as depression, and had attempted suicide already once before. In

1905 the dean of his faculty had reported that Boltzmann was unable to pursue research, owing to neurasthenia; in that year Boltzmann committed himself to an asylum, although he was as rapidly discharged. On his last lecture tour to the USA in 1905, colleagues noted with dismay or distaste his increasingly manic episodes.

A few months before his death, Boltzmann confided his suffering to a friend, saying, 'I could never have imagined such an end were possible.' A lifetime pondering the scientific and philosophical basis of irreversibility, the dissipation of all order, seems not to have prepared him. How could it? The end comes always as a surprise – not least in this case to Boltzmann's daughter, who until her death in 1966 refused to talk of the experience of finding her father suspended there between worlds.

For eighteen months after his death, all lectures in theoretical physics in Vienna were cancelled as the academic city grieved.

Today Boltzmann would most likely have been diagnosed with late-onset bipolar disorder. He had long shown an awareness of his propensity to mood swings. He used to joke that it was because he had been born on the cusp of Shrove Tuesday and Ash Wednesday.

Let us imagine him lingering, therefore, on the creaky floor of the Kunsthistorisches Museum (although in these early years of its existence, perhaps it did not creak so much) before Bruegel's *Fight Between Carnival and Lent*. What does he see? A swirl of atomic humanity, gaseous molecules in a box with an average kinetic energy perhaps higher than in other paintings, other times of the year (there are nearly two hundred

figures depicted in the panel), weakly organized around a left–right axis across which mummery representatives of Carnival and Lent do battle.

Or do they? To be sure, there are two converging processions, one coming from the direction of the church, the other from the inn (called the Blue Barge), and they are about to clash; but the rival armies have already dissipated across the panel. And they approach one another in what can only be ultra-slow motion, a ritual combat, a slothful dream-fight, the floats they ride on freighted with symbolism, Lent's tiny wheels, Carnival's sled-barrel steed. Will they ever engage? Can they? Are they not mutually opposed across some singularity of physics, a threshold of state-change?

Boltzmann knows that this is not actual Lent, actual Carnival; it is a play-acting of Lent and Carnival. Everything is costumed, enacted. What appear at first glance to be Boschian monsters are, on closer inspection, masked revellers; some of the townsfolk are putting on a play (*The Dirty Bride*); elsewhere, a group of beggars similar to that in the Paris *Beggars* panel is preparing to get up a performance of its own. Everywhere, children play. And what is the Mass, after all, if not a ritual designed to ward off death or thoughts of death?

And in the midst of the great collision of revelry and parody, a genteel couple strolls the length of the faultline.

Their path is crossed by a little jester individual, carrying a torch. His costume is split down the middle, half red, half blue-and-white horizontal stripes, as though an embodiment of cusp-existence, moving easily from one side of the panel to the other.

What sort of humour is Boltzmann in today? It is, perhaps, a joyless enough panel. The masks worn by the carnival

Embodiment of cusp-existence: *The Fight Between Carnival and Lent*, detail.

revellers are ghoulish, conveying horror and sadness; faces are bleak and expressionless; Lent offers not discipline but frigidity, some dry-looking pretzels like the one the big Bavarian threw at Steve (and had we in fact offended some Lenten observation? – we were there the week before carnival).

But then, if you are feeling a little manic, on an upward trajectory, you might enjoy the children at their games (spinning tops, playing knucklebones), the women preparing Lenten fish, the pig eating excrement, the wastrel on a barrel being cheered on by a group of excited children while someone pours a bucket of water on his head.

And, if it is weakly organized, it is nonetheless unavoidably organized. Bruegel clumps and groups his figures so loosely

you almost cannot see it. But there is a shape in all this flux of bodies. A gradient. Lent and Carnival will not worst one another with those weapons. They will play off in mock and magical battle. The efforts of the year will be renewed. Clean your windows, gut your fish, enjoy your small beer. Pursue your small pleasures and economies. Until the fall of the knucklebones alerts you that your time has come.

In the sixteenth century there was a violent upswing in recorded suicides. This may have been partly a side effect of the expanding bureaucracy of the age, but there are other possibilities. Some have suggested that the Reformation opened paths to spiritual introspection which were never going to lead anywhere very good. To philosophize, to theologize, is to let yourself be led over the edgelands of melancholia. Speculate on the intricacies of entropy and thermal death at your peril.

Suicide in the Renaissance had its classical and biblical antecedents. There were those like John Donne who argued in private that suicide was in some instances akin to martyrdom, the body seeking dissolution in God. How else should we read representations of Lucretia, self-slaughtering? In a Rembrandt version of the next century, which hangs in Washington, she seems to be exploding in scintillations of heavenly light at the touch of her dagger.

And then there is Saul. There are two Sauls in this room in Vienna: the New Testament Saul who is converted to St Paul on the road to Damascus, and the Old Testament Saul driven to suicide by the Lord for his failure sufficiently to smite the Amalekites after an earlier victory.

The latter is a small panel (33 x 55 centimetres), tucked on this visit just inside the door, at right angles to the immense jumble of *Christ Carrying the Cross*. Saul has just lost the battle of Gilboa to the Philistines, and is falling awkwardly but effectively on his sword, alongside his armour-bearer who is doing the same, to avoid being taken or killed by the enemy soldiers climbing up towards him.

Below him there are impossible myriad armies waving tiny and numberless lances, a mockery of the stout forests higher up the valley; the lances are organized, like iron filings, around a line of engagement, where the last Israelite resistance is playing out.

Awkwardly but effectively: *The Suicide of Saul*, detail.

Bruegel seems to have taken inspiration for the composition from late medieval miniatures, where Saul's suicide was a popular subject. Miniature landscapes and miniature battles, a miniature king running his sword through his miniature neck. One among many possible and wholly interchangeable microstates of humanity.

Saul does not have much choice regarding the time and place of his suicide. The first soldier is just creeping up on to his ledge. Do it now or be thwarted in the attempt.

The same may or may not have been true of Boltzmann. He may have selected a particular window with a particular view of a particular sea. He may have filled his gaze with images of his bathing family as he raptured himself away. Probably not. There are as many ways of committing suicide as there are ways of doing anything – intently, fumbling, absent-mindedly, in terror, in love, with indifference, with a funny taste in the mouth, with a fear of interruption, a desire of interruption; with a final flash of insight, a sudden idea, a recognition, an understanding, a relief. Or perhaps none of those. Chemicals flood the brain in endless new combinations. This is a new landscape.

Saul, if he turned his head, if he could turn his head, with that sword sticking through it, would look out over the unlimited world. Bruegel has placed him atop one of his cosmic landscapes: forests, mountains, a great river valley, the broad river across which the army of the Israelites retreats, a distant Jerusalem on the horizon where a sun may be setting or a city burning.

All Bruegel is rooted in the tension between the miniaturist

observation of detail and the expanse of open landscape. You raise your eyes – not here in the Netherlands where there is nothing much to see – but the eyes of imagination, or memory, or interior vision. Whatever happens, happens in a landscape. Peasants dance, in a landscape. We can go in close, stand with our nose to the panel and trace the blotches on their skin, the coarse stitching of their wool and leather clothes, the splinters on their clogs. But to live is to live in landscapes, to move between horizons. You can always lift your head.

Dante places Saul in Purgatory, among the ranks of the proud. Paraphrasing David's lament over Saul (how the mighty are fallen!), he dwells on the place of Saul's ending: on Gilboa, he says, which never thereafter felt rain or dew.

Purgatory, for Dante, is a place. When you die, you go to a place. You move through it. Eternity is an unfolding of horizons and landscapes, of endlessly mobile and evolving contexts.

Boltzmann, perhaps, guessed otherwise. Eternity is a dead and non-interactive emptiness. A thermal death. The horizons of eternity contract in suicide to a sweaty knotting of window-casement cords, a final finessing of the material world.

I leave the room, glancing at the *Saul* perhaps, and wander around the museum. Steve and I meet in the café for a preposterous coffee – mine has some orange liqueur in it and a great dollop of whipped cream on top. Welcome to Vienna.

There are other paintings in the museum, and I spend some time looking at those. I circulate back by way of the Bruegels, several times. In the end, our two or three hours are enough.

On the train back from Vienna my fever takes full control. I doze, am restless. At one point, half an hour out from Munich, Steve bashes his bag on the table and wakes me. I open my eyes. He says, 'We're nearly there.' We are not nearly there. I conclude I have been snoring loudly. Snuffling. Groaning. He is waking me from embarrassment.

It is only a few yards from the station to the hotel where Steve has to share my sickbed. Steve wants to get Chinese food from a takeaway, but I am shivering so violently that I just head up to the room. By the time he gets back with his noodles I am in bed. Shivering. Steve has drawn the short straw. I would rather be ill than spend time with someone who is ill.

In the Alte Pinakothek in Munich, half a mile down the road from our hotel, hang *The Land of Cockaigne* and *Head of an Old Woman*, but I will not be visiting the museum. Not this year. I am too ill. I lie writhed in bed sheets while Steve first gets me some breakfast which I do not eat, and some pills which I do; then negotiates with the receptionist to let me check out an hour late, then goes off to the museum and leaves me to pass the morning in a paralysis of fever.

All my thermal gradients are gone haywire. Our train is at half past twelve. I must check out by twelve. At eleven I get up and sit on the side of the bed for twenty minutes, thinking about a shower. I do not shower. I get dressed, a sock at a time. It takes me twenty minutes, groaning. I cram what I can see into the Samsonite and pull on my shoes. Another twenty minutes, sitting on the edge of the bed. At midday, I somehow propel myself downstairs and sit on a rococo chair in the lobby of the fleapit, head swimming. I am sweating.

Outside it is lightly snowing.

From the hotel to the station is a walk of three minutes, crossing tram-tracks and roads and a swarming taxi rank. I may also be walking in some viscous liquid, for all I know. Ahead of me is a three-hour train journey, some fiddling about with transits in Frankfurt, and a flight back to Stansted, from there to Cambridge. I may as well be proposing to myself to bicycle across the steppes of Central Asia.

Steve meets me in the station, and we find our train, our seats. I will spend the next few hours slumped across the little triangular table which separates us. But before I slump, Steve briefly tells me about his visit to the museum. He has seen the Bruegels. I have not.

And now he produces a gift. He has bought me a postcard, of a detail of *The Land of Cockaigne*: an egg. Between the

Witless toing and froing: *The Land of Cockaigne*, detail.

snoring clerk and the peasant with his threshers, there is a small egg, with legs, running around. His top has been knocked off, and a pocket knife is balanced in him. Someone, it seems, had been about to eat the egg (with a knife?), perhaps before collapsing in a stupor, and now the egg is making his escape, or simply offering himself around. This, after all, is the land of Cockaigne, where food and other delights are available on demand. No one currently demands the egg.

I take it (not at the time, but later) for a token of the project. I prop it on my desk as an emblem of my own witless toing and froing over the map of Europe. I am a blind egg on legs, my addled yolk slopping out, trying to discover a purpose in the midst of mute objects, all the time cooling, losing heat, kinetic energy, direction.

It will be more than a year before I pick up the threads of the project again.

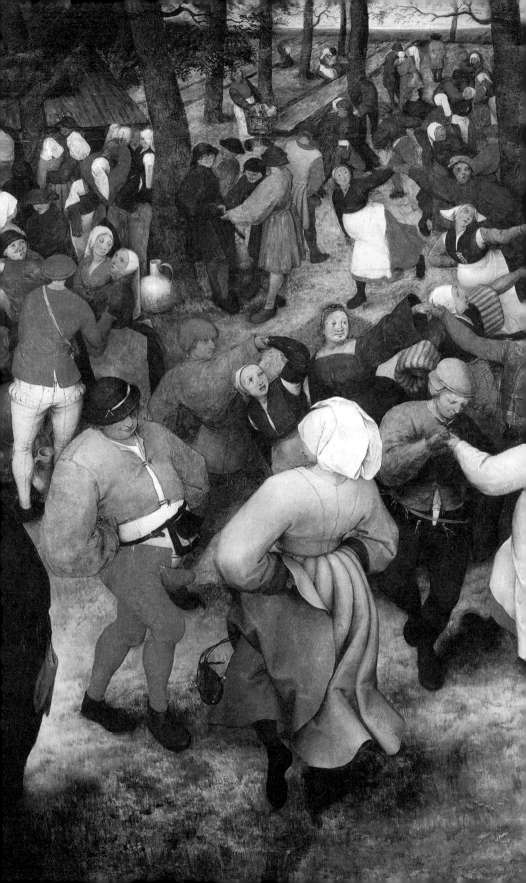

VIII Bear

USA (9.467%)

'Rigor of beauty is the quest. But how will you find
beauty when it is locked in the mind past all
remonstrance?'

William Carlos Williams, *Paterson*, Book 1

When you sleep in certain forests in the USA, the park rangers
give you a bear canister to carry. It is for your protection. The
canister is an air-tight black barrel made of smooth and
toughened plastic, roughly 20 inches high and 8 in diameter.
Empty, the standard-issue canister weighs over 3 pounds. But
it is never empty. Inside it you put whatever is odorous or
malodorous – in our case, bacon, cheese, a pound of stewing
beef, an onion, toothpaste, deodorant, and other salves and
lotions and medicaments – so as not to attract bears to your
camp. And since space is at a premium, you cram in whatever
else you can, stow it in your pedlar's pack as efficiently as
possible. It becomes a large, dense, weighty object. Black.
Slippery. An encumbrance. A wearying lifesaver.

In the foreground of the Vienna *Christ Carrying the Cross*, a pedlar sits with his pack still on, watching the carnival crowd walk up to the place of skulls. He is resting a moment. His pack is an analogue of the cross which Christ, near-invisible in the crowded middle ground, carries: the pedlar's life-burden, his penance, his whole world is packed into or strapped on to the contraption on his back, a wooden half-barrel with a hinged lid slung from the shoulders by means of leather straps.

The pedlar's life-burden: *Christ Carrying the Cross*, detail.

Life-burden, or perhaps just a pack. You wouldn't call peddling a quest, exactly. Nomadic, peripatetic, itinerant perhaps; or feckless, idle, excluded. But a quest? No. The pedlar moves from place to place, each place both briefly sustaining him and propelling him onward. A quest does not invoke place: it is played out over open space. It requires a landscape.

My brother and I are driving down the west coast of the USA, cutting through its cosmic landscapes, its great forests and estuaries and ancient coasts, in search of my current grail object: the earliest, most distant Bruegel: the *Parable of the Sower*, which hangs in San Diego.

Right now, we are on a side-quest, walking in Olympic National Park in the extreme north-west of the continental forty-eight of the USA, in Washington State, carrying a bear canister about. It has a number – 394 – painted freehand in large devilish red numerals on the side.

We plan to camp out for a couple of nights: the first on the beach just north of the Ozette River where the virgin forest with its ancient pines and its bears and its damp prolific undergrowth of glistening ferns comes down to the sea; and the second a few miles up the Hoh Valley, a temperate rainforest so wet it has its own species of slug. Stand still long enough and floating spores, epiphytic plants, will root on you.

I enjoy the little rituals of pitching my tent in wild places. Each night, we unpack our miniature travelling theatre of survival: make shelter, make fire, make food.

On our backs, we carry everything we need to survive a night or two. Tent, sleeping bag, water. Spoon. We have a blue enamelled saucepan we bought in Port Angeles when we

stopped for gas canisters and fresh food. I don't think we strap it to the outside of our packs, but I don't remember.

And there is the bear canister. On the first two days, on the walk into and out of Ozette beach, I stuff it in my pack; but it will not sit easily. It rides at the top, oblique and heavy, pulling at the shoulder straps, straining the muscles of my neck. Going into the Hoh Valley, I decide to carry the canister in front of me. I have seen other people on the trail doing this, and it feels natural, a counterweight to the pack on your back.

It is, to begin with, an acceptable compromise. But the canister gets a little slippery in the rain, and after an hour or two you find yourself shifting its weight from one arm to the other in search of relief, perhaps stooping a little forward under its weight. It gradually starts to occupy more and more

You hate it more and more: bear canister, Hoh Valley.

of your attention. You hate it more and more. At one point, on the way out of the Hoh Valley in the pouring rain, wet to the skin, we set the canister down and photograph it. The black plastic glistens. No. 394.

We have not seen any bears. Has the canister warded them off? Or have we been caught in a play-act, a mimicry of danger and wildness, an imitation of the forest?

Pieter Bruegel may or may not have seen bears in the wild. He certainly drew them, playful on the fringe of woods, on the brink of cosmic landscapes. There is a drawing in the British Museum from 1554 and another, discovered in Prague in the 1960s, also dated 1554, rather badly damaged. In the former, which remained in the possession of Jan Brueghel after Bruegel's death, seven bears play-fight and dig and grub in the dirt in a forest clearing; in the latter, there are only five bears, but they too lead a convivial forest life.

In the sixteenth century, did they know less about bears and their habits, or more? We can be certain they did not fool around with bear canisters. Perhaps those humans who met bears in the forest did so prepared in other ways – with forest craft and know-how and technology.

More humans enter bear territory in our latter days, hikers in bright colours, with Colgate smiles and beef jerky falling out of their pockets. Civilizations – of humans, of bears – clash now in new ways; we shake the bears from the forest and are required to ward them off with bells and sprays. And canisters.

*

The Prague drawing was the subject of a print by Hieronymus Cock. In the print, the landscape – an obscure *repoussoir* bit of forest giving on to a river view with a small church and distant port, the whole dominated by the twisted trunk of one great tree – is reversed. And the bears have been replaced by the figures of Christ and the Devil, the latter dressed as a hermit, wearing a sort of tree-hat; he might be a Boschian genius of the forest, expressed from the sedimented weight of playful bears: he is in any case (and unlike Christ) *of* the forest, not merely *in* it.

Bruegel provided the raw matter of the drawing; Cock, with his commercial eye, supplied the religious motif, licking those prodigies of incomprehensible nature into a little narrative of salvation. Christ, dogged by the Devil, may be leading us out of the forest, but Bruegel's bears are quite happy there, untempted, unjudged. Unextinct.

Bears are prone to extinction, big lumbering beasts, like kings and cardinals and industrialists. The little people pick them off, sooner or later, with their snares and spears and keen minds.

The first humans to stretch their legs over the cosmic American landscapes met with new challenges of megafauna, a Boschian zoology: Giant ground sloths. Sabre-toothed cats. Mastodons. Before long the diabolical humans were picking their teeth and throwing bones the size of telegraph poles over their shoulders. They grew fat. They moved on, littering the plains with carcasses.

Or not. There are competing theories. Early humans were foragers and scavengers, says one, not hunters. There was no call to hunt impossible animals when so many lay dead or

dying on the plain, pushed to extinction not by human agency but by climate change. Early humans, according to this reading, moved over an endless steppe of rotting strange beasts, dead creatures punctuating unknowable quests. What sort of place was this to which they had come, where great animals died around them as though by divine ordinance?

When Albrecht Dürer was on his tour of the Netherlands in 1520–21, he was most poetically struck by the products he saw of the New World – ornamental suns and moons (the sun 'wide a whole fathom'), weapons, armour, marvellous shields, implements of gold and silver, strange garments, bedspreads, 'and all sorts of wondrous things for many uses, much more beautiful to behold than miracles' – which were brought to Charles V after his triumphal entry into Antwerp. 'In all my life,' said Dürer, 'I have seen nothing which has gladdened my heart so much as these things. For I have seen therein the wonders of art and have marvelled at the subtle ingenuity of people in distant lands.'

The products of the New World were one subcategory in the cabinets of curiosity. Tine Luk Meganck has chronicled the growth of interest in such collections from the mid-sixteenth century, and their relation to Bruegel's painting *The Fall of the Rebel Angels*. Bruegel's friend Abraham Ortelius, for example, was just such a collector. 'He was especially fond of things that nature had made in a particularly artful way, such as exotic seashells, colored marble, or tortoiseshells that were so small or so large that they seemed to have been made by human hands. He also collected antique coins and medals, artefacts made "in the Indies" (a term encompassing America

as well as Asia), and modern works of art, among which the best known was Bruegel's grisaille painting of the *Dormition of the Virgin*.'

That Bruegel himself should end up an exhibit in a collection of *artificialia* and *naturalia* (and Ortelius in his posthumous tribute to Bruegel clarified that Bruegel's pictures 'I would not really call *artificiosae*, but rather natural') is ironic, perhaps, but the visual language of these great collections had already spilled over into the print and visual culture of the age. Encyclopaedic descriptions of everything – flora, fauna, *artificialia* – abounded, and Antwerp, centre of printing and world trade, was at the heart of it.

In particular, Meganck notes that in *The Fall of the Rebel Angels*, Bruegel drew on fauna and *artificialia* from the Americas. One devil wears armour derived from the shell of the armadillo; elsewhere, a creature that is perhaps a sloth is hanging in space (or perhaps just in free fall); a blowfish is puffing itself up in response to a threatening angel; and a near-nude devil wears an Amerindian headdress of parrot feathers.

The discovery of the Americas had thrown open a door on an overflowing repository of God's creation, for better or worse. Perhaps rummaging through the great storeroom, collectors might hope to find sufficient alphabet to read off the deep order of the cosmos, the created world. Or perhaps – given that the Americas did not know revelation, were pagan, cannibalistic, magical – they might stir up devils.

We pitch our tents by the mouth of the little Ozette River, and build a fire on the beach, and make our beef stew. We have a beer; and we have a small plastic bottle of Jim Beam.

It is a pleasant night, down here on the beach, on the uttermost edge of the Forests of the World.

During the night, I wake and go for a pee against a tree, reminding myself that bears also sleep. But, by that logic, they also get up to go for a pee.

The following morning, we are trapped in our bay by the tide. We must wait a couple of hours before we can round the headland and return to our car. It is raining lightly. We shelter in a half-cave on the foreshore, little more than an overhang, which turns out to be a place of interest for small brown hummingbirds: they periodically dart in, hover, and dart out. Seals pop up their heads from the ocean and inspect us. There we sit on the deserted coast, plagued by hummingbirds, inspected by seals, warding off bears, a pair of unsociable hominids.

Bruegel and the museums seem a long way off.

Before we arrive on the West Coast, I have already ticked off the three Bruegels which hang in the east: *The Wedding Dance* (1566) in Detroit, and in New York *The Harvesters* (1565) in the Metropolitan Museum of Art and the tiny *Three Soldiers* (1568) in the Frick Collection.

This is to be a complex, time-pressured trip, in which I must cover seven cities with several thousand miles of driving, and four internal flights. On the East Coast the logic of my sensitive timetable bases me in Baltimore, from where I fly to Detroit before heading up to meet my brother in New York.

Of all the cities I ghost through, Detroit sees me at my most phantasmal. My first impulse is always away from people. But as it happens, I do chat with the taxi driver in Detroit. He

wants to talk about the economy in England, as he calls it; I tell him something (what? I have no memory, no idea; what do I know about the 'English' economy? Always just a little bit shit, I vaguely suppose), then I ask tentatively about the economy in Detroit, which I know to be epically shit, and he becomes defensive, and tells me it is somewhat improved relative to several years ago. Then as we approach the gallery (which is in Midtown) he apologizes for the seediness of the neighbourhood, pointing out this or that disgrace (from memory, a dilapidated building, a burnt-out vehicle, some homeless people, but I could very well be constructing something plausible), so that by the time he drops me it feels as though I have landed on a safe island in a sea of incalculable woe. I do not exit the gallery at any point, except to hail a taxi for the return journey.

Detroit, for me, is a peculiar echoing art gallery, an airport, and a couple of taxi rides.

And a single Bruegel, of all Bruegels one of the most convivial. It is a large panel, a *Wedding Dance*. One hundred and twenty-five guests dance to the bagpipes in the greenwood. The dancers are at once organized and set loose by the music. It is a great social press.

Unlike the gallery, which is very large (658,000 square feet), and, on the day I visit, very quiet. And such visitors as there are do not evenly disperse: every so often I encounter school parties of local children come to see what their city could once afford to buy; but they are rapidly absorbed into the immensity, or encouraged back out into the Detroit sunlight, leaving me to tread its strange spaces in silence.

It wasn't always thus. Detroit in the first half of the twentieth century was one of the great modern economic powers in the world, and it built a museum to reflect both that modernity and that power. The Detroit Institute of Arts has its own entry in the 1927 *Encyclopaedia Britannica*. It was, when it was built, a model gallery, exhibiting objects by period, not by medium, and the architecture reflects that. There are Romanesque rooms which have piers and arched ceilings; medieval rooms, Renaissance rooms. There is a great cycle of murals commissioned from Diego Rivera showing the Detroit proletariat at work. There is William Randolph Hearst's armour collection.

Perhaps it is busier at the weekends.

I Skype my family. It is hard to get a signal. Someone in the café volunteers that it is a bit stronger in the Romanesque galleries, but it is not as strong as all that. My family cannot see me, but I can see them: they are blocky, jerky, laggy; they loom and make strange noises. I bellow platitudes in the echoing hall. I might be telephoning from the eleventh century, down some portal.

At some point in the morning I get my bearings in the Allan Shelden III Gallery – eleven or so paces across, roughly square, wood-panelled like Cardinal Wolsey's study – and settle to view *The Wedding Dance*.

Here is the whole world assembled, for a small-village inhabitant: all the trades, all the relatives, all the known and nameable people.

It appears a mayhem of bodies but is not. It is a loosely but strongly organized geometry of arms and couples, a play of

aggressive codpieces and concealing headscarves, an orderly bacchanalia. A whole village dancing.

Dancing is not the only form of social interaction going on: villagers are engaged in conversation, in drinking, in kissing; a woman to the rear is holding her small child up for the inspection of an older man; one woman to the left has raised an earthenware jug aloft and is glugging down ale; another has her arm around a friend's waist; a man is urinating against a tree (a different sort of communion); another seems to have a woman in what is either an embrace or a headlock, whether grappling her towards the dance or engaged in something more brutal is not clear.

A few figures merely stand and observe: two benign burgher types to the left and right, for instance, and more curious still, the solitary figure towards the top of the painting, near the turf-cut benches and tables, with his back to the company. He stands there like one of Plato's philosophers emerged from his cave and inspecting reality in the manner most habitual and comfortable to him: at a distance, sensing the presence of a sunlit social world.

There are other figures with their backs turned to the dance, but none quite so distinctly separate. The main axis of the painting runs from the viewer – standing no doubt in similarly contemplative mode – through the weave of the dance to the isolated man. He is an iteration of the viewer. He views something after all, even if it is only the sixteenth-century-countryside equivalent of the cave wall – vanishing birds, fields, trees, perhaps the distant steeple of the next village.

His detachment is anomalous. The social world is our reality, whether we participate or observe at any given moment.

Inspecting reality in the manner most habitual and comfortable to him: *The Wedding Dance*, detail.

We are social creatures, we hunt in groups (bears, mastodons, brides, husbands), we survive together or not at all. But the social world is also the place where we fight for supremacy, battle our peers in mock-fight, courtship dance, codpiece wars. We are all dragged into the dance sooner or later: there we go along with everyone else, skittering around, bumping into people, uncomfortable, enveloped in the warm smell of manure and beer and breath; all elbows and clod-feet. You push your way to the heart of the group with your great codpiece swinging, and there you brace yourself, cudgelling peasant, not to be dislodged. Your whole existence is played

out within the ring of firelight; beyond, there are only dark forests, predatory bears. Exile and death.

A few – artists, introverts, melancholy souls – wander the outermost edge of the rim of firelight, distant satellites of the tribe, looking out to the darkness beyond. It is the darkness which makes the fire remarkable, after all.

At some stage in the life of the painting, the codpieces were painted over (the painting was 'discovered' in 1930 by the director of the Detroit Institute of Arts, William Valentiner, hanging neglected and in need of restoration in a back hall in an English country house). Someone had perhaps recognized, and could not abide, the violence at the heart of this dance. Marco Antonio Altieri, writing at the beginning of the sixteenth century of Florentine wedding customs, likens all weddings to the rape of the Sabine women. In Florence, the groom's party, coming to collect the bride, were as a *brigata* (Altieri's term) descending on her house; in some circumstances there were tableaux acted out of forced entry to the house, and submission. The return of the groom and bride to the groom's house would be attended by riot and drunken carnival, with missiles thrown at the wedding party, and feint attacks, as though trying to liberate the bride.

And we know it from our own experience: marriage is gravitational, drawing people in, keeping them in formal orbit; but a wedding is a wild release, Lapiths and Centaurs drunkenly going at it. Marriage provides children, apportions land, stabilizes the social structure. But the threshold to marriage, the wedding, is walked by spirits of Falstaffian unrule.

On the extreme right foreground, half-concealed in the shadows of the trees, hard to see, hard to read, there is a curious-sinister dark presence, a man, we must suppose, although he has the bearing of a forest-spirit, staring directly out of the panel at us. Impossible to make anything of this, or of the jolt of surprise which accompanies his discovery (or rediscovery in my case, my memory of detail not being exhaustive). Here is a woodland creature, peering not in at the social world which seems to have drawn him here, but out at us, the solitary viewer standing alone among the wood panels of the Allan Shelden III Gallery. He recognizes us for what we are because he too is an outlander. He does not belong. He is not welcome. Visit the peasant wedding in disguise, if you must visit at all, and if you don't want a cudgelling.

Once I have seen the Bruegel and wandered the galleries a little, I take a taxi back to the airport – no conversation this time – eager to be reunited with my stuff in a hotel room in Baltimore. Detroit has been an unreal dalliance, and equally unreal is the flight, an awestruck hour gliding down over the East Coast as the sun sets over the western horizon and the lights of six million souls come twinkling on in the blue deeps of Maryland. My peasant heart dances at the pretty sight; my bourgeois mind settles into the zone of unstable melancholy, diaphanously suspended between flaming sky and the pinpricked dark valleys and woods below.

I am back in my hotel room by midnight, drinking decaffeinated coffee, depleted, revived, and on schedule.

*

From Baltimore the next morning I take the train to Washington where I drop my rucksack in left luggage and set out wheeling my black Samsonite, a bag slung over my shoulder, heading down Constitution Avenue to the National Gallery.

Washington is warm and muggy, and the streets are big and the buildings bigger, in a *Welthauptstadt* sort of way. These are buildings not of commerce, as in New York or Baltimore, nor of industry, as in Chicago and Detroit, but of bureaucracy. Great impenetrable stone edifices lining streets which make you feel managed and small. Congress is a towering ziggurat at the end of the street, twice the size of St Peter's in Rome. And the National Gallery of Art is a cavernous compendium, with a collection of European art which seems to fill every gap and cranny of my knowledge. I Skype my absent family, again unsatisfactorily on the slow Wi-Fi, and we shout and scream at one another in an attempt to make some sort of meaningful contact. The experience leaves me slightly exhausted, and sorrowful, a sorrow I carry around my whistle-stop tour of the museum. When I am done peering into rooms of great art, I trundle my stupid Samsonite off in search of the White House which, when I finally find it, I am pleased to see is more modest, of different stone, than the rest of the city.

I do not love Washington and shake the dust from my heels as I leave it. There is no Bruegel here.

I am booked on the early-evening train to New York. As I approach the city, my phone, and with it my brother, splutters into life. He flew in this afternoon and is at our hotel, on Seventh Avenue. I am to take such and such a subway from Penn Station, change at Times Square, then a couple more

stops. It is ten o'clock on a Wednesday evening, and I stand bewildered in the crowds, trying to read non-existent signs. I get on a train at a venture, and it happens to be the right one. In ten minutes, I am walking up to the hotel. My brother is standing outside. We dump my bags, then go for a beer across the street. Two beers.

In 1944 my father was operated on in Toronto for an appendicitis under local anaesthetic. He said it was unpleasant, but there was an attractive nurse mopping his brow while they rummaged in his belly, so he bore up. He then had a period of sick leave while he recuperated, so he took himself by train to New York.

New York in 1944 must have been exciting for a young man who liked jazz and played a bit of jazz piano. He told us much later in life that he had missed his calling and should have been a jazz musician, but he said it to my mother's mingled fury and mockery, and didn't really get a chance to develop the idea. Whatever the reason, from New York he had no stories he was willing to share. Perhaps he just wandered around apologetic and bewildered, agog at the sight of a vertical city, an outsider with a pain in his side.

I have been to New York before, have walked its Manhattan streets and ridden its giddy elevators and delved its subways. I am by now only slightly agog at the sight of a vertical city, but grin anyway like a peasant bringing turnips to Antwerp. At the door to the Metropolitan Museum, I expose my yokel soul. The woman at the till asks me what donation I would

like to make. They recommend twenty-five dollars. I offer one dollar. She takes my dollar and gives me a little badge and asks where I am from. I tell her London and she says, 'Huh, city of free museums.'

The Met is a world city of its own specification, copious and bewildering; to open a towering door is to look in on a distant Greek temple or a Georgian villa, reconstructed in its entirety, a thousand people skirting it and looking at it and circling it. Are they lost? Close the door again, leave them to their confused business, this is not what we are here for.

After much wandering, we find the picture galleries and the Bruegel they have here, *The Harvesters*.

Peasants are reaping corn. It is a hot season. Summer slows you down, and the peasants alternately work and slumber, eat and drink, labour with scythe or stoop over lines of cut wheat, assembling them into bipedal ricks, nature animated. One woman as she bends to gather an armful of straw might in turn be a rick herself, a peasant de-animated.

These peasants are not serfs: they are hired labour. Availability of capital in the economically developed west and north of Europe allowed peasant labourers a modicum of freedom; lingering labour shortages kept their value relatively high. No one is going to whip you to work in the hot sun if you choose to sleep off a little beer and cheese under a pear tree.

They are, nevertheless, wedded to the land, to their locale. There will be no migrating over blue horizons for these peasants, not yet; although in time their descendants speaking glottal languages and driven by discord and want will make their way over precisely those horizons, to this place where I stand now, this America.

How does the work-weary peasant refresh his body and soul? For one thing, you can eat bread and cheese and pears and drink beer at lunchtime, and sleep it off afterwards in the sun; if you are prudent, you will place your great jugs of beer in the shade of the corn itself, a bit of know-how easing you around the jagged corners of work and life.

And there are games to be enjoyed. Down there in the middle ground, to the right of the huge trundling haywain, some individuals have stripped off and are swimming in a

A bit of know-how: *The Harvesters*, detail.

square pond. And to the right again, in front of the bridge leading to the village, a few of their fellows are whiling the hours and entertaining the children with a round of cock-throwing.

The rules of cock-throwing are simple enough: set up your cock or other bird (a popinjay?) either suspended from the crook of a stick or on some elevated place, and throw prepared sticks called, in England, coksteles, in Flemish, I do not know, at the bird until it dies. If you break its legs before the game is over, the bird can be stood up with splint or propped in an earthenware jar.

That I am aware, no prizes were awarded, beyond the general gift of an absurd and suffering animal, but Thomas More professed himself to be very able with a cokstele when he was a boy, so perhaps there was a certain prestige in judging the trajectory of a throwing club as it rotated around its displaced centre of mass.

Much later, in 1751, William Hogarth would include cock-throwing in the first stage of his four-stage *Descent into Cruelty*, a series credited with sparking a decline in the popularity of the sport in England.

Cock-throwing was one variant of the great theatre of suffering which kept the sixteenth century amused. As such, it vied with bear- and bull-baiting, cock-fighting, and the sequence of Senecan tragedies that was about to take hold over the sea in England, where the new theatres would line up on Bankside in Southwark alongside the Bear Garden or Bear Pit. Theatres and bear pits were laid out on a similar round or polygonal plan, so much so that when a stand at one of the bear pits on the South Bank collapsed in 1583 leading to the death of seven spectators, the theatres were quick to

shore up their own structures. The bear-baiting entertainments were on a grand scale, with music and dancing and firework displays; one account given by a German visitor in 1584 notes that at one point someone started to throw white bread into the crowd, sending the hungry groundlings scrambling, in much the same way as I have seen people scramble for hot dogs fired into the crowd at baseball games.

The most popular Elizabethan bears were given names: there was old blind Harry Hunks who was whipped until the blood ran down his back, mightily amusing the spectators; then there was George Stone, and Ned Whiting; and most remembered of them all, Sackerson, who made it on to a different sort of stage when Shakespeare wrote his fame into *The Merry Wives of Windsor*:

SLENDER: Why do your dogs bark so? Be there bears
 i'th'town?
ANNE: I think there are, sir. I heard them talked of.
SLENDER: I love the sport well – but I shall as soon quarrel
 at it as any man in England. You are afraid if you see the
 bear loose, are you not?
ANNE: Ay indeed, sir.
SLENDER: That's meat and drink to me, now. I have seen
 Sackerson loose twenty times, and have taken him by the
 chain. But I warrant you, the women have so cried and
 shrieked at it that it passed. But women, indeed, cannot
 abide 'em. They are very ill-favoured, rough things.

To tie up a bear and bait it was to contend, in mummery, with natural forces: out of the forest the bear comes, representative and champion of his world, and is engaged in ritual

fight. Until around the end of the thirteenth century, Michel Pastoureau writes in his cultural history of the bear, the bear was accorded totemic powers: they were said to sire monstrous children on female humans, bear-men who would go on to found royal lines; and if they were not heroic, then they were demonic, diabolical familiars of the forest.

By the sixteenth century, however, the bear had been displaced as image of majesty by the lion and the eagle, and as devilish spirit by the owl and the lizard. It was no longer accorded ancestral power. The bear slouched into town, fool of the forest, and took up its lodging in the bear-baiting pit. Marginal, declawed, melancholic, it had begun its long shambolic Lear-like descent into absurdity.

But a king remains a king, even on the heath, and to bait a bear was to turn the world upside down: those crowds might as well have been pelting a dancing James I with manure.

Out of such contention, such play, between the social and the natural a culture is formed, and preserved; but a culture, we are reminded, is but a bubble on the surface of the raging torrent of time. Bruegel's peasants are always on some wild edge, and might at any moment be pulled back in. They drowse and sleep in the warm sun surrounded by the fruits of their labour; but if they drink all the wine or beer in those earthenware jars they might before long fight too, break bones with cudgels, beat their wives and their children, submit to the urgent prompting of the bear in their soul.

'[Bears] are manifestly intelligent, and display very
human-like bodily and facial expressions, even
weeping when upset. Their sitting position resembles

that of a man, and so does their capacity to stand
erect on their hind legs. Almost without exception,
observers have noted the remarkably human form
and proportions of the bear's carcass after it has been
skinned, lending credence to the idea that the animal
is really a man in disguise.'

Tim Ingold, *The Appropriation of Nature*

We live in a world of overlapping worlds. Martin Heidegger,
building on the work of the German biologist Jakob von
Uexküll, would have called them *Umwelten*, surrounding
worlds. Each animal, each person, each culture has its way of
understanding the world, a particular splash or sample of
variegated sense data. Its *Umwelt*. A burrowing worm will
live in a world of temperature and moisture gradients, will be
alive to the variable resistance of soil; a bear will live in a
world of forest smells and strong seasonality; a painter will
see primary pigments mixed in colour, will see – will perhaps
powerfully feel – the way a woman stooping to scoop up an
armful of cut corn rhymes with the stack of corn itself. The
corn in the woman's *Umwelt*, the corn in the painter's, the
corn in ours, is in each case different corn.

There are those – for instance, the Catholic theologian,
Josef Pieper – who would take issue with Heidegger, who
would argue that we can, through some rational process,
remove ourselves from our allotted *Umwelt* into a higher
region, a *Welt*, or world, where bear-baiting, to take an exam-
ple, would be outlawed and moral reasoning universal. But
then Catholics have their own *Umwelt*, of which this is but a
fragment. There is a town in Cheshire – Congleton – which

according to folk legend sold its bible to buy a new bear. We all of us have our itches to scratch.

It may be that we do not live in a *Welt* of universals but there can be, nonetheless, a transfer and an exchange. If I stroke a cat, what the cat understands, and what I understand, might be largely incommensurate, but there is nevertheless a transfer of something: something non-identical, yet interchangeable. There is a coin and an economy in the world. A bartering between man and bear.

And perhaps that is how we should see a painting: as an interface, a medium of exchange, between one mode of understanding and another. Bruegel and I stand in a market, jangling our coin, eyeing one another's wares in good-natured competition. If we are sufficiently temperate and broad-minded, we will strike a good bargain, at a fair price, and each go home happy.

It is a short walk from the Met to the Frick, one we punctuate with a sloppy hot dog eaten on the steps of the museum and a coffee in a diner.

The Frick is pricey, with a sense of its own exclusivity. I cannot offer them a dollar. It is the house of a rich man.

Bruegel's *Three Soldiers* is tiny. It is hung in a corner of a small room against green flock wallpaper. The room is six paces by seven; or was it seven by eight? It is impossible to make notes since my brother tells me someone he knows was bawled out for doing just that.

The Frick acquired the painting in 1965; it had been held in English private collections, and notably in the Royal Collection, since probably before 1625. It is listed in the inventory of Charles I, as follows:

> A Peece of three Swittz little entire figures, being
> an Auntient, A drummer, and a ffluter done by old Peter
> Brewgill given by Mr Endimion Porter, in blacke and white.

Old Peter Brewgill. We must have been pronouncing his name *Brewgill* in England for centuries. People still ask me if I'm keeping up with the Brewgill. *Broigl*, I snap. It's *Broi-gl* – an /oi/ diphthong and the dark /l/, not so hard for an English speaker. Brewgill indeed. 'Brewgill' is all front-of-the-mouth, all lips and teeth; 'Broigl' is dark, back, palatal; say it too fast and you might swallow your tongue. *Broigl, Broi–gl*. A name to savour, an umami of a name. No tongue-tip cream and sugar here. *Broigl the Elder.*

Later, however, I learn that *Brewgill* might be a bit closer to the Flemish than *Broigl*. There's no hard *g* in Flemish, for one thing, so the *g* is more of a back-of-the-palate, phlegmy rasp; and the *oi* is more of an *oeu* (or some such impossible diphthong), with a Frenchified rounding of the lip; and the *r* is rolled around the tongue a number of times.

And the last bit, especially, means that I have to give up on pronouncing it with any sort of authenticity – I even struggle to say my own name, *Ferris*, without burring the *r* (I was tongue-tied for the first two or three years of my life; I was tested for deafness and general mental incapacity by, I must suppose, incapable medical professionals, until one day when I was crying my father noticed how oddly my tongue cleaved to the floor of my mouth; my earliest memory is coming around after the anaesthetic, aged barely three, in the clinic where – snip, snip – they restored my power of speech. My brother visited me, I remember, wearing one of my father's ties).

So in the end we are only going to locate our man in phonemic space by an approximate spattering of mouthparts: a best-guess, accounting for historical drift and local variation, as to how he might have pronounced the name himself.

Old Peter Brewgill, in short, will do.

The three Frick soldiers are outsiders. *Landsknechte* were German mercenary soldiers usually in the employ of the Holy Roman Emperor or the King of Spain. In times of peace they dispersed over Europe, where, exempted from sumptuary laws, they gathered a colourful Gypsy reputation. Gypsy, nomad, *Landsknecht*, all bring a hint of something strange, something other; all might at any moment turn on the settlement, pillage the farm, steal the close-husbanded sheep.

Colourful then, but old Peter Brewgill has painted them in grisaille: in this case, a palette of cream and rust.

The two musicians, one playing a fife, one banging on a great drum, were painted into spaces over the white ground, and are more luminous in consequence. Their posture implies but does not quite lock into a rotational symmetry, as though they are caught swaying into a step of the dance, great lumbering bears. Behind them, painted not over the white ground but over the black background, is a standard-bearer raising his colourless flag. The fife, drum and standard are the regimental soul, there to rouse the dancing bear in the meek and social heart of man.

The Frick soldiers, like the beggars in Paris, are depicted in a sort of non-space. Outsiders, itinerants, they belong to no landscape.

My brother and I, two days later, are also suspended between worlds as we wait for tides to change, at a point of balance between the *Umwelten* of bear and seal and humming-bird, their separate spheres of possession. My brother and I are not of the landscape; we are merely in it. And so it goes on, down the coasts of Washington, Oregon, California, this skimming between worlds, across surfaces. Not of the land-scape, merely in it.

America, with its staffage, its theatrics, its landscapes, might very well be a Bruegel painting. It is John the Baptist preach-ing, Mary and Joseph fleeing, fleets sinking, forests girdling, armies like civilizations clashing and falling; the great whirl of the heavens and the seasons, time and space, all depicted here.

In Healdsburg, California, I abandon my brother. We almost come to blows, and I leave him sitting alone in a park, and drive off.

We are tired. We have been driving for many hours and have several still to drive. We have stopped in Healdsburg for a burger. Healdsburg is a pleasant town just to the south of the Dry Creek Valley, in wine country. Raymond Burr, the actor who played Perry Mason and Ironside, had a vineyard here. He also cultivated orchids.

We each get a beer with our burger, and I broach the idea of stopping here for the night and getting an early start. I take a few sips of beer. My brother is firm. We must push on.

He is right, but if we are to drive, I should not drink any more of this beer. It is refreshing, cold, dark, honey-coloured craft beer. There is condensation on the outside of the glass. Cold alcohol on an empty stomach after a long drive. Life

could be so good. But no, my cold and delicious beer is snatched from in front of me. I watch my brother drink it. And my mood rapidly sours.

We walk back to the car. And sitting in the stationary white sedan, my brother gathers some aggression on his two beers and tells me I must be a nightmare for my family to live with, what with my passive-aggressive sulks and unspoken angers.

I go a bit berserk. Not so passive. I shriek a little bit. Hammer the steering wheel. Actually, I don't remember. But I do remember that I yell at him to get out. *Get out of the fucking car.* I have clenched my fists, and wave them at him as a manifest of my exasperation. He tells me I am deranged and slams the door on me. Not a moment too soon. I would have done such things.

I reverse in my childlike and very adult fury into what might for all I know be a stream of traffic, get lucky and hit nothing, and roar off in a cloud of dust (in my furious imaginings), leaving my brother to enjoy the evening, the rest of his life perhaps, alone in America, there on a bench.

The inverse of a quest, after all, is a flight. *Homo, fuge!*

'When a man encounters a resistance to the fires of self-infatuation he becomes quarrelsome and disturbed.'
Flemish devotional manual, quoted in Joseph Koerner, *Bosch and Bruegel*

Much later, in Vienna, I will have a chance to look at some of the engravings taken from a series of drawings Bruegel

made on the seven deadly sins sometime around 1557. Among them, *Wrath*, or *Ira*. On the drawing, Bruegel has scrawled a little text. It reads: 'Anger makes the mouth swell, and embitters the nerves; it disturbs the spirit, and blackens the blood.'

It is a dense composition: the allegorical figure of Ira, knife in mouth, arm in sling, crosses a landscape of battles and fights and flaming towers, not unlike that of *Dulle Griet* in Antwerp; there are whips and swords, naked cudgellings, one individual is roasted on a spit, a tormented frog or toad is biting its own arm. And, sure enough, at the bottom of the composition, a bear with a collar is nibbling the leg of a naked man.

What motivates us to do what we do? The drivers of sex and social ambition and power and love and protectiveness and whatever else coalesce in a black interior of chemicals and psychic sumps; what will emerge, where will it next vent, with what power and force? Rustle the branches of the forest where they overhang adjacent and neatly husbanded fields, and bears will stir.

Every journey has a recto and a verso: there and back, quest and flight. They are not opposites. In escaping contexts, we can look for enlightenment; in seeking enlightenment, we alter contexts. Galahad not only sought the grail: he left the court behind, with its schemes and its betrayals. Clarity is hard to find in the torrent of social life.

In seeking out, one by one, the scattered fragments of my talismanic All-of-Bruegel, I routinely leave my family behind. I wave at them down murky tunnels of photons and binary data, but I am manifestly *elsewhere*.

For some men, perhaps, fatherhood is an amplification of power. Children, grandchildren, are an annex to the theatre of life. The family is a kinship group, a tribe. If I go to battle, says the father, we will be many.

For others, fatherhood is a surrender. The father sires his children, and slowly drifts to the margins of everyone's life, his own included. My father would from time to time, deep in his whisky, try to assert his own dissatisfactions. He would be shouted down by my mother and mocked by us, his children. Thrust out again to the margins of our lives, saggy old bear, where he belonged.

This is where Bruegel occupies himself. Out on the margins of the world. And when I walk in strange forests or plan new trips to cities existing to me only in name, it might be that I am summoning the Don Quixote in my soul: telling myself stories of relevance and centrality. Out here, right now, thumping the steering wheel, I am in the centre of something. A quest.

It may in fact be the case that I am difficult to live with. A hibernating bear.

There he sits, then, my brother, in the little park where I have left him to meditate on the accidental precision of his words, while I roar free and alone over the plains and highways of America, lost in rituals of abandonment and flight.

Recto and verso: quest and flight. But both entail return. Normal life, let us call it, reasserts itself. The bear has by now returned from the bear pit to the forest; the rain-soaked hikers have returned from the forest to the pleasant little town with the burgers and the beer on tap. We each return

to the world which begat us. My fatherhood is not only an alienation but a readmittance, an acceptance into a social role, one animated by love and active duty, one familiar from childhood.

In reality, I only drive a hundred yards up the road. At the first opportunity I turn the car around and return to the town square. My brother is still on his bench. He doesn't see me. I honk the horn. There is some final posturing (*Are you going to hit me? Just get in the fucking car*), and we drive off. We have opened some fissures and peered in. This is fun.

One way to take your dead father's place is to have children of your own. Any anthropologist will tell you that, in having children, you kill yourself, and simultaneously carry out a ritual sacrifice of your father, and an Abrahamic sacrifice of your own youth. And all that without noticing. A youth may quest, but a father can only fly, or seek to return.

Which is to say, it is past time I was going home.

But there is one picture still to see, and two days of heroic driving take us to San Diego, shimmering silver desert city by the ocean. To find, at the earliest point of the Bruegel spreadsheet, a youth out sowing.

If Detroit is a city of dust, a demotic, demonic city, then San Diego is a fiction, a shiver of discrete images: Balboa Park with its chaos of architectural styles, representational beaches, glass skyscrapers, highways. I have been there, and yet I most assuredly haven't. A city of 1,300,000 people, reduced to a few blurry mental snapshots. Does anyone really live down

there, in that obscure corner of my mind? I know they do, and yet I find it hard to credit. There were workmen labouring on the bridge, in their orange coats and hard hats. They were chipping at the cement, drilling channels and smearing hot tar around, as though demonstrating for me the solidity of the place. They refuted me *thus*. And yet. I threw out the remains of our trail food in a bin near the car. Peanut butter. A loaf of white sliced bread. Beef frankfurters. Bacon. Last memory of the bear canister, emptied now, on a shelf back in the ranger station in Port Angeles, or assuring other wide-eyed travellers of protection.

We walked over to the Timken. The Timken is a tiny museum, just six rooms. The Bruegel is hung on pale salmon-coloured wallpaper. *Landscape with the Parable of the Sower.*

What does the San Diego sower sow, unknowing, over the surface of his little hundred? Dragon's teeth? The teeth of giant sloth and mastadon and smilodon? Away across the centuries of art history, great megafauna of art will spring up, peasants dancing, or reaping the harvest laid down here. He knows nothing of that, little Johnny Appleseed.

We have traced Bruegel up to his painterly origins. Perhaps. Manfred Sellink sees the attribution as tentative, problematic. There is a signature, but it is hard to read or verify. The quality is variable. Let us call it a confusion of youth.

The sower drifts across the foreground of a cosmic landscape. Behind him the fields fall away to some cottages, woods, a great river disappearing into the sea, a port city, mountains, ethereal skies and horizons. Over his shoulder and in front of him are naturalistic trees and tree stumps and brambles. He sows, we might conjecture, from a dream world to a real one, the seed sown in solitude, in isolation, by the

Little Johnny Appleseed: *Landscape with the Parable of the Sower*, detail.

lonely boy up on the hill dreaming of blue horizons, reaped
in some future by great brawny men and their capable wives.

We are an archaeologizing civilization. We dig for truth,
acquisitive of the relics which tell stories of our own barbarism,
the sack of cities, the slaughter of mastodons. Bruegel's
peasants by contrast live up on the surface of the world, locked
into everlasting cycles. Echoes of parables and proverbs once in
a while emerge out of the warm earth, not in abstract stories,
but in the consonance of their own actions, the play of their
own limbs, with actions taken long before. They ghost over
meaning, unseeing, but connected. They are fully alive.

My brother and I have one further stop to make. Two nights in Los Angeles. We visit the Getty, and the Walt Disney Concert Hall. I have a photograph of me standing on some street with the Hollywood sign up in the background.

And in the middle of our final morning, we drive over to a sporting goods store, and I buy presents for my small children: an LA Galaxy football shirt, and a USA football shirt. They will be too big for my smallest son. But it doesn't matter. My children don't yet know much about Bruegel, but they already belong to a wider world of symbols, emblems, flags: the culture is steadily claiming them for its own.

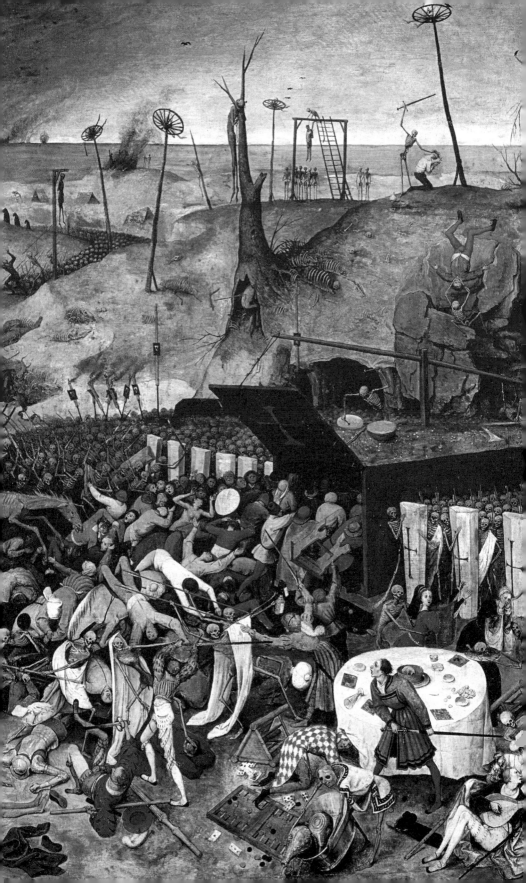

IX Technique

Naples and Madrid (16.398%)

'The Bushmen, who walk immense distances across the
Kalahari, have no idea of the soul's survival in another
world. "When we die, we die," they say. "The wind
blows away our footprints, and that is the end of us."'

Bruce Chatwin, *The Songlines*

At the end of July 1787 the French naval officer and explorer
Jean-François de Galaup, Comte de La Pérouse, anchored his
two ships, *L'Astrolabe* and *La Boussole*, off the coast of Sakhalin
Island in the Sea of Okhotsk and had himself rowed ashore.
Over the next two days, gifts were bestowed on the wary Ainu
villagers, studies made, and observations taken on both sides.

Keen to know whether this parcel of land was an island or
a peninsula, La Pérouse solicited the help of a local elder, who
drew him a very adequate map in the sand on the beach,
showing how the straits between the island and the mainland
narrowed at the point where the Amur River entered the sea,
but that it was in fact an island. La Pérouse was surprised that

this primitive's grasp of the science of geography was so good, and even more surprised when, the tide coming in and the map being endangered, a younger Ainu man, seeing the difficulty, took a pen and La Pérouse's notebook and made a fair copy of it.

More gifts were given and measurements taken, and the French expedition departed in a flurry of waving arms, gesture, sign language. Off they went, in the direction of the Amur River.

For the philosopher Bruno Latour, the only substantial difference between the maps drawn by the inhabitants of Sakhalin Island and those of La Pérouse is that, for the former, the maps, no matter how accurate, may as well be drawn in the sand. Maps for the Ainu are like spoken words: they convey information and are then erased. They can draw many more as occasion demands, just as they can repeat themselves in conversation. Knowledge of the world is not a permanent and perfectible structure, but an effective know-how. Knowledge helps you find your way.

But La Pérouse's use for maps is rather different. Such maps and other records as he makes on his three-year tour of the Pacific will be returned to France and published. They can then be referenced, revised, compared to other maps. And so they will come to form part of a connected, distributed and impersonal object: the encyclopaedic Western structure of knowledge.

In themselves, La Pérouse's maps are no more immutable than the map drawn in the sand. They are equally subject to errors in transmission. And that Western body of knowledge

will itself evolve over time. But they have, nonetheless, achieved a degree of persistence unthinkable to the Ainu elder.

Pieter Bruegel mostly painted oil on wooden panel, a combination of materials considered antique in his own day. But he also painted a number of works (how many, we have no idea) using a technique known as *Tüchlein*: glue-size or distemper on linen canvas. *Tüchlein* was relatively quick and cheap, and the colours associated with it were bold. It was often used for banners in processions, and for less illustrious works. It has an exceptionally poor survival rate. Paintings drawn in the sand.

All of the extant spreadsheet Bruegels painted in *Tüchlein* are held in collections in the warm South: two in Naples (one watercolour and the other tempera) and one in Madrid. Bruegel is known to have painted more, but, apart from the Brussels *Adoration of the Magi*, a highly doubtful attribution and not on my spreadsheet, none in the cold damp North has survived.

In 1558, when his painting career was just beginning – when his world of substances and properties would have been as much of ink as of paint – Bruegel produced a design for an engraving of an alchemist. The alchemist sits at his workbench fussing with his concoctions and distillates, his crucibles and residua; he is assisted by a fool who is stoking the fire, and surrounded by his destitute family (one of his children, a satirist, is sitting in a cupboard with an empty pot on his head). In the background the whole family, suitably transformed, is being led to the workhouse.

The alchemist is motivated by hunger both for gold and for fame. To operate on the base metals of the world, he intuits, is to take up the Ovidian challenge of the cosmos. Metamorphosis is true meaning. Little piles of pigments and bolts of canvas, a dead rabbit, a controlling intellect, by themselves mean nothing. But what can we make of them?

Metamorphosis, after all, is already a form of preservation.

Each painter has his or her techniques. We know that Bruegel used his fingers and thumbs to smudge still-tacky paint; we know that he reversed his brush and scraped with the pointed end to bring texture to fabric; we know that he altered his preparatory underdrawing in his finished painting (in some cases with dramatic flourish: the bird trap in *Winter Landscape with a Bird Trap* was not in the underdrawing, but was added to the final composition); we know that he favoured a quick wrist, fast brushstrokes, thin layers, bold economy. He would have used brushes of subtly differentiated qualities and dimensions, made from the fur of subtly differentiated small animals (squirrel, marten, polecat, ermine, sable) bound into quills of appropriate dimensions (goose, vulture, hen, dove), and he would have owned coarser brushes made of hog-hair, used for applying the ground and *imprimatura*.

Everything was at his fingertips, endlessly varied, studied, improvised, tried out. The estate of the Croatian miniaturist, Giulio Clovio, whom Bruegel befriended in Rome, lists a lost Bruegel gouache *View of Lyon*, as well as a gouache of a tree, a *Tower of Babel* painted on ivory, and a miniature painted in part by Clovio and in part by Bruegel.

Different mediums, different supports, different approaches. The career of the artist is an endless experimentation, experimentation which contributes to the life, if not directly to the material survival, of the works.

Technique mediates the world. What you do as a matter of technical address – painter, accountant, stonemason, writer, engineer – delimits your world, wholly or in part. How else to explain the trauma of what we call 'retirement'? If we are no longer socially relevant, it is because we no longer engage, tame, subdue or exploit the world on behalf of the tribe. The world slips through our inactive fingers. The antechamber to death is a taking off of hands. The elderly ghost through the world, frictionless.

My father, when he retired, understood this. In desperation, he had furnished himself with painting materials. He knew he would need a hobby. But after a few pointless daubs, he laid up his brushes for ever. He was not incapable, but he had no technique, no history of looking at the world like this. He saw his hobby for what it was: an ersatz engagement, a baby's rattle. So, in fuddled protest, he sat and smoked and drank whisky and rapidly sickened.

Bruegel's early artistic endeavours, like La Pérouse's maps, were portable, immutable objects: landscapes engraved and printed and distributed throughout Europe from the hub of European printing, Antwerp. The great Antwerp print houses – the Plantin Press, The Sign of the Four Winds – occupied themselves not only with standardizing and

distributing printed texts (classical, didactic, theological, etc.) but also with exploring, as a commercial venture, new areas of knowledge. You can visit the original printworks of the Plantin Press today, and peer in at its racks upon racks of sets of cast type in Hebrew, Greek and Syriac; the press also published staved music, and maps, and illustrated volumes of *naturalia* (botanical works) and *artificialia* (coins, medals, etc.).

It is in the midst of this highly literate print culture that Bruegel emerges. And since at the outset he was producing drawings as the basis for engravings, he was accustomed to finding his images treated like *emblemata* (of which Antwerp was Europe's leading publisher), adumbrated by epigraph and quotation and proverb. Little wonder then if the images themselves take a turn towards the verbal, incorporating rhyme, pun, proverb.

As in *The Misanthrope*, for example. The misanthrope is assailed by a small and indigent figure trapped inside a World Globe (probably best understood simply as the thievish world itself) who preys upon the unworldly man. He, the misanthrope, is all nose, no eyes, cowled like a Benedictine, but mendicant (mendicants wore hooded capes rather than cowls, and some – observant Franciscans, notably – took pride in the degradation of the fabric), concealing power, vulnerability.

The little thief has crept up in his wake and is relieving him of the burden of his purse.

The purse is in the shape of a heart. Why? We are encouraged by the painting to speculate. To read. This is, for the moment, an intellectual, not an aesthetic or emotional experience, although there are emotions to be had in reading puzzles, emotions of frustration or delight. The misanthrope, then, is concealing a heart-shaped purse. Not so unworldly as

Relieving him of the burden of his purse: *The Misanthrope*, detail.

he seems. You can try to remove yourself from the world, walk out to its margins, contemplate a flight disguised as a quest; but you will forever be attached to it by the strings of your heart.

Or perhaps we should remember that the heart was the emblem of the Familists. The Family of Love was a clandestine brotherhood. To its adherents, the implication would

have been clear: to remove yourself from troubled society is to remove yourself from the interconnected networks of love, to lose that which is of greatest value to you.

And there is an inscription, perhaps not in Bruegel's but a later hand. It reads: *Om dat de werelt is soe ongetru, daer om gha ic in den ru*. To an English reader, this itself reads like a breakable code. The *werelt* (world) is so *ongetru* (untrue) that I go about in *ru*. Ru? In one translation, I read *mourning*; in another I read *rue*; our misanthrope is rueful, then, or mournful.

The painting is round. Bruegel reserved the round form for single or paired figures (or, in the case of *The Drunkard Pushed into the Pigsty*, a small group of figures) made available for moral commentary. Bruegel's early illustrations of the proverbs are roundels; roundels are medallions, by nature emblematic. Larry Silver notes the resemblance between a roundel painting and the slightly convex bull's-eye mirror you might see in, for example, Van Eyck's *Arnolfini Wedding*, whose shape embraces a whole world (or an 'encompassing vision', as Silver has it).

Silver also notes in this context that Bosch's *Wayfarer* in Rotterdam (hanging in the same room as *The Tower of Babel*) is also a roundel, mounted on an octagonal board. Bosch's pedlar, like the misanthrope, makes his solitary journey through the world, troubled in his case not by cutpurses (not for the moment, anyway) but by a small dog.

In 'Fine Knacks for Ladies', an anonymous poem set to music by John Dowland towards the end of the sixteenth century, a pedlar asserts the value, not of his wares (*pins, points, laces and gloves – cheap choice brave and new*), but of his heart as represented in those wares. His knick-knacks are small plain emblems of affection, quick, throwaway, and, on the face of it, contrasting with a more grounded sincerity

(*though all my wares be trash, the heart is true*). It is in many ways a puzzling poem and remains so even when it dawns on us that his song is one of the *knacks* of which he speaks, cheap (words are cheap), but pointing to a true heart. *My trifles come as treasures from my mind.*

And what is it that Dowland's singing pedlar wants, in the end? Isn't this just a song of seduction, from a man who comes from afar and disappears over the horizon? What man speaks true, or plain, in pursuit of casual sex? There is a levity to the verse which belies its emphasis on truth: truth itself, or anyway sincerity, set in a song, becomes a gewgaw, a bauble, fit to bedazzle *a country fair.*

We have drifted a long way from the misanthrope, perhaps. But perhaps not. To detach yourself from the world, after all, is to make a show, to the world or to yourself, of your own sincerity.

And the misanthrope did not make the painting. Pieter Bruegel did. Pieter Bruegel, lover of puzzles, painter of gewgaws with a light touch, a seductive brush. Dowland's pedlar may be adept at the casual encounter, but at heart he is a melancholy wanderer. So too the misanthrope; so too the artist. Each has adopted an approach to life: a technique of light engagement.

Is misanthropy in fact a pathology? We are a social animal, and we cluster around the fires of society for warmth, but in so clustering we also jostle and riot and steal and kill; we seek advantage and manipulate; we consume by the gallon and the metric tonne, and generate great streams of waste; we grow drunk and fat, petty and small-eyed; we find no answers and

live by no code; we splay and we loll; we chatter and parade and preen; we grow bored and seek stimulation; and we judge and condemn. And we belch and we fart. And feel pretty good about ourselves.

Contemplation of our own species very naturally provokes a scorn of vice, smallness, corruption, stupidity, indolence. An artist, a professional close observer of his or her fellow humans and their works, will tend inevitably, if not wholly, toward bitterness.

No wholesale reform is possible, even if renewed attempts might be desirable. Whatever rigours of social control you impose, whatever programmes of liberty and social justice you dream up, will only generate their opposite: corruption, licentiousness, dissolution; hatred, impatience, intolerance.

If you are clear-sighted, you are left with a choice: walk to the margins and there nurse your own damaged soul; or accept the terms of the contest and pitch into the impossible fight.

'Och och ick woen onder die doorne!'
('Oh oh I live among thorns!')
Proverbia Communia, Delft

The misanthrope and the cutpurse are not the only ones out here on the edge of the world. There is a shepherd, a practitioner of domestic husbandry; he serves a social purpose, is woven into the edgelands of society, a relic of the nomad who comes into town only infrequently, whether to barter or to pillage.

But the shepherd is nevertheless loosely attached. Unlike the misanthrope. The misanthrope makes himself vulnerable, to ridicule in the first instance, to robbery, assault or death in

the second. The shepherd looks on as the misanthrope is deprived of his purse. According to legend, Timon, a misanthrope of Athens, fell out of a tree and broke his leg, and so loath was he to have contact of any sort with his fellow man that he refused all help and died lying there.

Bruegel would have known this legend. Timon was, to the Netherlandish humanists of the sixteenth century, proverbial, known through printing and translation of Lucian, for example, but also through the works of Erasmus. According to Margaret Sullivan, it is highly likely that Bruegel was illustrating, not just any generic misanthrope, but Timon in person, in a proverbial roundel. Bruegel, artist, knew that there are degrees of engagement, disengagement. Survival, on all sorts of levels, is a joint endeavour. In isolating ourselves, we dehumanize ourselves. We remove ourselves not only from the foolishness of the world, but from its love, from its communal possibility.

Next to *The Misanthrope* up in the long Capodimonte Gallery in Naples hangs another late *Tüchlein*: *The Blind Leading the Blind.* Six blind men, each holding on to the staff or shoulder of the man in front, their faces raised ('as toward the light', in William Carlos Williams's phrase), are stumbling, or have stumbled, or are about to stumble, into a ditch. One has gone and is lying on his back, flailing; a second is falling on top of him; a groping third has started to go; and the fourth, fifth and sixth follow on, perhaps oblivious, or perhaps sensitive to the tremor in the line. Together they are like a flipbook of a man walking and falling, an Eadweard Muybridge strip of photographs.

Like a flipbook of a man walking and falling: *The Blind Leading the Blind*, detail.

The theme of the blind leading the blind had appeared before in Bruegel, in the background of *Netherlandish Proverbs*, where there are only three blind people, and they are yet to fall. Edward Snow notes that '[a]llusions to earlier works are frequent in Bruegel: they constitute a kind of internal mapping of the oeuvre.' But each time things are repeated, he says, they indicate a change in vision, not a reiteration.

Our blind men, then, are proverbial and biblical, and perhaps politically symbolic (they have been linked with the institution of the Council of Troubles in 1567 and the ensuing persecutions in the Netherlands; the proverb, familiar both from Horace and St Matthew, suggests a crisis in authority), but they are also real. Their blindnesses have been diagnosed by a succession of art-loving anatomical

pathologists: so the second man has undergone enucleation or removal of the eyeball; the third suffers from corneal leukoma; the fourth, atrophy of the globe; the fifth might be photosensitive; and the sixth seems to be afflicted by some sort of autoimmune condition affecting not only his eyes but his skin too. Together, we might speculate, they have the makings of one good eye.

Soon after his retirement at the age of seventy, my father was struck down by macular degeneration in both eyes, a common condition which affects the focal point of each eye but not so much its peripheral vision, and which in fairness must at least in part explain his failed hobby of choice: watercolourist. He could make out your face by looking over your shoulder, he could see a kerb well enough. He could follow the football by sitting close to the screen and deducing the trajectory of the ball from the scurrying of the players. He couldn't drive. The last time he drove me from his house into Norwich, on grey roads through grey fields on a grey day, we pottered along at twenty miles an hour, and he said, hunching over the wheel, *just tell me if you see any grey cars.*

Over the last years of his life, his vision seemed to improve, not through any treatment or cure (there is, or was, none), nor through any useful technology, although he occasionally used a magnifying glass with a bright torch built in to read dosages on medicines or instructions on packets, but because his brain learnt better over time to interpret the peripheral signals available to it. Whether this involved forging new neural pathways I do not know, but I like to think so. An old man with a plastic brain.

He adapted in other ways. He learnt to use the bus, for the first time in fifty years; he bought and listened to spoken word books (no hardship, but requiring perhaps a tweak in certain powers of attention); and he came to rely on the radio, an earpiece always in on a Saturday afternoon for the football.

His life, in short, became a series of workarounds. In his last years, he filled cupboard after cupboard with canned soups and stews, and little tins of evaporated milk, of which he was fond. After he died, my mother told me he had been secretly planning for the eventuality of her death, when he would be forced to look after himself. He could not operate a microwave, so fell back on a sort of wartime hoarding. Eight years later, before she went into residential care, she was still telling me that she was all right for food, because my father had stocked up on tins.

Bruegel's blind men are similarly adapted to a dark world. They carry the tools and accoutrements – a hurdy-gurdy, a wooden bowl, a knife, a purse, a small funnel – with which they eke out a corporate, caterpillar existence. And walking in line is a good workaround: alternate the lead position and you spread the risk.

Larry Silver talks of the 'tragedy in the foreground', but we can only assume that he is working with an enlarged definition of tragedy. Very enlarged. We are witness to a blind man falling in the mud, dragging his companions down with him. It might be sad. It might be comic. It might just be a regular minor annoyance, like barking your shins (and the third in line has indeed made for himself a set of

wooden greaves). In any case, they will get up and go on. This is not the end. There is no tragedy, except in the much broader context of a social organization which results in people with disabilities forced to walk the countryside in search of alms.

The subdued, near-monochrome palette of *The Blind Leading the Blind* is suggestive of a world of shapes and textures, not colours. But the village behind, we know from a close copy by Jan Brueghel, was originally much more colourful, green and brightly lit, with a gooseherd in bright red standing with a brown cow in the field (a white cow further back is leaning over the brook to drink). The gooseherd, almost entirely obliterated in the Naples canvas, also appears in *Netherlandish Proverbs* just over the water from the three blind men, possibly illustrating the proverb 'who knows why the geese go barefoot?'

Who does know why the geese go barefoot? Everything in the world has an explanation, but those explanations are not always available to us. Contexts, common habits of thought, are erased over time. The thing we most want to explain (Bruegel, in this case) is also, paradoxically, our best source for the contexts which would explain him.

Painters are not immune from social pressure. By which I do not merely mean that Bruegel moved up the social ladder (commercial Antwerp to royal Brussels), a peasant now numbering cardinals among his patrons. I mean, more generally, that painting is a social practice. Painters paint for others, for the group; they learn from other painters, they take what they know and add to it or change it.

What are you going to learn from your fellow painters, if you visit their workshops? You will learn different ways to prepare a panel, different recipes for ground or *imprimatura*; you will learn what could be done with the *imprimatura* if left exposed; you will learn about layering, about whether to place your underdrawing on the ground but beneath the semi-opaque *imprimatura*, or over the *imprimatura*, which as it happens was Bruegel's practice, slightly unusual for a Netherlander, but in evidence in Italian painting. You will learn, in short, not only about composition or colour, but about much invisible technique.

Bruegel in fact was renowned for his structural use of the *imprimatura* layer (which he may or may not have picked up in Italy, and which seems to have been used also by his son, Pieter the Younger), into which he introduced pigmentation (lead white, a siccative pigment, seems to have been common) and then left exposed here and there. For example, he reserved certain figures and painted them in bright colours over the *imprimatura* rather than over any duller background – the light-blue jerkin of the man pollarding willows in *The Dark Day*, for example, seems to bioluminesce in a world of no reflected light.

How did he do that? his peers must have wondered. Why do the geese go barefoot?

In Madrid, in the Prado, two of Bruegel's paintings hang in the great Bosch room, alongside or near *The Haywain* and *The Garden of Earthly Delights* and the rest.

It is a large room. How large? Ten metres long? Twenty? By five? Ten? It would be impossible to pace it out, as I have paced

A world of no reflected light: *The Dark Day*, detail.

out so many rooms in which Bruegels hang. If you wanted to measure it in easy approximate strides, you couldn't. The space is rammed with tourists. There must be a hundred and fifty of us, rammed into this space. You can barely get in the door. Tourists, after a day walking the streets of Madrid, seem comfortable not moving. They dally and shamble and stand and chat and go nowhere. You have entered a compaction of Bosch (and only incidentally Bruegel and Patinir – it is the Bosch which draws the crowds), and you slow to timelessness. Slow motion does not capture it. You have entered an impossibly dense medium, a treacle of space-time.

Only there is, it turns out, if you are patient – and I am patient – a periglacial flux to the crowd, a frost-heaving. There are barely perceptible eddies set up between the Bosch panels and the Bruegel panels and the neglected Patinir panels. There are asymmetries of interest, drawing people this way and that. And so in time you get to stand where you want.

Where I want to stand is in front of the Bruegels, both of which reflect the crowd in the room. There is *The Triumph of Death* (1562?), a panel associated by its size and subject matter with *The Fall of the Rebel Angels* in Brussels and *Dulle Griet* in Antwerp; and the enormous *Wine of St Martin's Day.*

Like *The Blind Leading the Blind* and *The Misanthrope*, *The Wine of St Martin's Day* is a *Tüchlein*. The composition is borrowed. There are similar works by Peeter Baltens which seem to have pre-dated this. In the centre, a giant orange-red barrel of wine is under siege by an entire village – I count roughly a hundred individuals, many of whom clamber up and over the barrel in much the same way that Bosch's *Haywain* is overrun with ladders and billhooks by a supplicant humanity.

On the right, St Martin of Tours is performing his emblematic act, dividing his cloak for the relief of two beggars, each of whom is a variant of the Paris beggars: one, a double amputee, on crutches and wooden stilts, the other sitting in a wooden cradle, his legs doubled up behind him in a grim contortion.

On the left, we can see the effects of the wine played out in vomiting, fighting, dancing; a mother seems to be feeding wine from a bowl to her infant child; others come running with bowl and jug; a couple of pilgrims, caped and carrying staves, stare out of the canvas at us, their eyes, like the blind in Naples, hollowed out by the depredations of time on a fragile medium.

*

The Wine of St Martin's Day is a recent addition to the Bruegel corpus. Manfred Sellink relates how he was invited to inspect it in the autumn of 2007 when it was still in a private collection, and tentatively identified it as an original Bruegel. It was subsequently bought by the Prado in 2010 and restored. During this process, a signature and partially legible date were discovered.

When it was acquired, it was in a very reduced state. It was covered with a polyester varnish, which had been applied in an attempt to hold together and protect, and tonally unify, the painted surface. The varnish had darkened, however, and obscured the painting almost entirely. At some point, the linen on which it was painted had been relined, and this had had the effect of wrinkling the canvas.

Restoration work was painstaking. Elisa Mora, chief restorer, relates (in a video on the Prado website) how she had spent hundreds of hours in cramped, uncomfortable positions. The varnish was removed, as was the lining. Removing the lining left a large number of holes of varying size in the canvas, which had to be repaired and repainted.

What do we see now? The original, restored? Or a new confection? Something between the two. One form of poorly conceived mummification has been undone, and another, more reverential, more alive to the subtlety of the original, has been substituted for it. The mummy now walks, mumbling and groaning in this painful afterlife, of illumination and tourists. The painting is still dull, barely legible in parts (the background, in particular, is much erased). There is much to see, but seeing requires patience, adjustment of the eye; you must ignore the great glinting Bosch panels which

hang around it. You must wait for its detail to emerge from the gloom of centuries, like a voice from the grave at a séance.

The maddened figures in the panel clamber over one another, eager for a drop of new wine. Half a cloak might offer a little warmth and protection, but it does nothing to take the edge off. Wine can give the poorest life a little patina, suppress certain perceptual spikes, accentuate others. Life takes on colour, savour.

My father, on the night he died, collapsed at the top of the stairs. He had been trying to get a supersized whisky up to his bedroom, half a pint at least, laying it carefully on the top step before crumpling in a dead heap. His last act on earth: not spilling a drop. When I arrived in the early hours of the morning my mother tried to persuade me to drink it, death and whisky naturally associating in an Irish mind. But I poured myself a fresh one, a failure of defiance, of solidarity, I now regret.

Opposite *The Wine of St Martin's Day* hangs a somewhat smaller but much denser work: *The Triumph of Death*.

Left to right, skeletons shepherd all of humanity towards a hell's mouth: an artificial structure resembling a vermin trap. The skeletons seem happy in their work. They cut throats, lop heads, wield swords, string up bodies, try on costumes and masks; two are ringing a great bell with gusto; one is playing a hurdy-gurdy, another is thumping on a big pair of kettle-drums. From the right, more skeletons are approaching in serried ranks with coffin lids for shields, less joyful but no less purposeful than their marauding companions.

This is no comedy of death. Nor is it an apocalyptic scene. There is no judgement, no redemption, no fate to be escaped. Wherever we are, so is death.

Until the middle of the nineteenth century, Bruegel's *Triumph of Death*, unsigned and undated, was taken to be by Bosch. But it clearly derives from other visual traditions. Between 1523 and 1525 Hans Holbein (painter of anamorphic skulls, and dead of the plague by 1543, at about Bruegel's age) produced a series of woodcuts depicting the dance of death. In each, a cheery skeleton assails the living in their everyday pursuits and takes them off to their fate. Holbein himself was drawing on a long tradition of *danses macabres*, hourglasses and skulls. There was a vogue in Northern Europe in the sixteenth century for so-called cadaver or *transi* tombs, in which the entombed was depicted as a rotting body. Some, in double-decker tombs, show the person as in life above, and as in verminous death below. Bruegel might also have known his friend Giulio Clovio's *Farnese Hours* of 1546, which has an illumination depicting skeletons on horses hunting down the living, and the *Trionfo della Morte* fresco in Palermo, in which a skeletal death on a skeletal horse gatecrashes a picnic.

I once gave English lessons to an Evangelical Christian from Hong Kong who worked for Morgan Stanley. He was a believer in the literal truth of the Bible. He had lived in England since he was ten years old and was a native-level speaker. I had nothing to teach him. But it transpired that he was chiefly interested

in improving the skill of reading aloud. Every Sunday he would read from the Bible for the congregation at his church, and felt he could do so more fluently, more expressively.

So I had him read to me from Ecclesiastes. *For that which befalleth the sons of men befalleth beasts: even one thing befalleth them; as the one dieth so dieth the other: yea, they have all one breath; so that a man hath no pre-eminence above a beast: for all is vanity.*

I asked him what he made of it all, the beauty of the verse, the desolation, the irredeemableness. He told me that Ecclesiastes painted a picture of a world without God. I put it to him that this was an interpretation. After all, nowhere did it actually say: this is a vision of a world without God. He was quite firm. No. This was not an interpretation. It was literally true. How could it be literally true? Because there is a God, and this is not what the world is in fact like. So it was literally true that this must be a vision of a world without God. He was adamant.

We went on to think about the pronunciation, all those terminal consonants, so difficult for a Chinese speaker. *Beast. Men.* No afterlife of the vowel, the breath. Just a terminal click of teeth, tongue, soft palate. And the breath stops. Watch my mouth. Try again.

Later on, he told me that he had come to England when he was ten years old to live with his uncle and aunt, because both his parents had died.

Bruegel, unlike my Hong Kong banker, had no trouble contemplating finality. The finality of *The Triumph of Death* is akin to that of Ecclesiastes: nothing is redeemed. There is no saviour. Resurrection is not in the flesh but in the bone only.

Beating on the kettledrum of our heart: *The Triumph of Death*, detail.

Skeletons rise up, get themselves organized in rank and file, and persecute the remnant living.

But who are these skeletons? They are not demons. They are simply the already dead. Among them, for us, would number Bruegel, Bosch, Hans Holbein, the parents of my Hong Kong banker, my father. And they are, by an easy step of the imagination, us. We are each of us dragged to the grave by the skeleton grinning inside us. Feel him jangle in there, turning the hurdy-gurdy of our spirit, beating on the kettle-drum of our heart, gleefully.

The desolation of *The Triumph of Death* is all in the horizon. The sun is about to rise, but the lightening sky only serves to

pick out the skeletal shapes of gibbet and ladders, blasted tree, raised sword and, especially, torture wheels.

The torture wheel was a mechanism of slow execution. There were a number of ways you could be 'broken on the wheel', but one common technique in Bruegel's day was to have your leg bones and arm bones snapped between the spokes and then to be raised up, unable to move, food for crows.

The Dutch still know the expression *voor galg en rad opgroeien*, 'to grow up for the gallows and wheel'. For Bruegel, we all grow up for the wheel. The wheel is his great emblem of life and death. The village in *The Census at Bethlehem* is a village of cartwheels; at the exact centre of the painting, there is a single wheel in the snow, seen front on; so too in *The Adoration of the Magi in the Snow*, there is a single cartwheel placed at the vanishing point, interrupting our visual escape from the picture.

But while the torture wheel for Bruegel stands for a sort of mystical savagery – the spreadeagled, crow-plagued victim bound to a symbolic circuit of life – it is also, we should remind ourselves, part of the furniture of the sixteenth-century landscape. Death was a theatrical event. The wind did not quietly blow away your footprints; rather the crows picked out your eyes while people picnicked around you. And for a painter, to have your eyes picked out is perhaps a special sort of prologue to death.

Here, then, in Death's final triumph and rout of humanity, what do we find? Raise your head to the horizon, to the faint light breaking through, and you see gallows, hanging corpses, and four wonky wheels set up on posts, as though the trundling cart of the cosmos had itself been dismantled, wheels

As though the trundling cart of the cosmos had itself been dismantled:
The Triumph of Death, detail.

wobbling useless on axles. The world has stopped, and the crows, minutely varying their spread of feather, their angle of bony wing, alight softly.

The Triumph of Death, unlike *The Misanthrope*, or *The Blind Leading the Blind*, or *The Wine of St Martin's Day*, is painted in oil. It is durable. Beetle-backed. Varnished. Beautifully preserved. Eternal.

Or is it? The philosopher Maurice Merleau-Ponty, after watching a slow-motion close-up film of Matisse's hand in the act of drawing, remarked that it seemed to be dancing: the drawing was no more than the trace of the dancing hand. Perhaps that is what these paintings are: the slow-decaying trace of a performance carried out in the mid-sixteenth

century: the ghostly flicker of Bruegel's hand dancing six inches above the panel we now look at. No code, no message, no useful information. Just a mysterious relic of a life lived in some other place, some other time.

The hand dances with a certain intentionality, however, which we might be able to recover. In parts of South India, dwellings are protected from demons by a labyrinthine pattern drawn on the threshold, and known, in Tamil Nadu, as a *kolam*. The *kolam* is made by the women of the household, who drift fine powder – rice flour, lime, chalk dust – with great skill from their fingertips. During the day, the pattern is kicked over as people come and go about their business. It must be remade each morning before sunrise.

If Bruegel's printed engravings place him on a continuum with La Pérouse and his navigational charts, his paintings are perhaps closer to the map of Sakhalin Island drawn in the sand, or to these *kolams*. A record of a performance carried out in solitude, one which is ephemeral; but also one which is designed to ward off evil. To keep death at bay. To show the way.

In the end, La Pérouse did not trust the map drawn in the sand by the Ainu man. It could not be a sound basis for navigation. As *L'Astrolabe* and *La Boussole* approached the Strait of Tartary, which lies between Sakhalin Island and the mainland and which becomes so narrow that it begins to resemble the head of a bay, they started to encounter shoals, shallow water. Inhabitants from the opposite bank seemed to confirm that a sandbank lay ahead: the strait was impassable. La Pérouse turned his ships south again and made for Hokkaido, and thence to Kamchatka.

The expedition had by now been in the Pacific for two years. After Kamchatka it headed south to Australia, where it encountered the British First Fleet in Botany Bay. La Pérouse took the opportunity to send back his journals and collections on a British ship, and then set sail for New Caledonia and the South Pacific, where the expedition vanished into the vastness of Oceania. Neither he nor his ship or crew was ever seen again.

X Gallows

Germany (5.398%)

'The one sin of which a Tarahumara Indian is conscious
is that of not having danced enough.'

Jessie L. Weston, *From Ritual to Romance*

My brother once had dinner in New York with Charlie
Harmon, assistant to Leonard Bernstein in the 1980s, who
told him a story about a conversation he eavesdropped
between Bernstein and the composers Elliott Carter, Peter
Maxwell Davies and Ned Rorem. He had seen them, he said,
at a party after a concert conversing earnestly in a corner of
the room, and felt he had to go over and see what these lumi-
naries of twentieth-century music might be discussing, and
was surprised and a little disappointed to discover that what
they were talking about was how they had lost their looks.

Is it that surprising, though? Physical beauty, youth, lithe-
ness, the physical manifestation of energy, define us, shape
our journey through the social world; their gradual passing
must effect also a more profound change, regarding our social

being. And to talk about your lost beauty is to talk obliquely about approaching death, because our death is foreseen and played out in our decay. We lose a tooth, or gain an arthritic toe, and the ratchet turns. My mother, through the mists of advanced old age and dementia, would say as she tried again and again to get to her feet, rejecting assistance: *this is what I am now; this is what I have become. I never thought it would happen to me.* Words to that effect.

Bernstein and Carter and Davies are all dead now. Bernstein died not long after that conversation, in 1990, aged seventy-two, and Elliott Carter died in 2012, aged a hundred and three. However, when I travelled to Darmstadt and stood in front of *The Magpie on the Gallows*, Davies was still clinging on, albeit suffering from the leukaemia which would kill him in early 2016, aged eighty-one.

Did Peter Maxwell Davies dance beneath the gallows? Of course. For many years he lived in glorious isolation on Orkney, much of the time without running water or electricity. He dug peat, collected driftwood and grew vegetables. Worried about civilization breaking down. Mulled his atheistical, republican, musical ideas. Dance? What else would he be doing out there, out on the edge of the world?

Ned Rorem is still going strong, at the time of writing, aged ninety-four. I don't know if he has yet lost his looks.

Darmstadt stands at one end of a brief German trip which I took with my brother in August 2015, and which had at its centre a first visit to the Wagner festival at Bayreuth. We

stayed in Bamberg, and finished in Munich, where I would finally get to catch up with that egg.

I had bypassed Darmstadt, just south of Frankfurt, on the winter journey in 2013. That year, the museum was closed for restoration work. I wrote an email asking if there was any way I could see the panel, given the special circumstances (my mania), and they politely replied that of course, by all means: I could simply come back in 2014. But in 2014 I went to the USA, and I didn't have the time or energy for Darmstadt.

And so here I finally was, in 2015, mopping up.

Bruegel died in 1569. The several paintings he completed in 1568 – the two in Naples (*The Blind Leading the Blind* and *The Misanthrope*), the Paris *Beggars*, *The Magpie on the Gallows* in Darmstadt, the Munich *Head of an Old Woman*, *The Peasant and the Birdnester* in Vienna and the Frick *Three Soldiers* – are sometimes taken to be a thematically coherent group, all painted, for reasons unknown, on relatively small panels or canvases. These are not just *Late Bruegel* by dint of their year of composition, the argument goes: Bruegel sensed he was dying.

There is a deathbed scene. As Bruegel's earliest biographer Karel van Mander tells it, perhaps on the authority of someone who knew the great painter, Bruegel had his wife destroy some drawings lest they incriminate her with the *Raad van Beroerten*, the Council of Troubles, instituted in September 1567 just after the arrival of the Duke of Alba with Inquisition-like powers and a brief to extirpate heresy in the Spanish Netherlands. It was a dangerous world.

One such late drawing which survived the putative cull, *The Beekeepers*, is inscribed, probably in Bruegel's hand, as follows:

dije den nest Weet dijen Weeten/dijen Roft dij heeten
(Whoever knows where to find the nest knows where
it is, but whoever robs it has it).

The drawing shows three masked and sinister beekeepers. One is grappling with an upturned hive, as though trying to open it; a second is carrying another hive in from the left, looking over his shoulder; and a third is walking towards the second.

Whoever robs it has it: *The Beekeepers*, detail.

The beekeepers wear masks made of woven willow inside cowls. The radial pattern of the weaving picks up the spokes and circumference of the inevitable waterwheel on the mill in the middle ground.

Just behind and above the three beekeepers, hugging a branch in a tree, is an unmasked figure. We cannot see his face, and cannot tell what he is doing, but interpretations of the drawing tend to hinge on a supposed opposition between the caution of the beekeepers and the audacity of the unmasked figure in the tree; he is an echo of another figure in one of Bruegel's paintings from the last, monumental years: *The Peasant and the Birdnester*, which hangs in Vienna, a panel which Joseph Koerner has interpreted in contexts of peasant knowingness and know-how.

We can deduce from the bare hands of the beekeepers that the hives are empty. Hives were symbols of the Catholic church – the figure of Lent in *The Fight Between Carnival and Lent* wears a beehive on her head – so where has the congregation of bees gone off to?

Other interpretations implicate the Spanish, the Protestant reforms, the Council of Troubles, and who knows what else. The Middle Dutch word *corfdrager*, hive or basket carrier, can also mean secret informer. Perhaps Bruegel kept this one back so that the inquisitors, when they popped in to terrorize his wife and small children, would be left scratching their heads over an incomprehensible puzzle.

Darmstadt emerged in the post-war period as the European centre of serialism, a sort of Angry Young counterpoint to the Eurovision Song Contest.

Serialism is a technique of musical composition which proposes that all twelve tones of the equally-tempered scale be fixed in some permutation or other, combined and recombined according to certain mystical or aleatory principles, the central tenet of which is that no given state or arrangement be repeated.

It is, then, a way of erecting a pitch-structure in atonal music, albeit those structures are for the most part inaudible to any but the adept. The resulting music sounds like someone trying to crack the combinations to the locks on the Seven Seals of the Apocalypse using brute-force computation: codified, fretful, arcane, not uninteresting in brief samples, but grimly antagonistic to any idea of dance or song.

Each year in Darmstadt in the decade or so after the Second World War, a summer school was held in new composition (*Internationale Ferienkurse für Neue Musik*). It was here that a young Peter Maxwell Davies met Karlheinz Stockhausen and Pierre Boulez among others. 'At Darmstadt,' Davies said later, 'I disgraced myself on one or two occasions by getting the giggles in concerts.' It rapidly became the seat of a troubling orthodoxy, its young zealots dictating and policing aesthetic boundaries, and, like the European Union, reacting to the inarticulable horrors of the war with centralizing purpose, a musical *Aufklärung* imbued with frightening clarity. You would not be altogether surprised to learn that Darmstadt was covertly run by the Jesuits or the Freemasons. The Babel of music, then, with, somewhere along its upward-winding course, a tiny screaming cacophonic pope.

After a decade, riven (appropriately) by internal discords, the party broke up.

The museum in Darmstadt is, like many provincial museums, an old-fashioned cabinet of curiosities, of *artificialia*, of *naturalia*, of art, of classical civilization, of natural history. If you want to see the pelt of the last wolf killed in Hesse (6th January 1741), this is where you come. If you want to be imposed upon by a mammoth skeleton, here it is. If you want to roll yourself up in the endless layers of Joseph Beuys's felt fetish, come on in. In one glass case, there are row upon row of stuffed songbirds – five bullfinches, ten great tits, eight robins, a couple of puzzled-looking crows (no magpies, that I remember) – and under them, row upon row of stuffed rodents.

There are also cabinets in which you can examine the stuffed and skeletal versions of creatures side-by-side: a snake, a frog, a kookaburra (?), a crane, some sort of tree rodent, a large flat fish; and there is a hall entitled 'Development of the Bauplan'. The *Bauplan* means the build-plan or, I suppose, the blueprint, or underlying structure. Here you can see suspended from the ceiling the skeletons of a whale, and a seal, and a dolphin; and below them an array of skeletal land-based megafauna: a giraffe, an elephant, a camel, a buffalo, an anteater, a tapir, a dancing bear, and in their midst, inviolate and serene now in death, a human being.

All life is here, in skeletal form. Or all death. I spend at least as much time studying the development of the *Bauplan* as I do *The Magpie on the Gallows*, insofar as they are distinct.

The Magpie on the Gallows is for many the summation of all Bruegel. Perhaps his last work in oils, it is a landscape, one of his most complete, with the characteristic corner-foreground

composition giving on to an evolved middle ground – a mill in one direction, the main street of a small town in the other – and a background stretching out over economically productive field upon field to spiritually productive ethereal infinities of sea and sky and mountain. In the foreground, some peasants have walked up from the town to the gallows and are dancing. A pair of proto-romantics, hands on hips, take in the view, while behind them in a bush a man takes a shit.

And there is the gallows, of course, and a pair of magpies: one alighted on the cross-spar of the gallows itself, the other on a stump underneath.

Below the gallows, halfway down the hill to the mill below, there is a large cross, similarly bent out of shape. And at the foot of the gallows, on the other side from the dancers, is the

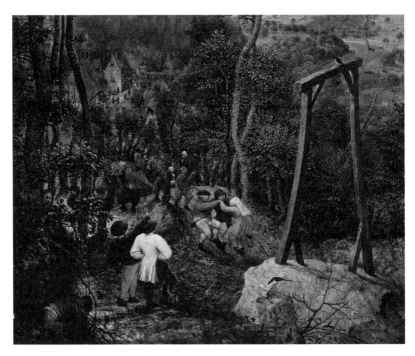

Like the furcula of a bird in flight: *The Magpie on the Gallows*, detail.

skull of a horse. As though the four horsemen had been vanquished, and the people were dancing.

But the four horsemen haven't been vanquished: they are merely occupied elsewhere, for now. The gallows is an Escher-like, twisting form, like the furcula of a bird in flight, perhaps, straining into the wind. It is contorted like the bodies of those who would ordinarily swing beneath it, racked in their death throes; or, freed from its weight of responsibility, it might itself be about to dance, mimicking the natural twist of the trees that frame the panel to right and left.

The torsion of the gallows is not in the geometry, but in the wood. Bruegel, we should not forget, was reliant on wood. His paintings are on wood panels, oak. He would have sourced them not locally but from wood felled around the east Baltic, shipped in by the Hanseatic League.

Wood, as it dries and seasons, will tend to warp and shrink and crack. It undergoes changes which are not uniform: the trunk of a tree is heartwood surrounded by sapwood. The sapwood contains more moisture than the heartwood, the cells of which are impregnated with gummy resins. And while oak, a tough and intractable wood, dries and settles more uniformly than the volatile limewood beloved of South German sculptors, it will, like all wood, continue to breathe, if not live, for as long as its internal structure of fibres and cells persists. It will thus absorb moisture in damp conditions and dry out again in the warmth of summer. There will be a constant slow-motion adaptation to conditions.

Bruegel would have known why builders favoured oak over lime or pine, and similarly why guilds in the cold damp north stipulated oak or walnut over limewood. He would

have assessed his panels carefully, by eye, traced their knots and their grain.

Tear away layers, strip back back back, past the last wolf killed in Hesse, past classical antiquity, past the great mammoth skeleton, to the point where the earth was forming, those rocks cooling, uplifting. You reach, not a *Bauplan*, but a material substratum. Tear back any layer and you reach, not geometry, not some pure form, but bone, or a wooden board, or a tree's roots. It is the material, not the structure, which is subject to deformation.

Bruegel would have known, then, that the foundations of his painting, like the trembling earth itself, were subject to deep shifts and adjustments.

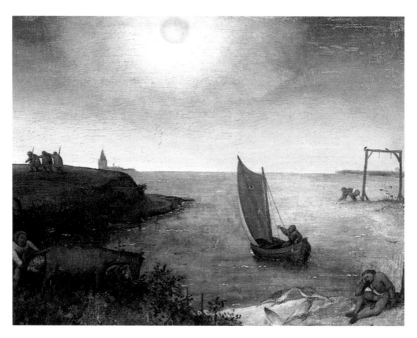

To shit on the gallows: *Netherlandish Proverbs*, detail.

Both gallows and cross emerge from the bowels of the earth and warp heavenward. Joseph Koerner points out that while the gallows might be symbolic, perhaps inevitably is, it is also a fact of life, the material manifestation of the law (also malignly present in the castle which squats over the village), dominating the views from the town and some corner of the mind, at least, of the peasants dancing beneath it.

Dancing, and shitting. Let us not forget our defecating man. He is by no means unique in Bruegel, whose drawings of kermises and carnivals, in particular, are punctuated with peasants relieving themselves one way or the other: a small child squats down against a wall at the back of *Children's Games*, while in the foreground another pokes a turd with a stick; a man urinates against a tree in the Detroit *Wedding Dance*; and in *Netherlandish Proverbs*, in the extreme top right of the panel, a man illustrates for us the proverb *op de galg schijten*: to shit on the gallows, or to cock one's filthy snook at the law.

Mikhail Bakhtin, great theorist of comedy and popular culture, of Rabelais and the carnivalesque, discussed at length this resort to what he calls (in a suitably ungainly and circumlocutory formula) the Material Bodily Lower Stratum. Bakhtin saw that there is no sententiousness, no profundity, in art or in life, which is not subject to, and ploughed by, parody. Gargantua and Pantagruel are a liturgy of the parodic: parody of the sacraments, of the teachings of the church, of the essential miracles of the Gospel. Nothing is untouched by the manure that Rabelais flings gaily around in the name of carnival. At one point in Book II Gargantua provides for his father, Grandgousier, a detailed list of everything he has ever used to wipe his arse: a velvet muffler, a lady's lace bonnet, some

crimson satin earmuffs, a cat, sage, fennel, dill, marjoram, rose petals, lettuce, spinach, linen sheets, the curtains, straw, oakum, flock, wool, paper. The list goes on and on, with commentary and digression, for several pages, culminating in his preferred method: using with care the neck of a live and downy goose.

Is our defecating man, then, parodying the sententiousness of the gallows, or the profound disengagement of the dancers? To dance is to raise up the body, just as to sing is to exalt the spirit. Both etherealize the plodding passage of time, the grinding mill of the seasons and the labours. You dance under the gallows, you peasants, to the implacable tuneless twelve-tone logic of death, defy and resist with your dance and your laughter. But we in turn laugh at you. All dance, after all, and all dancers must return to the earth.

The landscape in *The Magpie on the Gallows* is the same as that in *The Return of the Herd*, painted three years earlier. The same river, the same castle and the same double-peaked rock in the middle background. Even the trees in the foreground and middle ground are placed and shaped similarly, and there is the same mill, although larger, brought firmly into the middle ground, in *The Magpie on the Gallows*.

By 1568, *The Return of the Herd* was hanging in a house in Antwerp. Bruegel was living in Brussels. Perhaps he never saw it again, once he had shipped it. But he had the cartoon, we must suppose, or, more likely, the sketches, given the size disparity. One way or the other, he had the landscape, encoded. A good landscape. He used it again.

Place, after all, is not uniquely tied to time, or event. Gallows or herd, dancing shitting peasants or ghostly cattle: the cast changes, the bones of the land remain.

And in fact, if you peer closely at *The Return of the Herd*, really press your nose to it, there in the background, alongside the river, tiny but unmistakeable, as functional in the landscape as a farm or a tower, you will discern the lineaments of a gallows and its attendant torture wheels, and strung up from it, represented by a mere smear of diaphanous paint, a rotting body.

I say that these two paintings share a landscape, this is my observation, but nowhere do I read it. I hunt through all the books I have, and through all the essays; I google furiously. Nothing. It seems implausible but it is, for all I know, a discovery I have made.

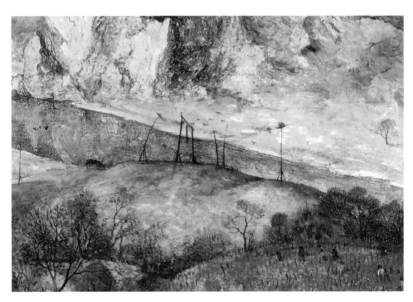

Functional in the landscape: *The Return of the Herd*, detail.

I find this exciting, the idea that I might have seen something new, but also disconcerting. I had not reckoned on altering in any way the object of my attention. I had taken the Bruegel Object to be a fixed point of enquiry around which, like a comet simultaneously lost and located, I would slowly orbit. But the solidity of the Object is called into question if I, a nobody in Bruegelian scholarship, can by gently pushing at its firm panelling suddenly pass inside, alter its code, make of it something new.

Later I write to Bruegel eminence Professor Larry Silver and ask him about this. He replies, 'You are QUITE CORRECT.' He sounds excited. Then, as we correspond, we both start to hedge a bit – these are stock Bruegelian landscape motifs, perhaps the diagonal of the river and the high vantage point just set an unstoppable train of Bruegelian landscape logic in motion. But I would hazard that there is, if not an underlying drawing, then at least an underlying flicker of memory at work here, something more than mere coincidence.

Then again, you see what you want to see, disregard what you want to disregard. Perhaps the Object is untouched after all, except in my head.

Van Mander, in mentioning that Bruegel left *The Magpie on the Gallows* to his wife, tells us explicitly that the magpies stand for gossips and informers, self-appointed custodians of the gallows and the law. Perhaps there is a simple play here then, a cocking of a snook against those who would cling on to the coat-tails of tyranny. The people continue to dance. And to shit. Put that in your report.

And there are painterly tricks to respect. The top spar of the gallows touches the river which winds across the middle ground and out to the background. It also echoes the wood of the cross, on which another politically motivated execution took place, and thus leads the eye down to the mill. Because, lest we forget, Bruegel's mind always ran, not on circles, but on wheels.

The wheel skims the surface of the river, mills flour. There are mills – windmills, watermills – throughout Bruegel. Grinding away, whether for bread, or for torture. And so there is the miller, custodian of the mill, just entering his house. If he looks back over his shoulder for a moment, what does he see? He looks up the hill, past his pigs, past the cross, to the twisted gallows. There are no bodies swinging on the gallows today. Just a magpie (a magpie can also be a magpie), and the people dancing, coming up from the village to the sound of bagpipes; as though they had not come up from the village, in fact, but climbed down from the gallows, piped down, let us imagine, by a bagpiping magus.

It is a pleasant sight, the air is soft, the distances agreeable; you could climb that hill, and dance along; or you can just watch, indulgently for a bit, the sun in your eyes, all these people faded to distant shimmering detail, perhaps the odd shout and cry and laugh wafting down the valley; before you turn and go back to your wheels, your work.

And what does the miller see, out of the corner of his eye, as he turns, looming beyond the gallows? A great puzzled face, marvelling and mooning down: my own, as I stare and study and attempt to read; and then the back of my head as I finally turn away, my own slow drag-footed solitary dance taking me out through the museum, between its skeletons, out through

the town of Darmstadt (a beer, a church, the hot sun absorbed by the 1950s buildings and streets), back to the hotel; then on, by train, to Bamberg, by car to Bayreuth, and, after a few days toing and froing, by train once again to Munich.

The miller shakes his head, rubs his eyes, and goes back to his work.

I am wary of Munich, city of fever and lumbering giants and flying pretzels. But today we are only passing through. We walk up to the cool neoclassical museum, itself undergoing some slowly evolving large-scale internal reconfiguration. But the Bruegel room is open, I have checked. We walk up the great stone staircase and locate it quickly.

There are two Bruegels here: the little *Head of an Old Woman*, and *The Land of Cockaigne* with its dancing egg.

Both are late works, from that last year or so of suffering, the year in which, among other notable atrocities, the counts of Egmont and of Horn were beheaded in the Grand-Place in Brussels, not far from Bruegel's studio.

Head of an Old Woman is neither signed nor dated, although the ascription to Bruegel is not doubted. It may be a fragment of a larger work (which would explain the lack of a date), but more likely it is a so-called study-head, or *tronie*.

Tronies are not portraits. The thought of a Bruegel portrait is a little boggling, as though to see a real and named person painted by Bruegel would bring the painter's own person suddenly into the light, caught in a precise and verifiable social relation. *Tronies* are, rather, character studies, used by some artists (Frans Floris, for example) as workshop models to be recycled in larger paintings. In Bruegel's case there is no

evidence that the *tronies* with which he is associated were reused in this way, although Silver notes a facial similarity between this woman and the dancing woman entering on the right in *The Village Kermis*.

If this is a character study, what do we make of the character it expresses? Is the woman old? We do not find so many elderly figures in Bruegel. There are a few, here and there. But given the numberless crowds at large over his panels – crowds of children, and vigorous peasants, and men and women aged before their time but not, for all that, old – the elderly are rarities.

So is this woman old? She is not young, certainly: there is wrinkling around the corners of the mouth, in particular, and the neck; on the other hand, she has a number of teeth.

Teeth are scarce both in Northern and Italian art of the fifteenth century. This is surely a matter of propriety: mouths are one of the portals to the inside of the body, the warm, clammy and damp interior. The teeth are an emblem of carnality, and to display them a contravention of decorum.

There are exceptions. The damned in Last Judgements, wedded in life to their mortal flesh, have teeth, and they gnash them. So do all manner of animals and devils. So, of course, do skulls, teeth bared in death. And so, not strangely in all these connections, does the dead Christ, in paintings for example by Van der Weyden and by Giovanni Bellini. To look on the face of a dead god is to see him as a man. And if Christ is fully man, then he must have a full set of teeth.

By the sixteenth century, however, the gawping peasants who are finding their way on to panels and canvases all have teeth, plenty of them, wonky and yellow and gapped and hilarious. And so in Bruegel, teeth have their place: the man in the green hat sitting on the bench in *The Wedding Banquet*

is a little toothy, as is the energetic man in the blue jerkin in *The Wedding Dance*; the peasant with the spoon in his hat in *The Village Kermis* has a gapped and carnivore row on the top (is he grinning or snarling?).

But in this little *tronie*, they are a focus. Teeth, as you age, come to the fore. When you are young they renew themselves, emblems of your indestructibility. But with middle age, alongside the decay of youth and beauty, your gums retract, inflame, bleed. Teeth throb, go yellow with tobacco or wine or neglect, or black with cavity; they fall out, or break.

And yet, in the end, all that will be left of you will be your teeth and a scattering of bones. *Col tempo*.

Col tempo: *Head of an Old Woman*, detail.

As artists approach death, do they become more cryptic? Or plainer? Perhaps it varies. Beethoven and Bach veered toward the cryptic, as though at the end of life there might be a sequence of challenges, a labyrinth to walk, with its guardian spirits – better to be prepared with spells and talismans. Roman Catholics associate rituals with the end of life: prayers said in Latin, last rites, crosses and incense. Bach, music's Newton and no Catholic, nonetheless traced affinities of number and knot and loop between the cosmos and his counterpoint; Beethoven returned to Bach, to counterpoint and fugue.

And Bruegel? In these final panels, does the peculiar clockwork of his conundra begin to elude not only us, but also those who might have been expected to understand – notably, himself?

For a little context, we must jump forward to Berlin, although, to be clear, I have only half an answer.

I have been to Berlin several times but return specifically for the Bruegels in 2017. We discover the Gemäldegalerie to be mostly empty. This is refreshing. I refrain from estimating how many square feet of floor-space I can hope to luxuriate in, the better to luxuriate.

Netherlandish Proverbs is a relatively early work (1559). It reproduces all the proverbs in the *Twelve Proverbs* of the previous year except one (the drunken guzzler in the top left corner); it then adds a further eighty, ninety, a hundred (the count varies from commentator to commentator).

Bruegel did not invent the composition – his painting is clearly based on an engraving of Frans Hogenberg created in

1558 – but as ever he exploded his sources. His panel, then, is a compendium of human folly and a puzzle book for the curious; but it is also a painting of a shivered world. Each vignette is radically discontinuous from its neighbours, just as the architecture is radically disjointed (town house, country hovel, fortified bridge). But look around you in the gallery café, where a little later we sit down to a plate of sausages and a beer, and what you see is, if you read well, not dissimilar. A city is a confusion of people going about their own manic business. Some talk to themselves, some do not; some look distracted, some focused. But we are all of us bound on a personal wheel of fire or misfortune. Freeze-frame this café, and what do you see? That man over there pisses at the moon; to our left, the fox and the crane sit down to dinner; this one here stoops to make her way in the world; it doesn't matter whose house burns, so long as that one can warm herself at the coals.

Our manias and dysfunctions are listed and labelled in different ways now. We consult, for example, the *Clinical Handbook of Psychological Disorders* and trace our pathologies there. But this is not a set of disjunctive behaviours which we witness in the Bruegel panel: it is a form of collective insanity. To behave proverbially, as we all do, is to behave like mad people. The painting exposes this social madness. As elsewhere – as always? – Bruegel has simply found a gap in the consistency of the world, and is peering in.

These are not puzzles to be solved, then, but dramas being enacted, dramas shorn of context. Look again at our little café tableau, or at *Netherlandish Proverbs*. What is lacking, in any given instance, is a context and a case history. Each of those proverbial fools, placed in an adequate context, of story, of history, might start to look a bit less crazy, a bit more human.

There comes a point in any given conversation with my mother, as she tires, notably, where only those who know her well can follow her. Her voice is quiet in old age, and she slurs and mumbles. But the roster of story, anecdote, fragmentary memory, grievance or observation which characterize her conversation is more or less stable. She is constantly scrolling, recombining, segueing, dovetailing.

While we sit in traffic on the Newmarket Road, she admires the trees and wants to know what they are. I tell her – plane trees, lime trees – and she says again, 'Aren't they beautiful.' They are, I agree. She says that in England they respect their trees, but in Ireland they dig them all up. 'Ireland,' she says, 'is not as green as people think. They say Ireland is green, but that is nonsense, England is just as green.' Then she might find her attention turned to the traffic. 'You don't see many white cars where I live,' she says. She doesn't see any cars where she lives: she lives in a room overlooking a garden. 'That's a beautiful car,' she says. It is a red Mondeo – she is given to overstatement. She once told me she had never seen such beautiful trees as those in Sainsbury's car park. Another time, driving down the A11, she told me she had never heard such 'powerful hi-fi' as the cassette deck in my old Mark V Ford Transit.

On it goes. She has difficulty, in full flow, distinguishing me from her younger brother, or my brother from her elder brother. She sometimes thinks I am my father. To know what she is talking about at any stage you have to know which member of your family you are currently personating.

In other words, I know her case history. She isn't mad. Just disjointed. A scatter of proverbs plucked at hazard of

association from the pool of possible proverbs, doing duty not as an explanation of the world, but as a commentary on it, an ongoing, if fading, engagement with it.

Gyula Ortutay, the Hungarian ethnographer, understood that oral transmission, the handing of stories or histories down through the generations, is subject to radical collapse. 'Retelling,' he spelled out glumly, 'nearly always involves a change … in its latter, final stages … oral transmission comes to be equivalent to deterioration, to a process of stuttering forgetfulness.'

Proverbs are not folk tales, but they are context-dependent, and as contexts change, the proverb will wobble on its axis. *Live horse*, my mother says of her marriage, *and you'll get grass*. 'What does that mean?' we ask her. 'I don't know,' she says, laughing; 'what *does* it mean?'

Images too? Who knows? Bruegel, we have seen, painted wheels, wheel after wheel after wheel. Perhaps it is a biographical fragment. Perhaps he grew up within sight or sound of a waterwheel. Perhaps his father made cartwheels. Perhaps his father had a cart.

Did Bruegel draw his *Beekeepers* and suddenly find he had included a watermill? Did he feel an inexplicable need to include in *Netherlandish Proverbs* the one about putting a stick in the spokes? Perhaps he had simply no idea. Not all contexts are available to us. Nor were they all available to him.

A codified legal system in a non-social world would be an insane document: so too *Netherlandish Proverbs* is a glut of statutes shorn of their cases. The panel as a whole is a madness.

In the early 1930s, the psychologist Alexander Luria travelled to Central Asia and undertook fieldwork with illiterate and semi-literate people, classified as such on a scale. He posed his subjects questions in the form of riddles, the riddle being a familiar oral device, and noted that, among other characteristics, 'illiterate (oral) subjects identified geometrical figures by assigning them the names of objects, never abstractly as circles, squares etc.' while the 'moderately literate identified geometrical figures by categorical geometrical names'. Thus, a torture wheel could never be merely a circle. In the same way, presented with the sequence *hammer, saw, log, hatchet*, the illiterate routinely failed to identify log as the odd one out. To us, the other three are tools. To Luria's subjects, all four were inextricably, because situationally, related. And then, to syllogistic queries such as *In the far north, where there is snow, all bears are white. Novaya Zembla is in the far north and there is always snow there. What colour are the bears?*, illiterate peasants replied by providing for themselves real-world contexts: 'I don't know. I've seen a black bear. I've never seen any others … Each locality has its own animals … You find what colour bears are by looking at them ... how am I sure that you know for sure that all bears are white in a snowy country?' It was especially hard, Luria found, to trap the peasants' reasoning within the logic of the syllogism. They would be suspicious, wonder about the good faith of the questioner, try to imagine why he was asking what he was asking.

Luria, in this and in his other work, thought always in terms of social development. As Oliver Sachs, a correspondent of Luria late in life (Luria died in 1977), noted, 'There is never just a child; there is always a mother and child; always a dialogue.'

We are what we are largely in virtue of our social being. In particular, oral thinking, as opposed to literary thinking, is situational. Drop my mother in a residential care home, in other words, and she will become a mumbling old shrimp. Usher her into a sixteenth-century village and she will become a witch. Sit her in a car with me on the Newmarket Road, and she will be, briefly, fitfully, my mother again, rambling as ever about the trees in Ireland.

At some point during my Bruegel project I tried to memorize all the proverbs. Keys are available. Alternative readings. How much can I remember now? Start bottom left. *She ties the devil to a cushion* (an expression of her shrewish power); *he bites a pillar* (hypocrite, bigot); but memory gives out. I cannot retain all of this uncontextualized information. I can no longer retain information for its own sake. Only that which has a bearing on my ends, even if my ends are insane.

I do not remember the proverbs, but I do remember all of Bruegel. Years of looking, years of filling in, annotating, crossing off. Years of travelling to actual places to see real objects. The father of a friend of mine is an international chess master who claims he can remember every game he has ever played. He was never so strong, he says, at remembering the games of others, but his own games are lodged without effort in memory. He says it is like recalling a day out, or a walk you have been on: you can remember which forks in which paths you took, where you ended up.

I cannot lay claim to such a trove of memory, but Bruegel I just know. I can picture each panel, more or less accurately, down to considerable, if never exhaustive, detail. I can recall the

rooms in which they hang, which paintings hang near them, the colour of the wallpaper, the sound the floor makes when you walk on it. I can put myself in the big Vienna room and talk you around the walls, like a lone actor in a memory theatre.

But now that I have set it all down in words, can I expect to retain it all in memory? How long before it fades? How long before I place the wrong painting in the wrong city, and stand adamant by my mistake because I am still, in my imagination, the final authority? Memory will certainly fade. Detail, chronology, spatial relation. The objects will float free of their spatio-temporal moorings and circle in my head, vaguer and vaguer, losing colour, piquancy, meaning. Until I am boring my children's children with unsolicited and fragmentary sets of reminiscence, about a painting I once saw in Berlin.

Next to *Netherlandish Proverbs* hangs one of Bruegel's smallest panels and, I like to think, his only portrait: *Two Monkeys*. Two-collared or red-capped mangabeys, natives of West Africa, sit chained in a window giving on to a view of Antwerp and the Scheldt from the south-west. The monkeys look a little mournful, but they have been eating some walnuts, so perhaps they are okay.

The panel has been extensively, some might say wondrously, interpreted. Sellink calls the readings, ranging from commentary on the introduction of a toll on the Scheldt River in 1562 to an injunction to imitate God as the monkeys imitate humans, 'amusing'. I have little to offer. Prior to the Berlin trip I spend a little time looking at videos of mangabeys online, and find myself wondering if they have any at Antwerp Zoo (provisional answer: no, but I should perhaps

visit to verify). If you were the director of Antwerp Zoo, you'd make it a matter of professional pride to keep a pair of mangabeys chained up and eating walnuts at all times, if possible within view of the Scheldt.

In 1562, the same year that he painted his monkeys, Bruegel produced a drawing for an engraving of monkeys robbing a sleeping pedlar. Twenty-nine monkeys rummage through the pedlar's stuff, try on his boots and his spectacles, urinate in his hat, pull down his breeches and hold their noses at the emergent stink, ride his hobby horses, bang his toy drums, tootle his toy trumpets. The pedlar sleeps on, a smile on his face.

Monkeys make mischief, and the scene is humorous. Not much need for cryptography here, as Sellink notes; it is 'one of Bruegel's few compositions that we can take purely at face value'.

Perhaps. We might note in passing that it resembles another drawing and engraving, in the British Museum, of Elck, or Everyman, in which multiple versions of a bespectacled figure rummage and search through a pile of objects not dissimilar to that of the pedlar. In fact there is a pedlar's pack in the middle of the pile: a chessboard, weighing scales, lanterns, trowels, etc. And there is an inscription on the drawing, amplified in the engraving: 'nobody knows himself'.

What is he looking for, Everyman, in this Ciceronian dementia theatre? We search and rummage and try out and puzzle over; but, monkey or greybeard, we are no nearer understanding.

*

I am coming to realize that Bruegel was not primarily creating puzzles for others to solve: more fundamentally he was attempting solutions to much more elaborate and defeating puzzles which he felt compelled to address, in the silence of his studio. How, for example, to place the isolated spots of lurid beauty in the world into a meaningful relation; how to accommodate the marginal, the disenfranchised, the broken; how to expose things for what they were without providing simplifying, explanatory or moralizing contexts; how to attempt all this, moreover, in a world – the Spanish Netherlands – that was fast collapsing to a state beyond consensus.

How do you reconcile your mortality, and the mortality of your children, with the pursuit of worldly goals – excellence in painting, for example – or goods? How do you dance beneath the gallows if the gallows is erected on the smouldering field of Armageddon, where the only music is the gnashing of teeth and the wailing of the damned?

Back in Munich, a tour guide is talking about *The Land of Cockaigne* to a group of pensioners, some of whom have brought stools. I cannot get near the painting, so I watch the tour guide, and the faces of the pensioners – attentive, bored, polite, unreadable – for a few minutes. People on the brink. The tour guide has a lot to communicate about Bruegel, but it is all in German, and my German is sketchy.

However, there is only so much she can be saying. Bruegel's *Land of Cockaigne* (generally so-called in English; the Flemish *Het Luilekkerland* more precisely translates to *The Lazy-Luscious Land*) illustrates the mythical Cockaigne, familiar from Netherlandish folk tales, and Elgar's concert overture, if you

are English. The land of Cockaigne is a place where food and drink and sex are available in endless quantities and on demand; where leisure and sloth and gluttony are privileged.

Bruegel's composition is derived from an etching made in around 1560 by his alter ego, Peeter Baltens. Both images show a representative sprawling wheel of humanity – soldier, scholar, farmer – lying under a round table, and surrounded by the sort of delirious visions the starving might entertain: fowl and pigs, already roasted and providing their own cutlery. One roasted bird is flying directly into the open mouth of a waiting knight. A cooked egg running around on legs which, when Steve Barley gave me a postcard of it, I took to be escaping, but now know to be solicitous to be eaten. Roofs tiled with pies or puddings, fences woven with sausages. Drink and eat and sleep.

This is paradise as imagined by the gluttonous and indolent, of course, and we are probably supposed to disapprove. In some representations – the etching by Baltens, and a posthumous engraving after the Bruegel by Pieter van der Heyden, for example – the scenes of plenty are framed by moral *sententiae*: 'idleness, indulgence and excess are wicked … None has seen this land other than Good-for-Nothings, who were the first to discover it …' etc. You arrive here, we are told, by eating your way through a mountain of buckwheat porridge, and sure enough, one lucky, or reprobate, soul is disgorging himself from just such a mountain in the background, spoon in hand.

Is buckwheat porridge not a touch austere, in fact? Perhaps after a life of mostly insufficient buckwheat porridge, a world of tarts and self-carving pigs might be a cosmic compensation we all deserve. It is a 'Big Rock Candy Mountain' version of the afterlife, the sort with which we might beguile children.

The tour guide wraps up with a smile and her audience pick up their stools and shuffle off in search of more art, more keys to life.

This one was easy. We have the key to hand. Even so, the painting has been assaulted with the ladders and grapples of interpretation for many years now. It cannot simply be a trivial indulgence, the thinking goes. It must be political, moral, religious. It is cryptic. It is, after all, late Bruegel.

For example, the land of Cockaigne is situated 'near the gallows', according to a Flemish text of 1546 quoted in Sellink as the probable source both of the Baltens and, therefore, of the Bruegel. This, then, is what you look like when you acquiesce; when you take the broad and easy road. Lifeless in the midst of life.

Is that what we imagine for ourselves in death?

Lifeless in the midst of life: *The Land of Cockaigne*, detail.

People give accounts which vary in detail, but in general we picture a place where all grief is assuaged, all struggle put aside, all questions answered, all those tricky corners of life straightened out; where you can have whatever you feel life denied you, even if that is a roof made of pies; a place where, whether we retain our identity – soldier, scholar, knight, farmer – or are dissolved in a community of the blessed, we are connected, both to the living we left behind and to the dead who went before. It is a place, in short, where we still count.

This is what we picture, even if we know it not to be possible or true. These are the steps of the dance. Every dance has steps or moves which are learnt from our peers and our forebears, steps which are specific to a time and place. Steps which the whole community knows, even if not everybody wishes to dance them.

There is, for example, such a thing as a labyrinth dance on the brink of the grave, a ritual interweaving dance designed to baffle the advance of death, characterized by a retrograde step. An equestrian version was danced in the *Aeneid* at the funeral games of Anchises, and another by the youth of Athens to mark the return of Theseus from Crete and the labyrinth of Minos.

In the labyrinth dance, as we approach death, so do we retreat from it. As we retreat from it, so do we approach it. Death is held, in the imagination for a moment, playfully, contemptuously, at bay. A dance under the gallows.

Jack Gottlieb, in his book on his thirty-year professional relationship with Leonard Bernstein, relates how, after a concert at the end of the 1980s where Bernstein had conducted

Tchaikovsky's 6th Symphony, Lenny left the podium blanched and drained. He felt, he explained to Gottlieb, 'on the brink'. Whether a different, non-musical Leonard Bernstein – nearing death in a worn but comfortable chair, watching a ball game, say, with a beer, reflecting intermittently on whatever life he had lived – would ever experience moments like this, 'on the brink', is unknowable. But perhaps every considered, even every half-considered, life ends like this. We read accounts by terminal cancer sufferers who, in amongst the pain and the morphine and the chemo, talk of the pinpoint beauty of the world as they now experience it. Birds, grass, sunlight, children, all suspended in moments of wonder encountered on park benches. So perhaps all we need is not time, but focus. And art, by its nature, focuses. Perhaps for this reason artists live always 'on the brink', a sort of professional damage akin to that of actors who live their lives on a bow wave of emotion constantly about to break.

Gottlieb goes on to gloss what Bernstein might have meant by 'on the brink':

> At such enviable moments, Bernstein was suspended between two worlds. In that timeless void he must have achieved the Hassidic ideal of fusion known as *d'veikut*, a kind of cosmic glue that leads one toward a sphere where mystical powers dwell, where joy is its own reward.

Bernstein, after all, was a conductor known for his dance-like presence on the podium.

XI Singularity

Bamberg (0.065%)

'For his art did expresse
A quintessence even from nothingnesse'

John Donne, 'A Nocturnal upon St Lucy's Day, Being
the Shortest Day'

There is a singularity at the heart of my project. A tiny black hole. I can measure it: 314 cm^2. A 0.065 per cent sliver of the total Bruegel Object. A panel I cannot see. An invisible Bruegel. *The Drunkard Pushed into the Pigsty*, the only spreadsheet Bruegel not on public display.

It is a small roundel which was firmly attributed to Bruegel in 2000 – although a tentative attribution had been suggested, and largely ignored, in 1975 – and was sold two years later at Christie's. For a while it was on loan at the National Gallery in London, but I barely knew who Bruegel was back then, and I do not know where it is now. Hanging on some corporate boardroom wall, perhaps. In a Japanese bank. On a Texan ranch. In an oligarch's dacha. Held in a safety deposit

box as collateral to a drug deal. Bruegel, alive and lubricating the art market. In any case, I have no hope of seeing it.

Perhaps it is not quite a singularity, however, since considerable information flows out from it, not least in the form of copies, one of which, by Pieter the Younger, is on display in Bamberg. This is, not coincidentally, where my brother and I stay on our first visit to the Wagner festival in Bayreuth, in between Darmstadt and Munich, drinking the smoky beer, eating the dumplings, and searching out and documenting the little Brueghels.

The Brueghel copy is, as so often, faithful and unfaithful to the original in curious ways. It respects the colour palette precisely, and the details of peasant and pig. But it includes a crowd of figures to the rear which were supplied, not by the Bruegel original, but in an engraving taken from it, made by the young Johannes Wierix in 1568. Wierix also must have had access to the original, but he includes the crowd of faces to occupy what would otherwise, in an engraving, be an unforgiving blank background.

Of what is our peasant guilty? In all likelihood, of some adulterous liaison. The pig in the sty is enjoying a dish of turnips and peelings, and the turnip, we know from Pliny and elsewhere, is the countryman's aphrodisiac. However, an early first impression of the engraving by Wierix bears a double inscription to the effect that the poorest of the poor are treated like pigs, and that this might be the viewer's fate tomorrow. It may just be that our peasant is guilty of extreme poverty.

More information is forthcoming. Technical analysis carried out before it was sold at Christie's, and vanished, tells us that the roundel is on walnut a couple of millimetres thick, at some later stage transferred to an oak support. There are traces of gilding on the underpaint, suggesting it was framed before it was painted. The walnut suffered woodworm at some point in its life, and is cracked down the middle, possibly when it was transferred to the oak support. The two halves are microscopically misaligned. The signature which emerged under infrared reflectoscopy is of Bruegel's Roman variety, with roman numerals indicating the date, and a ligature between the V and E. Fine grooves are visible in raking light, suggesting that whoever made this panel finished its surface by turning it on a wheel. And so on. As with black holes, we examine our objects askance, by inference.

And our visit to Bamberg confirms that the panel was almost certainly one of a set. In Bamberg, there are four roundels, showing respectively our pigsty peasant, an arrow-maker, a pedlar seducing a woman with a gift, and a bread-eater.

Information continues to spill out of the tiny rent in my project. News from nowhere. Of Bruegel panels lost for ever, or for now; of Bruegels perhaps still to come to light; of a project spilling out beyond the visible spectrum.

On my spreadsheet, *The Drunkard Pushed into the Pigsty* occurs twice: once in the main body of core-Bruegels, and once, below, in the sections devoted to possibles and probables – panels sometimes or often attributed, panels once attributed, panels of interest (copies, possible copies of lost originals, etc.).

Over the years I grow accustomed to the compromises that a tilt at completion necessarily entails. Where do I draw the line? Should I go out of my way to visit the misattributed *tronies* in Bordeaux and Montpellier? The panels of *A Peasant Couple Attacked by Robbers* in Stockholm, or *The Hireling Shepherd* in Philadelphia? What about the drawings? They mostly reside in public collections, viewable only by request. But when I make such a request to the Albertina in Vienna they briskly reply that, if I wish to view their holding of Bruegel drawings, I should attend the exhibition at the end of 2017, which of course I do. They see me for what I am: not an academic, bearing no credentials. And what about the subtle question of engravings, posthumous prints, multiple divergent copies?

No. I am comfortable with a half-explored and ragged hinterland, an arbitrary line drawn through the collections of Europe and North America. There is no completion. There is no final moment. *The Drunkard Pushed into the Pigsty* is my memento mori of the project. My lurking singularity. My little talisman of sanity, allowing me to let things go.

XII Crowd

Budapest (3.136%) – Vienna

'[Bruegel] was a quiet and able man who did not talk
much, but was jovial in company ...'

Karel van Mander, *Schilder-boeck*

Mine is a solitary project, an expression of ego, a fruitless development of self. I move through the great cities and museums of Europe and North America clanking my armour like a grail knight as he traverses the empty forests of the world, muttering and wondering.

Bruegel, conversely, is the great painter of crowds, drawn to kermis and carnival, to the fall of angels and the movement of armies, to the welter of bodies.

One of us is lost in a crowd, signals swamped; the other has situated himself in an exquisitely precise relation of bodies. But perhaps in the end we are not so different.

*

My spreadsheet tells me that roughly 74 per cent of the total Bruegel Object (by number, not by area) depicts crowds of one sort or another. Thirty-one panels out of forty-two.

Crowd is perhaps an insufficient term. A crowd has a certain dynamic, an interplay, which differentiates it from the mob, or the mass, or from people going about their business. So there are not only crowds in Bruegel, but also throngs, multitudes, hosts, presses, gaggles, assemblies. Armies crossing Alps. Carnival villages. Scions of the House of David having their heads counted. Wedding parties. Torrents of demons cast from heaven. Cohorts of skeletons marching to the beat of a drum.

Bruegel, in the quiet of his studio, liked to think in a proliferation of bodies. But let us call them crowds, for short.

How big is a crowd?

The peasants in Bruegel's village scenes mostly number in the low hundreds. In *The Wedding Dance*, I count 126. There are similar numbers in *The Fight Between Carnival and Lent*, *The Census at Bethlehem* and *The Massacre of the Innocents*.

Such a number is roughly a Dunbar number, a proposed quantification by the anthropologist and evolutionary psychologist Robin Dunbar of the cognitive limit to the number of stable social relations we can maintain, derived from correlations between average brain size and social group size in primates. Dunbar's number for humans is usually given as 150. That seems like a lot of people, and indeed, Dunbar regarded this as an upper limit likely to be reached only when a group is required to stick together for survival purposes – as in, for instance, a subsistence village or a nomadic tribe.

Dunbar went on to produce empirical support for his eponymous number, looking at kinship and tribal groups, military organizations, company departments, academic sub-specializations, and active friends on social media. I don't know if he has troubled to count the figures in Bruegel panels, but he would find it illustrative.

In the Budapest *Preaching of St John the Baptist* I count 213 individuals, not including the Baptist, Christ or the dog in the foreground, and setting aside the tiny crowd gathered around the baptism taking place by the river in the background. Somewhat more than a Dunbar number, then: this is a congregation. And a congregation, as Dunbar foresaw, is bonded by a need for a certain sort of survival, whether that survival be salvific (survival of the soul after death, a survival mediated by the church) or, as in this case, social.

In early 2017, *The Preaching of St John the Baptist* is not hanging in its accustomed place in the Szépmüvészeti Múzeum, which is undergoing a three-year renovation, but has been moved over the river to Buda Castle. So on the morning of the one full day my brother and I have in Budapest we walk over the Széchenyi Chain Bridge and take the little funicular railway up the hill to the museum.

On the funicular, it is exclusively tourists. We stand in line for ten minutes watching the Segway tours pulse past on Clark Ádám tér. Then we pay our tickets and climb in the little stepped carriage. A Chinese family crams in with us. The father is wearing a blue baseball cap bearing the logo of what appears to be a Chinese golf club.

As we judder upward, we all look out at the views from under the brim of our respective hats. Halfway up, we pass a different set of carriages heading down. Funiculars work on a principle of counterbalance. Tourists go up; tourists come down. The ride takes about forty seconds.

Crowds of tourists, their motions and desires, are governed by attractions. A funicular railway, for example, draws a small crowd, regulates its flow, portions it out, slows it down.

In the sixteenth century, there was no such thing as a crowd of tourists. A crowd of any sort was something to be seen. When would you encounter a crowd? At Mass on a Sunday, on holidays, holy days, processions, saints' days, carnival. It was an occasional thing. Now the crowd is normative. It is how we experience art. Sport. The city. Funiculars.

The national galleries draw huge crowds to exhibitions. People pay, and queue, and worm with their elbows towards the light, the illumination of Great Art.

But you can find or engineer exceptions. I have stood alone for an hour in front of *The Hay Harvest* (in Prague); also in front of *Dulle Griet* and *Twelve Proverbs* (Antwerp); also in front of the Paris *Beggars*; and *The Magpie on the Gallows* (Darmstadt), and *The Adoration of the Magi in the Snow* (Winterthur).

No shock, then, that in Budapest there is not much going on in the Castle Museum. I have neither recollection nor note of a single other piece of art. I have a recollection of being in the presence of certain historical frescos illustrating key moments of Hungarian history. There may have been a very large number of nineteenth-century Hungarian genre pieces.

None of this draws the crowds. A few lost individuals drift around. But as so often I am here for a single painting, a single shoot of living interest in a dead forest of information.

Some crowds are self-sorting, some are pre-sorted. Van Eyck in his great Ghent altarpiece, *Het Lam Gods*, paints his crowd as an anatomy of society, a sort of disassembled procession, with the estates ranged by degree. There are always hot tickets to good seats, and these are generally occupied by the grandees. The groundlings strain their necks to see, to catch a glimpse of whatever it is.

Bruegel's crowd in the Budapest panel is more loosely arranged, but it has its structure also. There is an inner circle surrounding the Baptist: the attentive, the devout, the respectable, the burghers, the middle classes. And there is an outer circle: Gypsies, pedlars, heretical monks, Ottoman Turks, masterless men and women.

You know them mostly by their hats. In Bruegel, almost everyone wears a hat of some description. In *The Wedding Banquet*, everyone is sitting down to eat in his or her hat. In *Children's Games*, children play leapfrog and tug of war, mostly in their hats. In *The Wedding Dance*, everyone dances in his or her hat or headdress. In a society given to identifying its insiders, its outsiders, with insignia or badges of shame, the hat announces your social being.

In the inner ring, the headgear is conservative in the main. Women wear the folded white linen hood known as a *sluier-kap* or *hovetcleet*, although one woman in the background is wearing a round hat tied under her chin with a white cloth. Men wear black berets, flat caps or hoods. There are some domed wicker hats, I cannot tell if worn by men or women. And then, as we work towards the outer rim of the crowd, headgear becomes more idiosyncratic: we have an Ottoman turban; a pilgrim's shell-covered hat; a little pork-pie hat,

Fragmentary information from far away: *The Preaching of St John the Baptist*, (Pieter Brueghel the Younger, after Bruegel) detail.

worn by the male Gypsy; a nightcap on the soldier front right, monkish cowls, caps with tassels, a great flat red beret, and on and on. And then, centre stage, fulcrum of the entire painting, the hat of the female Gypsy: a great pale wheel of a hat. It appears to have been wrapped tightly in a plain but decoratively striped cloth, and the stripe has been broken up in the pleats, a sort of illegible calligraphy. Fragmentary information from far away.

Romani or Sinti peoples were taken in the sixteenth century to be nomadic Egyptians, hence the exonym, *Gypsy*. In Hungarian, Romani are known as *fáreónépe*, from *pharaoh*. Like all nomads, they lived on the edge not just of the world but of a magical knowledge. A source of ancient wisdom, then, and excitement. But itinerants also make sedentary populations nervous in a variety of unaccountable ways.

When in December 1942 Himmler promulgated a directive expelling all Romani and Sinti people from the Greater German Reich, there were certain exemptions, including 'Gypsies of pure-blood and ancient lineage', since Gypsies, according to German anthropologists, were Aryans, albeit Aryans corrupted by miscegenation over the centuries. In the event, local fears and hatreds, and inexact application of the quickly forgotten laws, saw the extermination of anything from 30 to 70 per cent of Europe's Roma and Sinti population: 200,000 to 500,000 individuals. The inexactness tells its own story.

In the labour camps and extermination camps, Roma and Sinti were often classed as 'asocials', a catch-all category for those who, to Fascist eyes, did not contribute to society but in some sense preyed on it: vagrants, beggars, alcoholics, drug addicts, prostitutes, pacifists.

The Roma and Sinti refer to the Holocaust as the Porajmos, or the Devouring. No survivor was called to testify at the Nuremberg trials.

Christ and the Baptist both go bareheaded. If the hat is a civic symbol, a sign of belonging or not belonging, then barehead-edness is a sign of asociality, of the wilderness. In the

wilderness, St Jerome almost always goes bareheaded. John the Baptist never wears a hat. For Jesus, a halo and a crown of thorns are quite enough.

John the Baptist was not by reputation a convivial soul. He was a classic introvert, comfortable in wildernesses.

Although *introvert* is clearly the wrong word. Was the Baptist also low on agreeableness, or high on conscientiousness? No. The Baptist is more properly wrapped in a solitary psychosocial term: he is a melancholic.

A melancholic to the Renaissance was a stymied creative. Such, at any rate, was how the art historian Erwin Panofsky interpreted Dürer's famous engraving – a creature locked in a creative abyss, at loggerheads with his or her own creative drives.

Thus the Baptist – withdrawn, solitary, a mystic about to embark on a great cosmic project – ruminated in wildernesses. What did he have to do with society and its crowds?

My father during his life wore a variety of hats but, introvert or melancholic, he never managed to sit easy with his crowd. To wish to belong – and he did wish to belong – is to make yourself vulnerable.

His crowd was the giant General Electric Company. In the mid-1960s GEC employed a firm of consultants to assess its middle and junior managers. My father was subjected to several days of numeracy, literacy, problem-solving and psychometric testing, alongside interrogative interviews. The results were clear. My father, they decided, was a highly numerate, highly literate individual, with 'excellent' social intelligence (although 'he prefers working alone') and a good 'ability to

cope with unusual or problem situations'; but his 'regard for company rules and regulations [was] very low' and he had 'a rather exalted opinion of himself', and no decision-making capacity whatever. Under no circumstances should he be considered for further promotion within the organization, and the authors expressed puzzlement that he was able to discharge his current responsibilities competently.

He had either got on their wrong side, or they had found him out.

They wrote up their findings in a carefully worded if also formulaic document which went on file and effectively destroyed any hope of career fulfilment with the General Electric Company, my father's home at that point for more than twenty years.

In an age of social advancement, my father had advanced as far as he was able. He had read his Shakespeare and bought gramophone records of classical music. He had bought his clothes from Aquascutum and his furniture in the Conran Shop. But now he had been found out, the secret melancholic in their midst, destined for godless wildernesses.

However, not being a man given to decisive action (as the document took pains to note), it was more than a decade before he moved on – in 1977, the year his own father died.

For some reason, my father kept not only the fatal document, close-typed on three tissue-thin sheets of paper, but a duplicate of the fatal document. I first read it, with great hilarity, when my parents were moving house after my father's retirement in 1995. In amongst the stilettos to his career, they had captured him as a man uncannily well.

I don't know whether my laughter was cathartic to him. Perhaps he had been carrying around this immense burden of secret failure, and now saw it for what it was: a sham, a nothing, an irrelevance. Perhaps his shame redoubled in the face of his laughing child. He was an intelligent man, so perhaps a bit of both.

Either way, he still held on to the document, a sliver of poisoned apple skin slipped in among the papers of his life. It is possible it meant nothing, that he kept it. Some years after he died, when my mother moved house for the final time, I found receipts for furniture he had bought in the 1960s – Conran commodes, Slumberland beds, Quad hi-fi, something called a GoGo chair – and manuals, and bills, and correspondence. I found the receipts for my school fees, all my old school reports, details of salary and bills paid and ancient quotations for work never undertaken. It was like turning up papyrus fragments of a lost civilization: once you have mastered the script you see how banal it all is, the day-to-day of life. But here anyway was a man waiting a final judgement, a man who would be able to render account.

And I found that document again and reread it. And this time it did not seem so funny.

My favourite theory, for what it is worth, is that my father, with his exalted opinion of himself, believed not only that many of his colleagues were either idiots or Freemasons or both, but that especially these consultants with their 'tests' and their 'science' were a ship of fools. And he was right. Every company, every social or corporate institution, every Masonic lodge, is a ship of fools. But he may have

Osram (*G&C*) Limited

His social skills may be rated satisfactory for work as an Executive. He has good knowledge of the principles of supervision from a theoretical point of view and his understanding of human relations in face-to-face may be rated excellent.

His work productivity will probably be at a sub-standard level when compared with Executives.

Mr. Ferris dislikes participating in bargaining, arbitrative and persuasive activities.

He dislikes selling intangibles or ideas and he dislikes speciality selling.

His interest in outside selling and his interest in handling sales complaints (relatively) may be rated average.

In the business domain, he has good interest in business management in general and his interest in buying activities and labor management relations may be rated average.

He dislikes production supervision.

His regard for company rules and regulations is very low when compared with Executives. He tends to behave as a rugged individualist rather than as a company man.

Parenthetically we might add that he has high interests in artistic, amusement and musical activities. We refer here to interests; he need have no talents, skills or abilities in these areas.

His ability to withstand business pressures is only average when compared with the criterion group. We feel that he will have difficulty tolerating crisis situations and handling heavy work loads.

His personality structure is negative for work as an Executive. He is more submissive than dominant in face-to-face relationships , he is more introverted than extraverted and is a non-social person.

He has a rather exalted opinion of himself and at times has a tendency to "look down upon" people.

Considering the total test pattern, we find it poor for work as an Executive and we do not feel that he has potential for upgrading beyond his present level — in fact, we feel that he will have difficulty handling his present position in a truly effective manner.

This time it did not seem so funny: my father's GEC appraisal.

underestimated the capacity of these consultants occasionally to glimpse this for themselves. Unlike my father they were prepared to play the game.

My father, usually courteous, did not suffer fools. He could deploy a sharp and accurate tongue from nowhere. I like to think he said something. Declined to play. I like to think he earned his exile.

Muttered witticisms will not steer a crowd. How, then, does an introvert, a melancholic, a Baptist get a purchase on a mass of humanity?

Crowds are, in essence, simple. In 1986, graphic artist Craig Reynolds published a paper in which he demonstrated realistic flocking behaviour of bird-like creatures, which he called BOIDS (Bird-oid objects), based on a simple three-rule algorithm: avoid hitting your nearest neighbour (separation); steer in a direction that averages that of your local flockmates (alignment); and steer towards the centre of mass of your nearest flockmates (cohesion). Starlings and sardines, we must suppose, are running similarly simple algorithms. So are the tourists in Budapest. So was the General Electric Company. And so am I.

But simplicity has its pitfalls. In 1921, the American naturalist William Beebe observed in the jungles of Guyana a singular phenomenon, known now as an ant mill. A large body of army ants had lost the pheromone scent of the colony and had defaulted to the next command level: follow the ant in front. The ants were marching in a great wheel with a 1,200-foot circumference, each ant taking two and a half hours to make one circuit. In the end, most died of exhaustion.

The Baptist organizes the crowd by the power of his voice, encoding the simple logic of salvation and damnation.

Bruegel organizes his crowd by equally simple consonances of landscape. The landscape is conducive to preaching, to quiet involvement and listening. The trees fork like benches, the glade opens up, protects.

The interest of the crowd, however, is all on the fragment-ing margin, and this is where you, the viewer, stand. One of the burghers, whom some have taken to be a self-portrait, has turned his back on the Baptist and is having his palm read by the male Gypsy. On the one hand there is the gravitational mass of the Baptist with his weight of unvarnished words, and on the other there is the volatile hinterland of occult truth, where to wander continents is to accrue knowledge, understanding, oddity, and perhaps some shells in your hat.

And is the centre as benign as it seems? We know that it would not take much for that in-crowd of respectable burgh-ers to turn on the nomads who fringe it: the pedlar, the pilgrim, the Gypsy. Elsewhere in Bruegel, after all, a drunk-ard is pushed into a pigsty by his fellows. Elsewhere in time, Roma and Sinti are pushed into gas chambers. One of the terms of the social equation is ostracism. Pluck out what is strange, singular, impure. Some elements of that crowd are shortly going to turn on the Baptist and see him beheaded, crucify his Messiah.

Archetypes, we should not forget, come bundled in pairs: one man's collective purpose and solidarity is another's lynch mob. And what is the Baptist's trademark, in fact, if not a ritual of exclusion and inclusion, a marking of the sheep and the goats?

The art historian Hans Sedlmayr wrote an essay in 1934 on what he called the *macchia*, or the visual thumbprint, of Pieter Bruegel. He contended that Bruegel did not organize bodies or objects *in* so much as *against* or *across* space. Bruegel had practical facility but a peasant mind and would therefore

paint discrete little splotches of paint standing for a child, or a dog, or a bagpiper; and then there would be a stretch of unarticulated space, then another splotchy object, and on, and on. Paintings in his middle period in particular – *Children's Games*, *The Fight Between Carnival and Lent*, *Netherlandish Proverbs* etc. – were a mass of detail scattered over the surface of the picture plane. There was no sense of composition, just an array of detail spread out over the panel. *Macchia* in Italian means stain or spot, just as you might mottle your coffee with a splotch of milk and drink it *macchiato*.

For Sedlmayr, this way of organizing crowds in particular spoke to the barely human quality of the peasant. These people are not fully separated one from the other, do not function in a governed or self-governed way, hence are disorganized, disjointed, merely contingently grouped.

Sedlmayr summarizes it as follows:

They are all manifestations of life in which the purely human borders on other, 'lower' states that threaten, dull, distort, or ape its substance. Primitives – a hollow form of human; the mass – more raw and primitive than the individual man; the deformed – only half-human; children – not yet completely human; the insane – no longer human. These are liminal states of humanity in which and through which the nature of man is cast into doubt. And they are the very subjects … to which modern anthropology has turned its attention in recent times, as if it were possible to grasp the nature of humanity precisely in these liminal states … (One thinks of studies of the psychology of primitives, children, the mentally ill, the crowd, apes, and the intoxicated.)

Sedlmayr was an enthusiastic Fascist. An Austrian, he welcomed the *Anschluß*, having joined the Nazi Party in 1932. He left it again in 1933, only to rejoin in 1938. He is said to have recommended to his students that they denounce anti-Nazis to the Gestapo, punctuated his lectures with Nazi salutes, and proposed raising an Adolf Hitler City on the ruins of the depopulated Jewish quarter of Leopoldstadt in Vienna.

No surprise, then, that the collective peasant body, characterized by disfigurement, dissoluteness and knowingness, was his horrifying other. Bruegel's crowd was a noisy crowd, and a fascistic society seeks to damp the noise. Cherubic children play 'Edelweiss' on tiny handbells to the delight of their well-fed and doting bourgeois parents, while round the back of the pigsty blackshirts bludgeon the bagpiper and the cimbalom player, suppress their discordant half-tones, their godawful peasant honk.

In Budapest my brother and I eat goulash and pork and dumplings, ride the funicular, and in the evening walk out to a jazz club. The evening's music is unaccountably rounded off by an a cappella group being invited up to the stage to sing Billy Joel's 'And So It Goes' in pleasantly thick Hungarian accents.

In between, we visit a public bath, and I have a crowd-related collapse. My brother is keen to bathe in the waters, he has been to Budapest before and says he enjoyed it. But the first thing I see in the Budapest baths is a jowly paunchy man flip-flopping around in a little towel. He seems quite at home, naked in this public place.

So, like a mad-eyed horse, I refuse. My brother and I talk it over for quite some time. We agree in the end that I will wait in the great echoing atrium while he goes for a paddle in the sulphurous waters.

He is gone for an hour. I sit in the atrium and stare into space, contentedly running my broken flocking algorithms: sit and wait, do not participate.

And so it goes.

The next day, we take the train for Vienna.

My brother has just finished writing a book, a biography of that most bilious of melancholics, Beethoven, so we do some of the Beethoven trail. We go out to Heiligenstadt and poke our noses into the tiny museum in the house where the composer is said to have spent some summers and written his testament. We visit the Palais Lobkowitz and the Eroica Saal, where the Eroica symphony was first performed. The room is empty but there is a piano, and my brother picks out the theme, summoning crowds of the dead, his barmy project and my own intersecting for a spell.

In the Kunsthistorisches Museum I set my brother free to head-spin around the room of rooms, the Holy of Holies (it is his first time), and try to get my bearings.

The room has undergone a transformation. Unfamiliar paintings by other artists hang like malformed satellites and asteroids in the gravitational interstices of the planetary Bruegels. And I am quickly aware that three Bruegels are missing: *The Peasant and the Birdnester*, *The Return of the Herd* and *The Suicide of Saul*. Where *The Return of the Herd* should be, there hangs a bewildering large landscape by Lucas van

Valckenborch with a robber chasing a man down a hill and an industrial forge in the valley bottom. Where *The Suicide of Saul* belongs, there is a coloured copy by Jan Bruegel the Elder of his father's putative (non-spreadsheet) *Visit to the Farmhouse*, a grisaille which hangs in Paris.

This is all a little destabilizing.

The left wall as you enter, however, is untouched, with its row of theatrical transformations: *Christ Carrying the Cross*, *The Conversion of Saul*, *Babel*, *Carnival and Lent* and *Children's Games*.

In *The Conversion of Saul*, New Testament Saul is being metamorphosed into the Paul of the Epistles. His epileptic transformation is under way somewhere in the background, in the middle of a column of weary and distracted soldiers who spread out around him like bacteria around a spot of penicillin in God's Petri dish.

The fact that this is an army argues a certain temperature of common purpose, of uniform spin. And the foot soldiers, as they tramp up from the valley below and snake away towards the pass, are for the most part uniformly silver-armoured. Uniformed armies were still some way off: the early seventeenth-century army of Gustavus Adolphus of Sweden was reputedly the first to wear anything approximating to a uniform.

To be a soldier in the sixteenth century, as in any century, is to raid the dressing-up box – until, at any rate, you fight in an actual battle. Bruegel, then, must have plundered around in his box of props and staffage, mental or otherwise, for likely outfits, and fitted out his little soldiers.

So it is that in the left middle ground, prominent and exposed on a bluff overlooking the gorge, there is a child in

... parody of a soldier ... *The Conversion of Saul*, detail.

armour, standing to attention like a parody of a soldier. He
has pulled helmet, cloak, short-sword out of the dressing-up
box and has got, not just close, but close enough to the look
of a soldier to get himself enlisted in an actual army.

But out on the margins of this uniform crowd the homo-
geneity breaks down: there are the officers, Renaissance *bravi*
in their sumptuous finery, feathers in caps or caps all feathers.
There are one or two camp followers in stripy blankets and a
dog handler in the foreground walking alongside a powerful
mastiff. The handler wears non-regulation leather jersey with
a powder horn at his hip and his tiny flask flung over his back
and hanging between his shoulder blades. Just right of centre,
foregrounded and astride a pale horse, a general dressed all in
black watches Saul's Ovidian transfiguration. It might be

Alba, the Spanish general, watching the Netherlands understand its destiny.

Take a step back, in fact, and there is no uniformity here at all. Everything is about to fragment. Each soldier, each camp follower, will shortly be responsible for his or her own salvation.

Hans Sedlmayr was readmitted to the art-historical fraternity after the war and elevated to the prestigious professorship in Munich. He had by this time renounced his Nazism, and had drawn close, instead, to conservative Roman Catholic elements in Vienna, publishing articles in the Catholic journal *Wort und Wahrheit* (*Word and Truth*).

To mark his accession to the chair in Munich, he read a new paper, again about Bruegel, this time focusing on one of the paintings which hangs in Naples, *The Blind Leading the Blind*.

In the paper, he describes the effects of having people look at Bruegel through a tachistoscope.

A tachistoscope is an instrument once popular with experimental psychologists which allows for the very brief and controlled exposure of visual stimuli to a viewer. They were used during the war to train pilots in aircraft silhouette recognition; after the war, advertisers liked to use them to display marketing material to subjects to test for impact and memorability.

Sedlmayr used a tachistoscope to display precisely controlled snatches of Bruegel to test subjects. His aim was to reveal the deepest-lying formal properties of a work. To show a painting for a few milliseconds, such that the viewer has no time to scan, let alone study, the image, and no time to

construct a reasoned response, would, Sedlmayr supposed, strip back that image to its formal essentials. With *The Blind Leading the Blind*, viewers of the tachistoscope-Bruegel were unable to provide any coherent narrative to explain what was happening in the panel. They could not identify the stumbling men as blind, could not even accurately recall how many there were. All they had time to register was a sense of the uncanny. A *queasiness*. The painting, seen like this in a lurid little flash of time, was *unheimlich*, uncanny. 'I saw something that inspired fear,' Sedlmayr quotes from among his responses; 'I saw something like a dance of death.'

Viewed through a tachistoscope, *Christ Carrying the Cross* would be a hard painting to grasp. Certain elements – the torture wheel, the mill referencing the bread of the Eucharist, the circling corvids, the flecks of military red – might remain with us, but the singularity at its heart, the cross, that vehicle of suffering, persecution, and, to a certain sensibility, of mercy, would be lost. We would see only a populated landscape, experience a fleeting moment of *Unheimlichkeit*, perhaps, knowing ourselves to be in the presence of something uncanny: a crowd willing its own salvation by tearing apart its suffering God. Something like a dance of death.

Within the crowd there are subdivisions. A foreground group of John the Evangelist and the three Marys are painted in homage to earlier Netherlandish mourning groups, the Van der Weyden *Deposition* in the Prado, for example. Soldiers in red jerkins marshal the crowd here and there, punctuate its progress. Knots of onlookers surround Christ with his cross and, just in front of him, the two thieves sit in a tumbril,

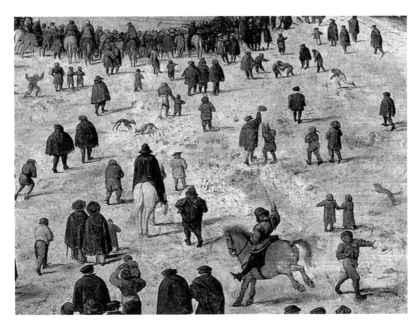

A day out: *Christ Carrying the Cross*, detail.

anachronistically clutching crosses and receiving the last rites. For the rest, it is a day out. Fathers carry their children on their shoulders to witness a marvel or snatch off their hats and hold them out of reach, in sport. Other children play games of their own, the adults fight and drink, or plod up the hill.

Unheimlich, though. Merely the glimpse of a crowd, after all, might do that for us. Because if there is one thing we, a social species, know instinctively, it is that a crowd, raised to the correct temperature, is capable of anything.

Sedlmayr believed that he had discovered, if not a scientific truth, then evidence of a certain subatomic, quasi-mystical play in Bruegel's paintings, something we can capture only

by filtering out our art-historical knowledge and engaging our spiritual intuition.

But such intuition was a faculty which Sedlmayr explicitly believed to have degraded: we think too much, we know too much, we delight too much in irrelevant detail, in the surfaces of life. Insofar as Bruegel verges on the modern and the godless it is here, where attention is shivered among a thousand objects and we no longer see clearly to the black or sacred heart of things – to the corruption of the world, or the redemption of humanity. Bruegel does not so much seduce us as scatter our powers of attention.

Perhaps the *Unheimlichkeit* Sedlmayr's test subjects experienced was in fact emanating not from the panels but from the man standing over them, egging them on, asking them to intuit God in the corner of their eye. But it may also be true that, beneath the crowded detail on the surface of Bruegel's panels, there does lie a psychological *imprimatura* informing the whole, something we might only grasp intuitively: a conviction of the deep springs of our collective life.

Bruegel may or may not have been of peasant stock. Karel van Mander certainly attributed the painter's insight into these peculiar small worlds to his village background. But then Van Mander is also the source of the myth that Bruegel would habitually dress himself in peasant's clothes and visit kermises and weddings, the better to blend in, to observe unobserved. Which was it? Peasant soul or the reconnoitring urban elite? Or both, peasant-child-made-good obsessively returning in later life to check his bearings with the Ur-Pigscape.

Towards the end of his short career Bruegel's figures grow larger as his panels grow smaller. The figures are not

monumental so much as human. The crowd is not necessarily less dense: we are merely deeper in it.

And it is organized now by bagpipes – in Flemish, a *doedelzak* (cognate with English *dawdling* or *doodling*) – the peasant's instrument of choice, drone and burden, perhaps, of the painter's youth, summoning him back from the city in his velvets and soft caps.

In Vienna, there are two bagpipe-Bruegels (a third, their companion piece, is in Detroit). In *The Village Kermis*, a bearded piper sits in the foreground on a bench, fingering some forgotten melody, drones thrown over his shoulder, his face a livid ecstasy of concentration, cheeks inflated like the goatskin bag he pumps at his belly.

Sitting next to him is a man who might be singing along, three-handled jug resting on his knee as he leans in to pick up

Deafening honk: *The Village Kermis*, detail.

and echo a well-known phrase, lips pursed in a search for tonal control quite at odds with the deafening honk his accompanist must be procuring from his great cock-and-balls of an instrument.

In the painting that hangs next to it, *The Wedding Banquet*, there are two pipers entertaining the seated guests, one with his back to us, dutifully playing, the other momentarily distracted by the sight of plates of food – puddings? soup? – coming in on a tray. The blowpipe has slipped from the piper's mouth, his fingers hover over the holes of the chanter, but the bag is sufficiently inflated, seemingly, for several choruses of song yet.

The bagpipes of the pipers in Vienna, the distracted *Wedding Banquet* piper and the apoplectic *Village Kermis* piper, and of one of the pipers in the Detroit *Wedding Dance*, are the same instrument: all three have the same elegant swan-necked bag, the same double drone. In both *Dance* and *Banquet* the drone has an identical white feather attached near the top of the longer, lower drone pipe; in the *Kermis* in the same position there is a little red-and-blue feathery tuft, like a large salmon fly.

There are other *doedelzakken*. It pays to be exhaustive. There is a drawing, for one thing, of a bagpiper, or *doedelzakspeler*. This might be the same set of bagpipes, but the bag is patched. There is a piper also in *The Magpie on the Gallows*, piping the people up to the dance, his face a red mask-like moon, the pipes perhaps the same instrument again. There are bagpipes in *Carnival and Lent*, a little piper in the background leading a procession towards the church. A scrawny bagpiper is being forced out of the door in the drawing *The Fat Kitchen*, and in *Children's Games* a foreground child is inflating a large bladder of some sort, a proto-bagpipes.

We can conclude, I think, that Bruegel had one set of bagpipes in his dressing-up box. In his imagination, the crowd is brought together by it – specifically, by the sound of it. A non-painterly, non-visual element. Something shared and understood by those who have seen peasants dance to a bagpipe; something not available to those of us who have not.

Perhaps in his secret peasant heart, there in his darkling studio in the big city (by the time of the bagpipe paintings, this would have been Brussels), the painter pined for a clear spring day and a kermis after winter, the sight of his clogged elders thundering over the compacted earth in a dance which was part courtship, part ritual. Here is spring again, says the dance. The young people marry, the old remember their youth. Drone and melody of village cycle: a little vigour is piped into the heart, an insufflation of warm memory.

Next to *The Village Kermis* hangs *The Wedding Banquet*, most famous of all the Bruegels. Around the long table sit the bride, her father, women in their *hovetcleets*, a cowled monk or friar, peasants, one or two grandees in finer clothes. Some are seated on a long, high-backed church pew, the father of the bride on a wooden dining chair; others, opposite, are on benches with untreated branches for legs, one on a three-legged stool. It is an ill-matched yet relaxed assembly.

At the back of the hall a much larger crowd, drawn by the smell of the food and the drone of the bagpipes, the general warm convivial air, tries to gain entrance, a good-humoured mob raising tankards and jugs, smiling, enjoying. Here and there, children are accommodated: one tiny one at the far end of the table; another in the middle of a rough bench; a third,

pudgy individual sitting on the floor, wiping his wooden plate with his forefinger. He has an ostrich feather in his flat red cap, an absurd holiday get-up.

They are delivering more soup or pudding on a tray improvised from a door balanced across two branches. One of the men carrying the soup has a white tassel tied in his hat; the other carries his spoon in the upturned brim.

Everything is a bit improvised, thrown together. The crowd is loose, socially diverse, easy-going, well fed. It is a crowd that creates its own energy, guarantees a certain futurity, or continuity (some have speculated that the bride is already pregnant).

A crowd, thus organized – multigenerational, self-regenerating, loose-knit but knit just the same – is resilient. The string passing through the knot is always different string, but the knot is always the knot. Not a crowd at all, in fact, but a community.

And Bruegel allows us to chase this community back to its origins. In the far corner of the Vienna room, across from the two great bagpipe-Bruegels, hangs *Children's Games*, the manic iteration of 215 children playing ninety different games in and around a market square.

The games range from role-playing games (a mock marriage, a mock baptism), through combative games (tug of war, running the gauntlet), games of chance (knucklebones and dice), games of athletic prowess (headstands, riding the fence, swinging on the bench, climbing trees, swimming), games of deception (blind man's buff), games of skill (hoops, stilts), games of imaginative play (dolls,

hobby horse), to games of generic rough and tumble. There are tops and quoits and balls, a mock joust, some target practice, and follow the leader.

Unusually for Bruegel, there is a strongly directed perspective scheme: a street to the right, a *gradus ad Parnassum*, funnels attention towards a church. But the goal is distant, if not actually illusory, and these children are not going anywhere. They are locked in their concentrated circuits of play, where all the material effects of this adultless town have undergone a transformation. The town hall becomes a play house, barrels and fences and benches are climbable obstacles or props, bricks are scraped for pigment, animal shit inspected for its ludic potential.

The rules of childish games are also Protean, volatile, omnidirectional. Nothing stays the same for longer than necessary, rules are amended, exceptioned, ad hoc, ad infinitum. Play is not a taxonomy of games each with a discrete rulebook; it is a mental space, an approach, a disposition, which, like the cosmos with its simple but peculiar physics, can manifest in any number of ways. Release these children from their painted stasis and they will whirl and collide, disband and re-form, melt and coalesce: brisk, unpredictable, semi-organized and anarchic.

Children seek out one another, and interact purely as ego. Each child shouts over the others, or retreats into him or herself, either way insisting on the primacy of his or her own version of things. But somehow this chaos of ego sorts itself out: each child, in the moment, accommodates itself in a rough-and-ready way to the 'game'; each child, over time, learns something about how to be in a crowd, how to rewrite continually his or her flocking algorithm. The

children, individuals or small groups, may seem atomized, separated one from the other; but they are all linked, like particles in a field, in a pervading social context, in this case, of *play*, with all its ambiguities of cooperation, solipsism, theatre and violence. Haltingly or exuberantly, soul-trippingly or tooth-gnashingly, each child, in her or his own way, enters the great dance.

The panel has been read as a molten society, a swirling cosmos in the process of forming. Edward Snow notes, for example, something else about the *macchia* of the painting. If you step back (or view it through a tachistoscope?), the girls' games fade from view and the male games dominate: the leapfrog which streaks across the middle of the panel, the rotational tug of war in the centre, the barrel-riding, the hoops rolling across the foreground. 'Both the linear patterns that thrust across the painting in all directions and the general mood of restless, driven activity tend to dominate the overall view and suggest a world attuned most obvi-ously to the energy that manifests itself in the boys' games. In this respect female difference is present in the painting much as it is present in the society whose formations the painting explores.'

However, something else is true of the girls' games: 'all [the girls] seem too happily immersed in primary activities and relations to be concerned with coagulating into larger patterns and power centers. But Bruegel appears to celebrate rather than feel threatened by this asociality: these images are among his most affectionately rendered and the ones with which as an artist he seems most happily to identify.'

In other words, removal from the violent coagulations of society in delighted, inquisitive separateness is to be celebrated. But then, what else would a painter think?

On some days I take my children in to school, or I pick them up afterwards. It is a school of many languages, different cultures. These children are the children of natives, and the children of immigrants – some cleaners, some taxi drivers, some academics, Polish, Romanian, Chinese, Bangladeshi, African-Caribbean, Irish. There are American accents in the playground, and German, there are Spanish kids, and Lithuanian kids, and Japanese kids. The parents are laughing, limping, scowling, swearing, chatting. Some, like me, just plod along and grab their kids and go. Others linger and chat. Some shout at their children, some never smile, some wait patiently while their children spiral and career around, a great centripetal release of pent-up energy. It is noisy, kinetic, wearying. This is England: the sky is often grey, the people not so cheery. But it is okay. It is an ordinary school.

My own children stand out for me, as every child does for its parents. They stand out in the crowd. It is always your own kids you notice, in that great collider of energies. They seem on their own idiosyncratic trajectory – impelled, running, looning. Or walking together, talking earnestly, hallooing theatrically to classmates, or wrapped solitary in great coats, *in* the crowd, but not *of* it. But then, so does every child to those who especially look out for it. That is what the crowd is: highly particularized, individual trajectories, averaged out.

*

In Bruegel's panel, some of the children enact rituals of inclusion and exclusion, not unlike that carried out by the Baptist in Budapest. A crowd of children will have many degrees of freedom, but these will not be infinite. Children are bullied here and there, or they fight, they learn to step up to the social challenge. Others mime marriage and other adult institutions.

And some are wearing masks, or hoods, or costumes. Trying on, as it were, different hats. Notably, one small individual leans from a top-floor window and holds a scowling, eyeless adult-sized mask to his or her face, directing its blind gaze out of the canvas directly towards us.

Ernst Kris, the Austrian psychoanalyst and art historian, talks in an essay on Franz Xaver Messerschmidt of the mask as the artist's way of mediating with the world. That child looking out through the mask is trying to make contact with us, or with his adult future world, by forlornly mimicking the adult.

And it succeeds, in ways it could not possibly imagine; succeeds in pinpointing for us – gloomy, pensive adults that we are – the uncanniness of children as they make their fizzing, sputtering, spiralling approach to adulthood.

When we leave the Kunsthistorisches Museum, it is lunchtime, so we walk around the Ringstraße to the Ministry of Justice. For some reason, no one stops you going in and up to the canteen on the fifth floor. You are X-rayed as you enter the building, but no one asks you your business. Our business is schnitzel. In the Justizcafé, they do a very acceptable schnitzel. You can also have a beer. And you can look out over the rooftops of the city.

Trying to make contact with us: *Children's Games*, detail.

The canteen is a relaxed to and fro of lawyers and civil servants and their guests, with a few interlopers – my brother and I, perhaps some other sheepish tourists. Colleagues say hello to one another, join one another for lunch; no one pays us, marginal observers, any attention. Would you call this a community? Workplaces are groups of people unbonded these days by blood or place or history. But there is common purpose, a space shared. Perhaps a community, then – one that is from a certain perspective porous, from a certain perspective exclusive. And perhaps, after all, with a little bit of shared history.

During the 1990s, my father's former company and social world, GEC, expanded like a red giant, acquiring company after company in the UK and the USA. But by the end of the decade, and around the time my father was retiring, it was

effectively bankrupted and broken up, its parts renamed, sold, regrouped, sold again. It no longer exists. My father kept an eye on its fortunes and would talk about it a little whenever I was home. Arnold Weinstock, the managing director who had transformed the company in the 1960s and 70s and an exact contemporary of my father, was dead by then, as was the world in which a young man's greatest desire was to be accepted into clubs and professions.

Whether my father took a mordant pleasure in his own immunity and the discomfiture of his enemies, all those cabals and Masons and consultants sucked down to perdition, or whether he experienced nostalgia and regret that the theatre of his youth and early manhood had been dismantled, I do not know. But he had anyway outlived it all.

If crowds and communities have their histories, their margins and centres, then so do paintings. Bruegel stands always on the other side of the panel from his subjects. Introvert, perhaps. Quiet, but jovial in company, Van Mander said of him. And as every introvert knows, a smile or a laugh can be a mere sign of joviality, sufficient to deflect the uncanny carnival of humanity.

He stood, however, in front of a panel, not a village scene, and not an illusory window into some real-seeming world. A panel is a thing of wood and splinters, a centre and corners. And Bruegel paid special attention to his centres and corners.

In the bottom left corner of *The Wedding Banquet*, for example, there is a basket of empty jugs, and a man is filling them for use at the feast – suddenly we are at the wedding at Cana, so many empty spiritual vessels about to be filled.

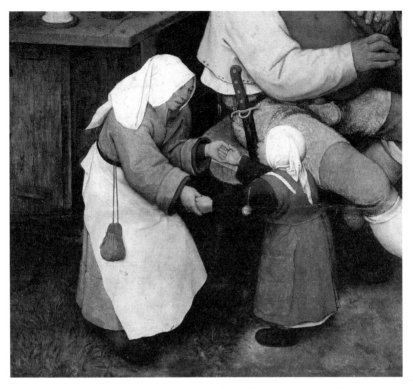

Encouraging her to move: *The Village Kermis*, detail.

In the bottom left corner of *The Village Kermis*, an older girl is tutoring a younger in the dance, holding her hands, giving her verbal instructions perhaps, showing her steps, encouraging her to move.

And down in the extreme bottom right corner of *Children's Games*, a girl is grinding brick to dust. She has, in effect, made a little pile of pigment for paint, ready to be weighed in the scales and guided through the paper funnel. And there she works, studiously ignoring the boisterous boys' games – fighting games, bullying games – going on to her immediate right.

Proto-painterly abstraction: *Children's Games*, detail.

And it is here, on the wooden beam where the girl works, in this moment of quiet, proto-painterly abstraction, on the far extremity of the crowd which was nonetheless pleasing and fascinating to him, that Bruegel chose to sign his panel.

XIII Home

Vienna – Prague (3.705%) – Breda – Brussels

'I am always going home; always going to
my father's house.'

Novalis (attributed)

The final year of the project is upon me, unplanned. This is
how it goes. Pages of your life get written, signed off, flutter
into the past. Who knows if they will make a coherent text
of some sort?

After the trips to Vienna and Budapest in the early part of
the year, and to Berlin in September, all accompanied by my
brother, I make a final tour late in October, as winter
approaches: Vienna, Prague, Breda and Brussels.

It is the final journey, perhaps I should make special
preparations, but in the end I just stuff a couple of shirts in
a suitcase (black, Samsonite), grab a book and wander off to
the airport.

For this last trip, I travel alone.

*

the catch-time is now at the end of the light

Two months after my father died, my brother and I went to Yellowstone National Park to do some walking and camping. At one point we gave a lift to a man about our age. He and his brother, like us, were just emerging from the back country, the forest, and since we could not fit both in with their bags, one of them needed to get back to where they had parked their car.

On the short drive, he told us excitedly that a few hours before, they had witnessed a pack of wolves chasing a deer, and we told him in return the story of a pair of wolves which had eyeballed us up in the mountains of Montana, just north of the park. And then he confided that his father had recently died, and that he and his brother were taking this opportunity to reconnect with one another.

The death of parents, we were all rapidly learning, entails tectonic shifts. It does not provoke a fear of death, so much as a temporary loss of our own identity. With their death, a stage and its sets – the first boards we trod – are silently dismantled and carried into the wings to grow dusty; the relevant scripts are put in drawers, lines forgotten; the troupe is disbanded. This is the deep blankness we fear. The loss not just of individuals that we love but of a communal manner of being. The loss, in effect, of a microculture or an argot – an argot encompassing how we speak and what we do and what we know. Because such microcultures and the identities associated with them are made together.

So these American brothers convened a summit to address this crisis of authority and loss which they were facing, and went out into the forest to perform a rite of passage they should perhaps have made many years since. And they came back with mythic tales of wolves and deer, and a sense, possibly, of a newly configured world.

only love fills the blankness

*

⁺ this is an old story. My father is now long dead. When he
˙re was no project, I had barely heard of Pieter Bruegel,
˙ve distinguished Elder from Younger.

ut, then, away from home. Prague.

˙roach Prague for a Bruegel enthusiast,
ıy of Vienna? There is after all the exhi-
˙ings to which, I like to think, I was
vithout alerting them to the fact, I
ɹ pass through Vienna, spending
...ᴜ ᴜ eat a schnitzel and drink a couple
ʌeinthaler's Beisl. Reinthaler's Beisl is pretty much
ı ɔnly place I have ever eaten in Vienna, and the schnitzel
is pretty much the only thing I have ever eaten there. Good to
be back.

The next morning I walk over to the Albertina and spend
a couple of hours looking at the drawings and engravings.
What do I see?

Wall after wall of lines and ideas, of shading and dappling,
of sharpness and precision. How did Bruegel come to discover
paint and colour? It is one of the great miraculous unknowns
of art history. His mind, to judge from the drawings,
the engravings, was all wire-frame precision, calligraphic
penwork, conjuring distance or shimmering horizon
from blank paper, gaps, emptiness. Any line he drew, he
knew, would be scoured out with the burin, incised in a
metal plate. His was an art predicated on reproduction, elab-
oration and dispersal.

His painting technique was similarly based on a play with
empty space: he would prepare the panel with a ground and
a tinted and luminous base layer, or *imprimatura*, and then

287

leave that layer exposed here and there, sometimes in great tracts. In *The Census at Bethlehem*, much of the middle-ground snow is just unpainted *imprimatura*. The great white cow in the foreground of *The Return of the Herd* is similarly just *not there*, a few lines over nothing picking out the idea of *cow*. And where he did paint, his layers were thin, like transcendental speculation leaved over filigree idea. The coloured world was somehow less solid, less precise, more imagined, etherealized.

But crucially, unlike the Florentines with their insistence on the primacy of *disegno*, or drawing, Bruegel's painted world is never merely an elaboration of line, a colouring-in. The art historian Max Friedländer remarks that Bruegel never considered the human form as an upright thing which he then bent and adjusted and rotated according to need. Rather he understood the stumpy, ungracious human form immediately, at a single gulp of the eye. A dollop of paint would capture it, a couple of flicks, perhaps an outline to sharpen the contours. His drapery, unlike that of those Italian saints and madonnas, is not an extrapolation of anatomy, an exercise in actuating ideal form: it is the coarse-woven, lice-riddled, mud-spattered body itself.

I like to think of him grinding paint – would he have ground his own paint? – in the dappled light of his Brussels studio, in the peace and quiet of an early morning. Thinking not about adorning his endlessly detailed, precise, worked-out wire-frame world, but translating it into something different, creating something real from nothing more than the accidents of colour, tinctures, light glazes.

*

I also like to think of him, in the clarity of evening, working with his pen and ink, under the bright illumination of candles. Working up his seasons, for example. In 1565, having recently completed the series of painted panel seasons for Nicolaes Ionghelinck, he turned his attention to a series of four large drawings, to be engraved by Pieter van der Heyden. He completed the first – *Spring* – that year. The next – *Summer* – would not get done until 1568. There he left it. After he died, the sequence was completed by Hans Bol, the whole to be published in 1570, riding the great Bruegel's posthumous tail.

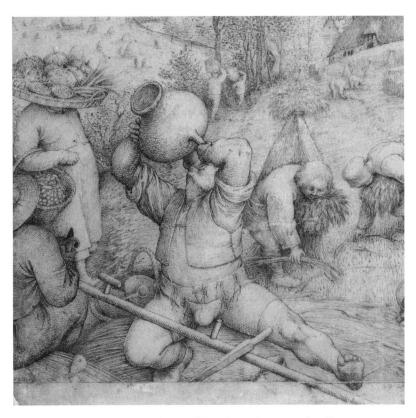

One great Hodge swilling beer: *Summer*, detail.

An ongoing project, then, lodged somewhere at the back of his mind and in the corners of his days during the last years of his life, while he worked on his great panels. Things of beauty they are too, *Spring* all order and parterres, gardeners working with long spades on an Italianate, ornamental garden, or tying climbing fruit in place over a pergola, or planting what might be flowers, might be vegetables, neatly, in raised beds. *Summer*, by contrast, is all fecundity, breadth: broad-arsed farmers scything a great field of swaying corn, women gathering up armfuls of sheaves, one great Hodge swilling beer from a capacious stone jar, foot and scythe cast easily over the front frame of the drawing. Another is scything with flowers entwined in his hair, and to the left an individual has transformed: he is carrying a flat basket of assorted vegetables balanced on his head, and over the crook of his arm a basket of small early-summer fruits. His head is invisible, has become the basket of vegetables itself. A motif we will see again shortly, transformation of the man into the archetype of the season.

Two drawings, half a project, years in the making. He was up in Brussels now, it was 30 miles across country to the Sign of the Four Winds. Could he have been a bit of a procrastinator, our Bruegel, needing a Hieronymus Cock breathing down his neck day after day to get him even so much as to pick up his pen, yawning, scratching himself? And then, when he does, he tosses off brilliancy after reluctant brilliancy.

In Prague there is one painting by Pieter Bruegel: *The Hay Harvest*, the early-summer panel (June–July) from the series of the seasons. It hangs now in the Lobkowicz Palace in the

castle complex, surrounded by room after room of *artificialia* and *naturalia*, accumulated over centuries. There is a room of portraits of named family dogs. There is a room of bird pictures, each made in part from the feathers of the bird in question. There are rooms of portraits of the ancestors, including one large canvas depicting the moment a formidable Lobkowicz matriarch concealed some fugitive or other under her skirts to protect him from an angry mob, which may or may not have had something to do with the defenestration of Prague. You make your final approach to the Bruegel via the prince's collection of blunderbusses and a room containing musical instruments and a great many Beethoven manuscripts.

And then there it is, *The Hay Harvest*, hanging alone (or nearly alone: over the door opposite the painting there is a rather poor portrait of the Archduke Leopold Wilhelm). In the course of an hour, only two or three people float through. There is a door in the south-west corner of the room with a number – 205 – on it. At one point three palace employees come through, unlock the little door, go inside – do I glimpse a winding stair? – and close the door behind them. Other than that, it is silence, the white noise of the dehumidifier masking the occasional murmur or laughter of the crowds passing up and down on the street below, in the rain.

I look at the painting.

When are you done looking? At what point do you stop looking at a Bruegel? Or, indeed, at anything? How do you decide that you have the measure of a thing, and can move on?

Bruegel presents particular problems in this regard. The panels are large and detailed. In the Prague panel, not a conspicuously crowded scene, there are at least sixty-four human figures. There are distant villages, boats on the broad river going out to the sea, a distant fortified town. There are people in the mid-distance doing something around a maypole. There are figures lost in the woods, and there are

Caught in the act of scrutinizing the ordinary: *The Hay Harvest*, detail.

the endless foreground details: baskets of fruit and a cart of fruit and vegetables to inspect, identifiable flora, the tinkering of the harvester in the bottom left corner, and on and on. And there are the three women heading out to the field to work, one of whom, rake slung over her shoulder, hat back from her broad brow, is looking directly out of the panel at us. Here we are, caught in the act of scrutinizing the ordinary, as though some revelation might lie concealed therein.

In several Bruegel panels, painted figures look back out at us. I count twelve panels in total. The masked figure in *Children's Games*, looking out of a window. The woodland man in *The Wedding Dance*. The man peering around the tree in *The Preaching of St John the Baptist*. One of the *Two Monkeys*. And so on.

While we are not exactly swept up in a Velázquezian play of gazes, we nevertheless catch occasional glances thrown our way. We are the stranger in the crowd, shyly or suspiciously regarded. We are also the audience. In an engraving of 1559, *The Kermis of St George*, one figure turns and looks at us, his mouth open mid-speech, and points at the scene unfolding. Such pointing and chorusing from the side of the stage, directly involving the audience, was a familiar characteristic of popular drama.

In one late panel there is a great deal of just such pointing and commenting going on. *The Peasant and the Birdnester* (1568) hangs in Vienna. It is dominated by the peasant. He wears a brown jerkin from under which protrudes a blunt, turnip-shaped codpiece. He is pointing over his shoulder at a youth who is clinging to the branch of a tree and grabbing a

handful of infant birds and losing his hat in the process. The peasant smiles. Perhaps it is a knowing smile. Perhaps a foolish one. The panel has been associated with *The Beekeepers*, which has a similar youth up a tree.

There is, too, *Winter Landscape with a Bird Trap*, in Brussels, where trapping small birds is associated with death lying in wait under the ice of the river. And indeed, both peasant and birdnester here are risking a fall. The birdnester hangs precariously, if perhaps also expertly, over empty space, while the peasant, delighted at what he has spotted, is about to walk into a river. On the banks of this little Lethe brambles grow, and on its watery margins, an iris.

There is another iris in Bruegel, in *The Blind Leading the Blind*, growing in the pond into which the first blind man has tumbled. It seems to be connected to a certain sort of unsightedness – ironic, given the part-aware, part-unaware state of the peasant. In early Flemish art, the iris, like the lily, was associated with the Virgin Mary, but also with Eve. Perhaps also, then, with falls of various sorts.

Our peasant, expert enough within his own local frames of knowledge, is also on the brink of discovering something. Something strange. We have to suppose he is not about to die in that sluggish stream. Perhaps he is just going to get a soggy boot, feel a little foolish. But he has, nonetheless, reached a certain margin over which he may not pass. Call it the river of forgetfulness, call it death, or just call it the front of the panel. He can make no more progress. He will have to turn back. His whole world is behind him.

And a strange, flickering world it is too. This is no all-encompassing, cosmic landscape, but a model of rural harmony, a domestic landscape.

Strange, flickering world: *The Peasant and the Birdnester*, detail.

There is a little farm, cows entering a barn, some chickens, a couple of tiny humans. The low vantage point is not new in late Bruegel – we are also low down in *The Village Kermis*, *The Blind Leading the Blind*, *The Misanthrope* – but now we are most assuredly *in* the landscape. There is no horizon. We

have, in a sense, arrived at a point of final belonging. This little world of peasant life is, like any world, or any life, circumscribed, located, functional. But it is, for all that, as on any day in late spring – that iris! – only half-materialized. The leaves on the trees, the bark, the weeds that fringe the pond, the cloud in the sky, all are so thinly painted, such wisps of existence, that they might be about to flicker out of – or into – being at any instant, like the peasant himself, the little birds, the birdnester. Or us, bewildered flickering audience.

, ephemeral.

And like that young woman, glancing at us out of *The Hay Harvest*. We know from studies of the underdrawing that Bruegel has worked hard to individuate her. He has changed the overlapping of sun hats, the better to frame her face. He has removed her apron, so we do not have a line of three identical aprons, and he has fractionally altered the hem length of the woman on the left.

We are looking at a woman in a group, anonymous; but she is also picked out, individuated, just as she individuates us. Bruegel is interested both in her social role and in her own self, the one emerging from, but not separating from, the other.

Elsewhere in the panel, the reverse procedure is under way. People are becoming their hats – the small figures at work in the fields in the middle ground, for example, where the great straw hats entirely replace heads or faces.

And some are becoming baskets of fruit. Five figures, male and female, carry baskets of early-summer fruit from left to right in the foreground, and at least two of them have baskets of fruit in place of a head. As with the figure in the engraving

Transformational possibilities of the habitual: *The Hay Harvest*, detail.

Summer, Bruegel understands the transformational possibilities of the habitual, the daily, the seasonal. Individual becomes social practice, social practice precipitates out into individual. We hover always somewhere between.

If we hover in between, can we not also get lost in between? Can we not find our sense of ourselves getting fuzzy, the social crudely overlaid on the individual?

I once knew an Italian man, a youngish senior manager in a large national bank, who told me that one weekend he had experienced just such an episode of fuzziness. His wife and son had gone to their house by the sea while he was forced by work

commitments to stay in Rome. He said that he had spent thirty-six hours by himself in his apartment, and he could think of nothing to do. 'When I was young,' he said, 'I was interested in so many things. I played the piano, I read books. But now I am just a father, a manager, a husband.' He had spent the weekend wandering from room to silent room. Looking out of the window. Alienated from his own spaces. Lost.

If we can get lost in our social roles, what redefines us? There is no simple answer. Life for social animals is always a precarious balancing, a tipping this way and that on your high wire.

In the end, my Italian banker bought himself a huge BMW motorbike and insisted I come down to the garage in his bank to hear the engine's roar. But a motorbike, exhilarating though it no doubt is, is a bit of a sledgehammer. Sometimes all it takes to redefine your individuality is a certain quality of noticing. A certain quality of glance.

The social defines the individual. Weddings, for example, drag you over the threshold of adulthood, maturity. Or they used to. All those weddings in Bruegel – *The Wedding Dance*, *The Wedding Banquet*, mock weddings in *Children's Games* – paint a daub of a line between the adolescent and the adult. Marriage brings you into relation not just with your spouse, but with your community, or society. With your world. A different sort of noticing. A communal noticing. You are accorded your place.

My own wedding came some years after the birth of my children, in the middle of the Bruegel projects. My wife and I stood up in the Bridges Room of the Cambridge Registry Office in front of a handful of heckling friends and family and we self-consciously vowed, I know not what. Afterwards we

had a pint in the Castle Inn and then a pie-themed lunch at home. Peasant wedding. Beer and cheese and pies.

It did not feel like crossing a threshold, but who really knows? The progress of the soul involves the crossing of many shimmering lines. We do not mark out the landscape of our maturation so sharply now. We feel that we have time. We prefer systems of deferral, loose and tacit public affirmation. When we get there, we get there in spite of ourselves, our social being catching up with what we had anyway become. We come into focus.

Just as the social defines the individual, the impressions and words of others will inevitably colour your response to a painting. For all that, you never really stand in front of a painting with anyone else. Looking at a painting is a solitary experience. What is there to say, standing in front of a painting, that isn't banal, pointless, performative, above all distracting?

Bruegel's contemporaries, we are encouraged to believe by a certain sort of art history, would have thought differently. A painting hangs on a wall, and is therefore available for a participatory viewing experience. The painter's humanist friends of Antwerp and Brussels would not have stood in mute delight in front of his panels. They would, together, have started to draw out the classical, proverbial, threads. To work up an interpretation.

I would be amazed, however, if some of those humanists, perhaps the painter prominent among them, did not grind their teeth at the observations of the connoisseurs in their midst. The chatterers. The workers-up of opinions. Of judgement. I would be amazed if some of the most marvelling and

marvellous reactions were not wholly mute, a dumb but profound resonance to the muteness of the art itself.

But perhaps I will indulge anyway in a little thought experiment. What would my father have made of this painting, had I brought him here, or sat him in front of it, and got him to verbalize his thoughts?

I don't think my father ever looked at a painting in his life. Or entered a gallery. I know that on the occasion he and my mother visited me in Rome, he went to the Sistine Chapel, and to the Villa d'Este in Tivoli; but he spent most of his time sitting in an English pub he found near the Trevi Fountain, enjoying a cigarette and a beer, and perhaps the sense of finding himself in a new place.

He would have had little to say about *The Hay Harvest*. But he had a gift, if not for contemplation, then for inaction. For an intelligent individual this perhaps amounts to something similar. Should we put him on the spot? Ask a question? He is long dead, so he cannot put up much of a fight. He can do nothing if I sit him here on this bench next to me – he can smoke a cigarette, if he likes, no one will stop him – and have him make some remark or other about this extraordinary panel.

Because it is, even by Bruegel's extraordinary standards, an extraordinary panel. In all the years I have been looking at book-Bruegel, I have never really dwelt over much on this particular one. It has passed me by, a little. But now that I see it, I understand quickly one or two things. First, it is one of the best-preserved. Most of the Bruegel panels are in good condition, many are excellent; but this is supreme.

And to see a Bruegel in such excellent condition is to be reminded of the lightness of his layering. No painter of his age worked the paint so lightly. The luminous *imprimatura*

layer he laid over the ground is allowed to shine through. This panel seems backlit. Alive within.

I should shut up. Let my father speak.

Does it matter if we never put our thoughts, or our emotional life, into words? For me, a little, yes. Like E. M. Forster, I never know what I think until I hear myself say it. But that doesn't preclude other pleasant and profitable ways of being in the world.

My father would no doubt like to have filled those blank pages of his memoir with exploits – sexual conquest, heroic resistance, victory and validation, wonders seen, armies worsted – the sort of things you see on some Bruegel panels. But engagement with the world does not always look like this. It is perhaps telling that my father chose for his medium not sheaves of lined paper, not a notepad, but a diary. A diary implies repetition, the self-similarity of days. Those days become building blocks of something bigger, a single unified exploit: a life lived.

Not all looking at the world leads to consummation. There is such a thing as a flickering light-touch looking. A noticing. An unconsummated observation. Failure to consummate can take you in two directions: towards frustration, or towards openness. Snatch at things and fail or let them drift by. We are all capable of a bit of both. But in the play of consummated and unconsummated longing which make up every life, the satisfactions to be had from simply observing, and saying nothing, are not the least.

If my father has nothing much to say in front of the Bruegel, then that is good too. Better, perhaps. People who

have a lot to say in front of paintings are not doing much in the way of looking – are not listening for the almost inaudible signals that only gather in time and silence. Blank pages are not the worst.

My father would have set his glasses on the end of his nose and smoked his cigarette, and inspected the panel and said little. But I like to think he would have enjoyed the experience. A quiet hour just looking at something. No opinions. No shared observations. Alive in the world, and just looking at something. The less said the better.

I failed to answer my own question: when are we done looking, and how do we know?

I am loath to leave *The Hay Harvest* at the end of my hour. The detail keeps toppling out. The hay is blue, I notice, like the distant hills. That farmhand is not sharpening his scythe, he is tapping at its blade with a little silver hammer (although for all I know, this is part of the process). Is that one individual or two, running about deep in the woods? That cart, about to crest the slope, surely the slope will be too steep, all those precariously balanced fruits and vegetables will topple off. And what are those early-summer fruits, toppling over the baskets' brims? The sinuous low roofs of the hamlet run into one another, as though the whole village were knocked through into one sprawling un-Babel, towering nowhere but unifying its little populace. The church, with its more severe verticals, stands apart. And, again and again, the round face of that young woman looking out into an unimaginable future, one untouched by seasons, or place, or belonging, still less by God or salvation. A potential everything. Her brimming life.

When am I done with looking? I will never be done. There is no completion to be had. No point of closure. To stand in front of a painting such as this is to be caught in a loop of contemplation. You can only at some arbitrary point summon the will and walk away, knowing that the instant you do, memory will already have started on the one hand to fade, and on the other to coalesce.

Later, when I get back to England, I show my mother a reproduction of *The Hay Harvest*, talk to her about where I have been, and ask her what she thinks those fruits might be. She is, or was long ago, a country girl, after all, from the west of Ireland, has told us many stories of her brothers catching trout from streams by hand, by tickling their bellies; of little dramas that she and her friends put on in Hurley's henhouse. Once she had just such a round inquisitive face, just such an appetite for horizons. She met my father when she found a job at GEC, in the drawing office of all places. They were married within six weeks. They must have represented new horizons to one another, for a time at least. Escape. Flight.

So I ask her about the fruit. She finds it hard to know what I am getting at, what I am showing her. The world is fugitive now, cannot be meaningfully pinned in place.

We drift on to other subjects.

I do not know that I have all that much coherent to say myself. Prague is odd pockets of space and time: windows of silence, a park I walk through with no one in it, a room with

a painting in an empty palace where outside great crowds of people walk past, muffled, near-silent.

The next day I fly from Prague to Amsterdam, and from the airport take a train to Breda. I arrive in the early evening and find my hotel.

The hotel I have booked is a chain hotel, well appointed, anonymous. The way I like them. The woman on the front desk asks me cheerily as I check in what brings me to Breda.

I haven't an answer prepared. What does bring me to Breda? A sense of endings, of beginnings. Bruegel may have been born here, or hereabouts. Or in Bree, or Brogel, or Bruegel or, indeed, in Antwerp. We do not know. Karel van Mander has him born in a village called Brueghel, near Breda, in North Brabant. But the actual village of Brueghel is nowhere near Breda. Some believe Van Mander might have been confusing it with one or other of Kleine-Brogel or Grote-Brogel in Limburg, close to the town of Bree, which in old Latin texts was sometimes Breda. Guicciardini, writing a little earlier, just has Bruegel born in Breda.

So there we go. Breda will have to do. It must stand for an origin, even if it is none.

I tell the woman on the desk simply that I am on my way home. I do not say from where. She accepts my answer. I haven't the energy to talk about Bruegel, about how he might not have been from here anyway, about how this does not matter.

She says, as if it were a reply of sorts, 'May I remind you that tonight, at 0300 a.m., winter starts?' Now it is my turn to be momentarily thrown. In English we talk of clocks going forward or back: it is just a mechanical question. Here on the cold flatlands of Europe it is a question of seasonal change, marked in a sudden moment. Winter starts tonight. Get ready.

If I were a mystic I would take it as a sign. Bruegel is winter's painter. I have just come from Prague, where summer is at its glorious height in the Lobkowicz Palace. But it is winter which underpins all of Bruegel. There is winter, and there is that which is not winter. Call it summer, or spring, or life. None of those figures looking back out at us from Bruegel's panels looks out of a winter panel. Winter is closed in. There is no fluorescence.

Or perhaps, poor mystic that I am, I have it wrong: Bruegel is not the painter of winter, but of cyclical systems. Call them seasons. Call it seasonal growth and change.

Bruegel was the painter of works and hours. Idealized, of course. Art creates ideal objects. That hay harvest never happened. There was no smiling young woman, no overflowing baskets of fruit, no blue hay and rocky outcrops. There were, perhaps, bits and snatches of all these, a feeling of plenitude in the land, a connection with the ancestors and their practices. But this is a nostalgia. Nostalgia for a world on the brink of destruction – actually, in the coming century of wars, or psychically, in the visual imagination of a painter cut off from some endless youth.

But the ideal objects are what you navigate by. Their coordinates are revealed to you, from time to time, as you watch your children, your wife, like glimpses of stars on an open boat by which you might dead-reckon your way to safety.

There are no stars in Bruegel. No night skies.

Breda on a Saturday night, at the going out of whatever winter is not, is a convivial town. I walk around thinking

about a beer. In the main square there are tables outside bars and restaurants thronged with people. It is all too energetic for me. I buy a kebab and take it back to my room. I am not lonely, not sad. I am just tired, and ready for home. I watch British television and drink a beer from the mini-bar, and eat my kebab, and get an early night.

The next morning, after breakfast, I walk back into town. It is a cold clear Sunday morning, and no one is around. No one. The streets are deserted. Silent. I have little films taken on my phone of the empty streets, the sounds of my own footfall, the ludicrous chimes of the church clock. In the course of an hour, I see perhaps ten people.

A ghost town, for me to ghost through.

And then, last leg, the train to Brussels. This should be easy but is not. A train has broken down on the line, I have to take a bus from Roosendaal to a village called Essen on the Dutch border where I board a two-carriage train and sit in silence, immobile, for an hour. The little train then lurches towards Antwerp, a sleeper at a time.

In Antwerp I bound up and down the endless escalators, trying to find a train to Brussels. I am running short of time, conscious now that I might miss the Beaux-Arts. But I find a train and work out that if I get off at Brussels Central rather than Brussels Zuid/Midi, I will be a short walk from the gallery. I can relax.

And then when I arrive in Brussels I discover that they have cordoned off the great square in front of the gallery with blue-and-white police tape. I am obliged to make a wide detour, dragging my Samsonite behind me, or carrying it up

flights of steps. It starts to rain, great melancholy splots, and when I finally stumble up to the gallery entrance there is a long queue. I stand in the rain and wait.

In the end, I get in with forty-five minutes to spend in the gallery before I will have to run for my train back to London. Forty-five minutes is enough.

I deposit my Samsonite in a locker and go straight up to the Bruegel room. Nothing has changed, in five years. I pull out my notebook and prepare to make some jottings.

I note the panels by the Younger. I had forgotten that there is a version of one of them, *A Village Festival in Honour of St Hubert and St Anthony* (1627), hanging in my own town, Cambridge. I pace out the distance between the Elder's *Census* and Younger's *Census*, and am astonished and delighted to find that what I had reconstructed in memory was exactly correct: a triangle nine paces by three.

I play spot the difference one last time, and find new points of divergence. To end where I began was perhaps the idea, but the detail keeps on diverging. There is a missing cart at the top of the Younger's panel, for one thing. And there is a cartwheel leaning against a house, also missing. And the Younger's central cartwheel is just a wheel, slightly squished. None of this had I seen before.

Then, at the top of the Elder's panel, there is a tiny child waving her arms at some geese on a frozen bit of pond. Is she trying to shoo them away in mimicry of the big children of the village, or is she mimicking, not the bird-shooers, but the birds themselves, as though by outstretching her limbs she might invest herself with the power of flight? Either way, the

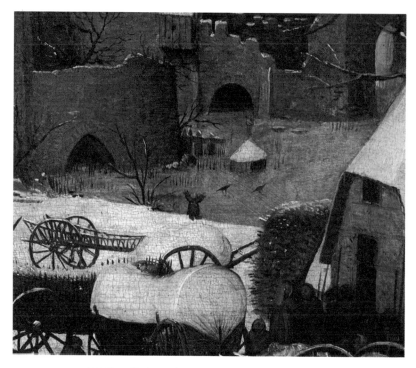

Taking flight: *The Census at Bethlehem*, detail.

birds are unmoved by this little person, who does not appear
in any of the Younger's panels, so far as I can make out in the
reproductions. An afterthought of the Elder, then, a child on
the brink of the great world, peering over. Taking flight, in
her imagination. Little Icarus.

And just as I prepare to run for my train, one final thing.
That man standing by the ice, watching the two small chil-
dren venturing out, the one I took years ago to be a father,
perhaps the Bruegel-avatar in the painting. He has his hands
in his pockets, looks cold, but watches his children anyway in
their explorations. I notice now that on his left shoulder there
is a round white dab of paint. Someone has thrown a

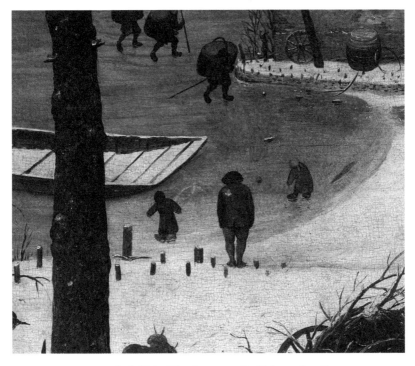

One deft flick: *The Census at Bethlehem*, detail.

snowball at him. Here he stands, hangdog, misused, butt of a childish snowball.

I walk over to the Younger's panel. The figure is there: the snowball trace is not.

And in that one detail I have a sudden little revelation of the man: Elder Bruegel, taking up a final brush to the finished panel, and with one deft flick signing the panel, not with his name, but with his whole colossal ambiguous personality: a clever man in a strange and difficult world, amusing himself by lobbing a snowball.

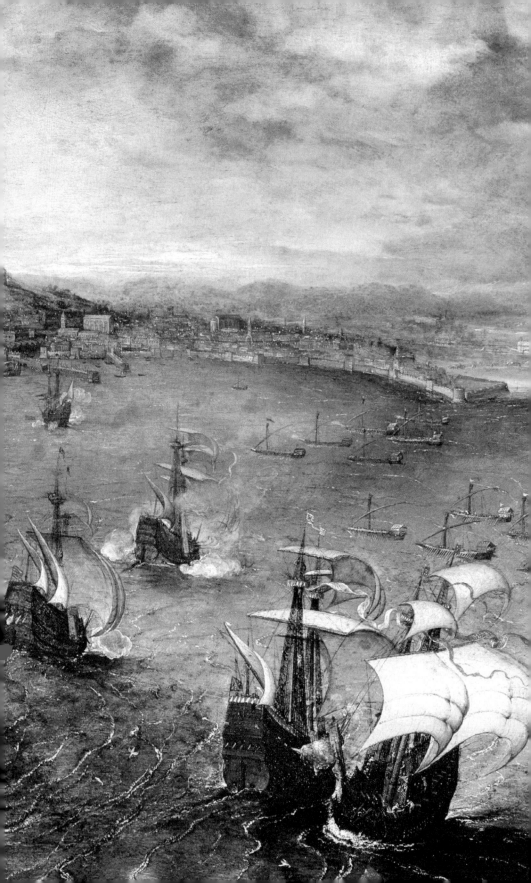

Epilogue

'There are explorations that can never end in discovery,
only in willingness to rest content with an unsure
glimpse through mists, an uncertain sound of becks we
shall never taste.'

Basil Bunting on the poetry of Ford Madox Ford

The first Bruegel I ever saw hangs in the Palazzo Doria
Pamphilj in Rome. For several years I worked in a language
school a couple of hundred yards away and visited the gallery
occasionally. In it, you can find the Velázquez portrait of
Innocent X sharing a space with the Bernini portrait bust of
the same Pamphilj pope; there are a couple of Caravaggios, a
Raphael double portrait, and much else.

The Bruegel – *View of the Bay of Naples* – is not large
(1,974 cm²). On the wall you can read about Bruegel's trip to
Italy, his topological views. And here we have the city with
its semicircular harbour, its castellated approaches, and a
green sea of ships all sail and streamer, lateen-rigged or

311

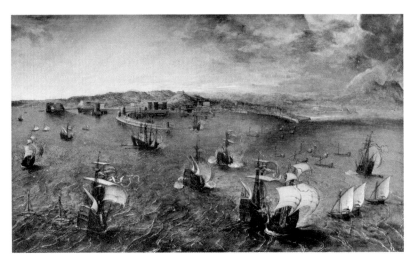
A green sea of ships: *View of the Bay of Naples.*

square-rigged, galleys and men-o'-war. Expensive, delicate ships. Some of them appear to be engaged in a battle. In the background, the double hump of Vesuvius rises out of the sea and culminates in a little fire and smoke (an anachronism: Vesuvius was quiescent between the end of the thirteenth century and 1631).

Is it by Bruegel? Sellink suggests that the attribution should be maintained for the present, pending additional study, but he doesn't seem to believe it himself. The brushwork is stiff, he says, the background mechanical. More a pastiche of Bruegelian motifs than an actual Bruegel.

But it was, as I say, my first, and I have given it a place in my spreadsheet. I moved to Rome when I was twenty-five years old and left when I was thirty-four. I liked art and visited galleries and exhibitions. Every so often, I would drift past this painting in a silent gallery and remind myself of the

little ships bobbing on the green sea off Naples, not so far, really, from where I stood. I think I may have bought a postcard, but I can no longer find it.

In 1495 the young King Charles VIII of France, following a whirlwind campaign down through the Italian peninsula, arrived at, besieged and captured Naples. From his correspondence, however, it is clear he had achieved not just the conquest of a new city, but of a new mode of experience. Naples had taken possession of him as much as he had of it. Naples was a city of gardens, of wonders, of warmth and citrus fruit. And the villa at Poggio Reale, where it is believed he stayed, was a villa in the new style, designed not with fortification in mind but openness. It was a place from which to gaze out over the world, over the scented lemon groves and the strange shrubs perpetually in flower. This was not damp, medieval, inward-looking, castled Northern France. This was something new. A Renaissance in miniature.

Naples marked the terminus of Charles's journeying out into the wide world. But it was also a coign of vantage: you stand at the uttermost limit of your imaginable world and look beyond. Charles supposed he would use his new kingdom of Naples as a jumping-off point for crusades, for the Holy Land. He was approaching the warm centre of the universe.

He was wrong. Before the year was done, he was chased from Naples and Italy by an alliance of the Pope, Venice and Milan. But as he ran, he took with him cuttings from the orangery, and the gardener, one Pasella da Mercigliano.

The king died of an epidural haematoma at the age of twenty-seven, after cracking his head on a door lintel in his

castle at Amboise – the building shrunk and contracted, perhaps, in his absence. But I have no doubt he spent the remainder of his short life contemplating his orange trees, dreaming of the South, of Naples, and the strange, sunlit, copious world to which it had seemed the threshold.

 I have a photograph of myself taken on Piazza Barberini on 8th December 1994, when I was around the same age as Charles VIII in Naples. I am riding an old sit-up-and-beg bicycle which I remember was named by its prior owner the Starbuck-Alice. I am wearing an open-necked cream shirt under a blue jacket, and a pair of jet-black sunglasses which I had just bought and was foolishly pleased with.

I know it was 8th December because that is the Feast of the Immaculate Conception when, in Rome, the Pope comes out to perform a little ritual in front of the column near Piazza di Spagna. We went to see him that day. I shouted something facetious at him as his open-topped car rounded the corner of Via dei Condotti where we stood, and he turned pointedly, fixed me with his pontifical eye for a second, and waved a blessing over me. I remember that two of his fingers were bandaged together. That should be my epitaph: *Here lies one blessed in error by a damaged pope.*

Blessed, all the same. The day was sunny and warm. Ever since, I have told people you could be walking around in your shirtsleeves in December in Rome, but I am always thinking of that day.

Whatever broader contexts surrounded that moment are gone. I can recall I was short of money, had just found a job in a language school, was always between apartments. Recall,

but not properly remember. The frame of the Starbuck-Alice broke apart a couple of months later where it had been clumsily welded, and I had to buy a new bike. But there I am still on that bicycle, in the picture, my years in the warm South lying ahead of me.

Past lives, or past versions of your own life, exist as little tableaux, paintings of cosmic landscapes once seen, drawn now from the spirit. Alfred Adler, Viennese psychotherapist, thought of such framed memories as a private logic. Bruegel must have known something similar, had similar sunlit inner views starting in upon him in the cold North, years later. Retrieved, remade. Ripe for paint.

Was whatever future that I saw in my mind's eye, on the bicycle that day, realized? No, no more than the tide of glory which Charles VIII saw ahead of him, but which in fact lay all around him. In the event, you become something you could not have imagined. You become – even if you are paranoid, watchful, proactive – not your father, but something very like it. Is it 2017, or 1978? Does it make a difference? No. Here we go again. Get a big blank book and turn its empty pages one by one.

But that inevitable convergence, as of Icarus with the cold wake of the Daedalic ship, conceals points of difference, edge cases, interesting data. I do not in fact know if I became my father, simply because I do not know what my father was – what those blank pages might have contained. Bruegel the Younger, in his workshop, perhaps took delight at the man he had become, the extent of his estate. But there were, for all that, innumerable details about his father's work – the mark

of a snowball; a boy tying on skates on the edge of a pond – which simply escaped him. To which he was not party. Which were none of his business.

My father was an observant man, alive to the world around him and attentive to detail. Shortly after his retirement and before he went blind, he sat down again at that huge red desk diary and began to make notes about his life. He did not get far. But for example:

1925: Born at 8 a.m. Sunday 5th July, in Royal Free Hospital, Gray's Inn Road, St Pancras, London; lived in small 1st-floor flat in Crowndale Rd, Camden Town.

1929: Around this time moved to Bourne Estate (Council), 5th floor, Portpool Lane, Holborn, off Gray's Inn Rd.

1930: One day at state primary school (St Albans). Removed after the only thing I had learned was to call my father a bastard. Enrolled at Mrs Glatty's Infant School (private) in Fetter Lane near the junction with Fleet Street (now a restaurant).

1936: Living at 169 St Mildred's Rd, Lee, SE12 – top flat. Shared with Mr and Mrs Lewis – a colleague of my father's. Mrs Lewis coached me in elementary maths. The house (Victorian) was on the corner of Manor Lane, with 11 poplar trees flanking the garden. Saw the Crystal Palace fire from the front garden.

Even this microcosm, this gloss of a life, is pricked with detail. Eleven poplar trees. The sort of thing Bruegel might have noticed about the world, with his own childlike sense of the

importance of trivial things. Not nine, not ten, not several, not some, but eleven. Eleven poplar trees.

My father's must have been a life of teeming canvases and panels, now almost wholly lost. Bruegel Object, Father Object: piece them together if you must, but you will never really know.

And then the last entry, before blindness or indifference overtook him:

1937: Saw Coronation procession of King George VI from east side of Regent St – with Mum and Dad.

Bruegel's picture of Naples hovers between topography and imagination, detail and idea; between what its painter remembered – the double hump, the arc of the harbour wall – and what he invented. Not so much a picture, as an incantation.

I make no special journey to see it. There it hangs in my inner gallery, marking a time when I felt no urge to complete anything in particular.

And what did I think I was trying to achieve, in fact, in scrambling to complete the circuit of Bruegels? Was I trying to wire them in series, to make a magical transcontinental talisman? Anthropologists will tell us that all art objects have their shamanic potential: by now, then, shouldn't I be able to draw down cosmic sympathies? Do a little snow dance and watch it snow, sing a little harvest song and reap great armfuls of golden wheat, wave my arms at a flock of geese and take flight across the Aegean? Shouldn't I be able to reconstitute

my father's life, my mother's memory, my own fled youth?

No. At some point in your progress through the world you must experience a magical bereavement. Step into the clear light of the ordinary.

The possibilities of existence are not always exhilarating, or exciting, or simple; but they are intricate, detailed, subtle, and bear scrutiny. The imaginary structure of your life passes away as you move through it, until you no longer have a foundation: you are the foundation. Of something real, however. Something substantial. Something that extends beyond yourself.

And if any artist is going to help you make that transition, it is Pieter Bruegel.

Occasionally, though, the possibilities of existence *are* exhilarating.

The highest mountain on the Isle of Arran is not all that high. Goat Fell is just shy of 3,000 feet. The walk up is not hard, and not so easy. I climbed it one evening, two or three years after bicycling around Piazza Barberini in my sunglasses, with Icarus-Dan and my girlfriend Anna, and Zabdi and Chris. We planned to sleep on the summit and paraglide down the next morning. We left after dinner, drove to the foot of the mountain and shouldered our packs, heavy with the great folded wings they contained. We walked through pine forests for an hour or two, then up on the paths leading to the summit, and it grew dark. Anna and I were not so fit, and the others allowed us frequent breaks. When we stopped, Dan would run on ahead, and then run back. He could not contain himself. At one stop, as we sat there breathing hard,

he walked about from rock to rock on his hands, naked from the waist up. An insanity of energy.

As we neared the summit and came up on to the shoulder of the mountain, we slowed. There was a lot of clambering now, heaving from big rock up to big rock. It must have been eleven o'clock or later, and it was dark, but a full moon had risen, and was climbing steadily. And so we climbed too, up through some scattered low cloud, and arrived on the shoulder of the mountain. We still had a few vertical feet ahead of us, but we stopped again, and took off our packs and sat down. And the clouds, milky in the moonlight, closed around us, until, for a few minutes, perhaps just for a single minute, the shoulder of the mountain where we sat was the only land visible, the only pinnacle of rock standing proud in a milky sea of cloud. The cloud poured over the shoulder of the mountain just a few metres below us. The whole sky beneath was white and silently mobile in the moonlight. Even Dan was reduced to stillness.

What a moment to be alive, and on a mountain. Did Bruegel the Elder, not so elder, a young man, go quiet on a mountain, ever? Crossing the Alps, on his return, perhaps. Did he ever rise to a point where there were only the mountains and the sky; where the cosmos was so ordered that it reduced itself to a handful of elements, so scant and simple that there was room even for him? A painter with his head full of paintings, a mountain top, the clouds, the moon.

Marcus Aurelius in his *Meditations* wrote that, since we have but a few short years remaining to us, we should live as though on top of a mountain. A chilly enough dictum: the sound of a Stoic trying to locate the transcendent. Trying to fix it in place.

But the transcendent is always moving on. We slept that night in sleeping bags on the cold mountain top and woke at dawn the next morning, but it was too windy to fly back down. We had to strap on the packs again and trudge earthward, five pedlars, into the green landscapes beneath us, the unfolding world.

Acknowledgements

There are many excellent books about Bruegel. I am particularly indebted to those by Joseph Leo Koerner (*Bosch to Bruegel*), Larry Silver (*Pieter Bruegel*) and the extraordinary three-volume *The Brueg[h]el Phenomenon* by Christina Currie and Dominique Allart. I also relied heavily on Manfred Sellink's complete catalogue of the works. My favourite book about Bruegel, Edward Snow's *Inside Bruegel*, is mostly about a single picture, *Children's Games*. I have tried to acknowledge specific debts in the body of the text wherever I am aware of them, but the presence of these and many other excellent scholars is pervasive, and always benign.

Most of the trips recounted here were shared experiences, and the book would never have been written without the company, by turns enthusiastic, thoughtful, provocative and simply companionable, of my brother, Simon Ferris, and my friends, Steve Barley and Anna Keen; nor without the support and involvement of my wife, Corinna Russell, whose astute observations and glee in Bruegel permeate these pages more than she can realise.

The finished text would not be remotely what it is without the extraordinary expertise and judgement of my agent Anna Webber, her assistant (and now agent in her own right) Seren Adams, my editors, Jennifer Barth and Nicholas Pearson, and my copy-editor, Sarah-Jane Forder.

Thanks are also due, for all manner of invaluable and generous contributions and assistance, to Katy Archer, Milan Bozic, Zabdi Keen, Olivia Laing, Robert Macfarlane, Jordan Mulligan, James Purdon, Susan Roberts, Peter Russell and Sheila Russell. And of course, Dan.

Chapter 2 (*Census*) originally appeared (in reduced form) in *The Junket,* an online quarterly published between 2011 and 2016.

List of illustrations

p. 148, *Christ Carrying the Cross*, 1564 (oil on wood), Bruegel, Pieter the Elder (*c.* 1525–69) / Kunsthistorisches Museum, Vienna, Austria / Bridgeman Images

p. 150, Bear Cannister, author provided

p. 159, *The Wedding Dance*, *c.* 1566 (oil on panel), Bruegel, Pieter the Elder (*c.* 1525–69) / Detroit Institute of Arts, USA / City of Detroit Purchase / Bridgeman Images

p. 165, *The Harvesters*, 1565 (oil on panel), Bruegel, Pieter the Elder (*c.* 1525–69) / Metropolitan Museum of Art, New York, USA / Bridgeman Images

p. 179, *The Parable of the Sower*, 1557 (oil on panel), Bruegel, Pieter the Elder (*c.* 1525–69) / The Putnam Foundation, Timken Museum of Art, San Diego, USA / Bridgeman Images

p. 182, *The Triumph of Death*, *c.* 1562 (oil on panel), Bruegel, Pieter the Elder (*c.* 1525–69) / Prado, Madrid, Spain / Bridgeman Images

p. 189, *The Misanthrope*, 1568 (tempera on canvas), Bruegel, Pieter the Elder (*c.* 1525–69) / Museo di Capodimonte, Naples, Campania, Italy / Bridgeman Images

p. 194, *The Blind leading the Blind*, 1568 (tempera on canvas), Bruegel, Pieter the Elder (*c.* 1525–69) / Museo di Capodimonte, Naples, Campania, Italy / Bridgeman Images

p. 199, *The Dark Day*, 1565 (oil on wood), Bruegel, Pieter the Elder (*c.* 1525–69) / Kunsthistorisches Museum, Vienna, Austria / Mondadori Portfolio/Electa/Remo Bardazzi / Bridgeman Images

p. 205, *The Triumph of Death*, *c.* 1562 (oil on panel), Bruegel, Pieter the Elder (*c.* 1525–69) / Prado, Madrid, Spain / Bridgeman Images

p. 207, Ibid

p. 210, *Magpie on the Gallows*, 1568 (oil on panel), Bruegel, Pieter the Elder (*c.* 1525–69) / Hessisches Landesmuseum, Darmstadt, Germany / Bridgeman Images

p. 214, *The Beekeepers*, *c.* 1567–68 (pen and brown ink on paper) (b/w photo), Bruegel, Pieter the Elder (*c.* 1525–69) (workshop of) / Kupferstichkabinett, Berlin, Germany / Bridgeman Images

p. 218, *Magpie on the Gallows*, 1568 (oil on panel), Bruegel, Pieter the Elder (*c.* 1525–69) / Hessisches Landesmuseum, Darmstadt, Germany / Bridgeman Images

p. 220, *Netherlandish Proverbs*, 1559 (oil on panel), Bruegel, Pieter the Elder (*c.* 1525–69) / Gemaldegalerie, Staatliche Museen zu Berlin, Germany / Bridgeman Images

p. 223, *The Return of the Herd*, 1565 (oil on panel), Bruegel, Pieter the Elder (*c.* 1525–69) / Kunsthistorisches Museum, Vienna, Austria / Bridgeman Images

p. 228, *Head of an Old Woman*, circa 1564, Pieter Bruegel the Elder, The Picture Art Collection / Alamy Stock Photo

p. 239, *The Land of Cockaigne*, 1567 (oil on panel), Bruegel, Pieter the Elder (*c.* 1525–69) / Alte Pinakothek, Munich, Germany / Bridgeman Images

p. 242, *The Drunkard Pushed into the Pigsty*, 1564–1638. Pieter Brueghel the Younger (*c.* 1564–1638) / Art Media/ Heritage Images

p. 248, *Christ Carrying the Cross*, 1564 (oil on wood), Bruegel, Pieter the

Elder (*c.*1525–69) / Kunsthistorisches Museum, Vienna, Austria / Bridgeman Images

p. 254, *The Preaching of John the Baptist*, *c.*1598 (oil on wood), Pieter Brueghel the Younger (*c.*1564–1638) / Kunstmuseum, Basel, Switzerland / Bridgeman Images

p. 259, GEC Appraisal, author provided

p. 266, *Conversion of St. Paul*, 1567 (oil on wood), Bruegel, Pieter the Elder (*c.*1525–69) / Kunsthistorisches Museum, Vienna, Austria / Bridgeman Images

p. 269, *Christ Carrying the Cross*, 1564 (oil on wood), Bruegel, Pieter the Elder (*c.*1525–69) / Kunsthistorisches Museum, Vienna, Austria / Bridgeman Images

p. 271, *The Village Kermis*, 1568. Oil on wood. Dim: 114 x 164 cm. Kunsthistorisches Museum / Photo © Luisa Ricciarini / Bridgeman Images

p. 279, *Children's Games*, 1560 (oil on panel), Bruegel, Pieter the Elder (*c.*1525–69) / Kunsthistorisches Museum, Vienna, Austria / Bridgeman Images

p. 281, *The Village Kermis*, 1568. Oil on wood. Dim: 114 x 164 cm. Kunsthistorisches Museum / Photo © Luisa Ricciarini / Bridgeman Images

p. 282, *Children's Games*, 1560 (oil on panel), Bruegel, Pieter the Elder (*c.*1525–69) / Kunsthistorisches Museum, Vienna, Austria / Bridgeman Images

p. 284, *The Hay Harvest*, 1565 (oil on panel), Bruegel, Pieter the Elder (*c.*1525–69) / Lobkowicz Palace, Prague Castle, Czech Republic / Bridgeman Images

p. 289, *Summer*, 1568 (pen and ink on paper), Bruegel, Pieter the Elder (*c.*1525–69) / Hamburger Kunsthalle, Hamburg, Germany / Bridgeman Images

p. 292, *The Hay Harvest*, 1565 (oil on panel), Bruegel, Pieter the Elder (*c.*1525–69) / Lobkowicz Palace, Prague Castle, Czech Republic / Bridgeman Images

p. 295, *The Peasant and the Birdnester*, 1568 (oil on panel), Bruegel, Pieter the Elder (*c.*1525–69) / Kunsthistorisches Museum, Vienna, Austria / Bridgeman Images

p.297, *The Hay Harvest*, 1565 (oil on panel), Bruegel, Pieter the Elder (*c.*1525–69) / Lobkowicz Palace, Prague Castle, Czech Republic / Bridgeman Images

p. 308, *The Census at Bethlehem*, 1566 (oil on panel), Bruegel, Pieter the Elder (*c.*1525–69) / Musées royaux des Beaux-Arts de Belgique, Brussels, Belgium / Bridgeman Images

p. 309, Ibid

p. 310, *View of the Port of Naples*, *c.*1558 (oil on panel), Bruegel, Pieter the Elder (*c.*1525–69) / Galleria Doria Pamphilj, Rome, Italy / Bridgeman Images

p. 312, Ibid

BISHOP PASS

LANGILE PEAK

JOHN MUIR TRAIL

LE CONTE CANYON R.S.

KINGS RIVER

DEVILS CRAGS

MATHER PASS

MT. PRATER

LOFTEPAL

DUMBBELL LAKES

2nd TRACKS

VANNACHER NEEDLE

CARTRIDGE CREEK

LAKE BASIN

MT. RUSKIN

TO 395

TABOOSE PASS

TRIPLE FALLS

MARION LK. (ILLEGAL FIRESITES)

CARTRIDGE PASS (1st TRACKS FOUND)

BENCH LAKE R.S.

BENCH LAKE

MARJORIE LAKE BASIN

ALDEN NASH CROSS COUNTRY ROUTE

LAKE MARJORIE

PINCHOT PASS

J.M.T.

MURRO BLANCO

LAKES

EXPLORER COL

SEEKERS ACCIDENT
RADIO FOUND
WATERFALL
WINDOW PEAK LAKE

PYRAMID PEAK

BACKPACK FOUND

WINDOW PEAK

JOHN MUIR TRAIL

N

HELICOPTER
RANGER STATION (R.S.)
— · — SEARCH BOUNDARY
==== MAJOR TRAIL
········ CROSS COUNTRY ROUTE

0 2
MILES

INSET SEARCH AREA (80 SQ. MILES)